ROCKPORT

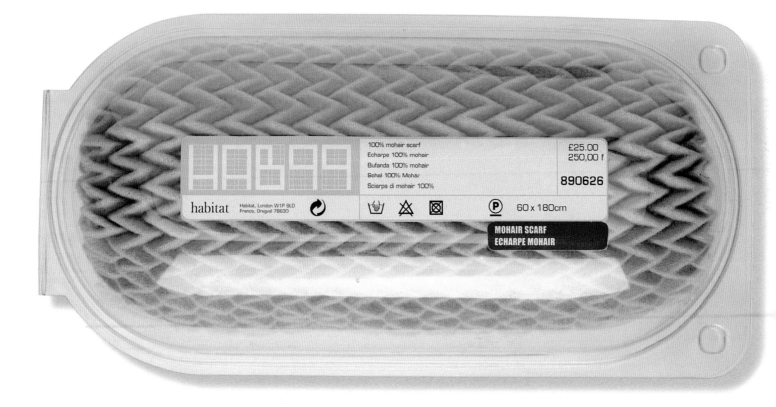

100% mohair scarf
Echarpe 100% mohair
Bufanda 100% mohair
Schal 100% Mohar
Sciarpa di mohair 100%

£25.00
250,00 f

890626

habitat Habitat, London W1P 9LD
France, Oregval 78630

60 x 180cm

MOHAIR SCARF
ECHARPE MOHAIR

EXTRAORDINARY GRAPHICS
FOR UNUSUAL SURFACES

MAKING THE MOST OF

HARD-TO-DESIGN SPACES

POPPY EVANS

GLOUCESTER MASSACHUSETTS

ROCKPORT
PUBLISHERS

First published in the United States of America by
Rockport Publishers, Inc.
33 Commercial Street
Gloucester, Massachusetts 01930-5089
Telephone: (978) 282-9590
Fax: (978) 283-2742
www.rockpub.com

Library of Congress Cataloging-in-Publication Data
Evans, Poppy, [date]
 Extraordinary graphics for unusual surfaces : making the most of hard-to-design shapes and surfaces / Poppy Evans.
 p. cm.
 Sports—Self-promotion—Entertainment graphics—Hotel and food service design—Fashion applications—Mobile graphics—Consumables—Souvenir and promotional merchandise—Other applications.
 ISBN 1-56496 860 X
 1. Graphic arts—Technique. 2. Commercial art—Technique. I. Title.
 NC1000 .E899 2002
 760'.28—dc21 2001006355

ISBN 1-56496-860-X

Cover Design: Stoltze Design
Interior Design: Plainspoke, Inc.
Layout: Yee Design
Cover Image: George Estrada, Modern Dog Design Company
Studio Photography: Kevin Thomas Photography and Bobbie Bush Photography
Project Manager: Francine Hornberger

Printed in China

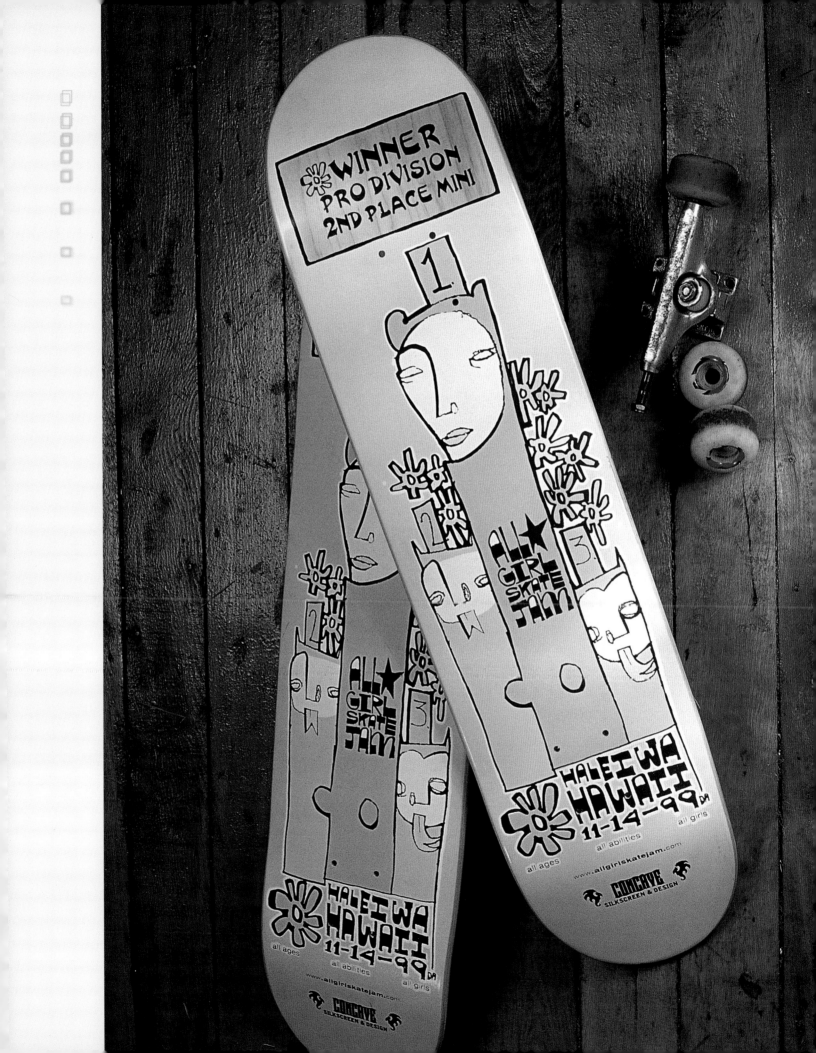

CONTENTS

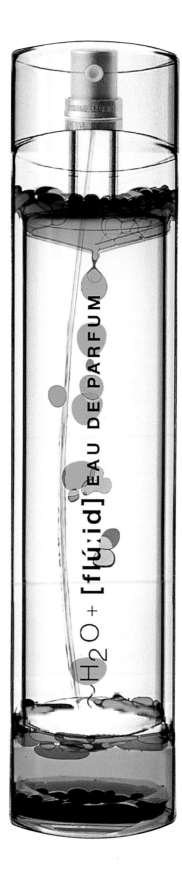

When designers tackle an ad, poster, or brochure, they're usually working well within their comfort zone. Designing on a two-dimensional plane within a rectangular format is the kind of design fare most studios handle on a regular basis. Making the leap into the third dimension, such as developing a design for a rectangular container, is also unlikely to present a formidable challenge. But what happens if that rectangular container is a casket?

Extraordinary Graphics for Unusual Surfaces focuses on designing for unusual situations, such as placing a design on an odd-shaped container or object, as well as other situations where space or shape is a major consideration. The projects that fall within this realm and are featured in this book encompass a variety of applications, including inline skates, garments and garment labels, transport vehicles, and, yes, even caskets. This book also features projects where a design must work in a number of situations—perhaps a series of garments, shopping bags, and packaging, or the range of items that comprise a CD box set, board game, or promotional package.

However, *Extraordinary Graphics for Unusual Surfaces* goes beyond the scope of most graphic design books in its recognition of projects that have gone further than merely positioning a logo on a variety of items. In the course of acquiring materials for this book, it soon became apparent which projects demonstrated truly innovative approaches in their integration of design and spatial/surface characteristics. There were many submissions of identity campaigns that included applications on shopping bags, garments, and company vehicles. Quite a few of these projects featured outstanding logo designs and handsomely designed stationery, worthy of recognition in a book on letterhead or logo design. But many of them fell short when it came to a creative interpretation of the identity for the three-dimensional elements of the campaign.

In addition to designing for unusual shapes or a range of design applications, *Extraordinary Graphics for Unusual Surfaces* also recognizes innovative packaging design for unusual items. Some of the examples featured in this book include packaging concepts for products ranging from rubber bands to recycled glass.

But most important of all, *Extraordinary Graphics for Unusual Surfaces* celebrates innovative problem solving and designers who have developed creative design solutions when faced with a challenging situation.

—POPPY EVANS

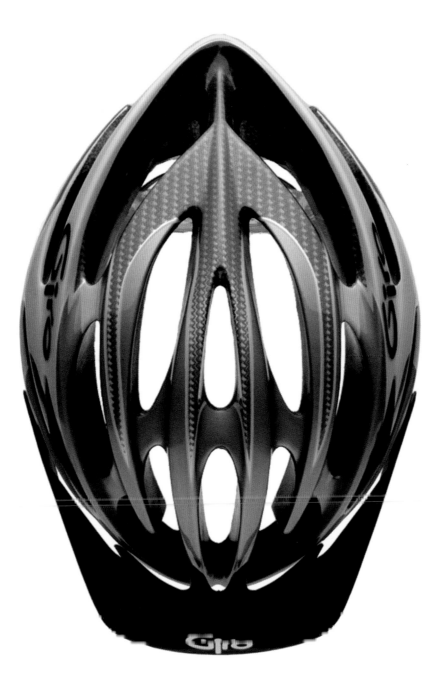

SPORTS | 01

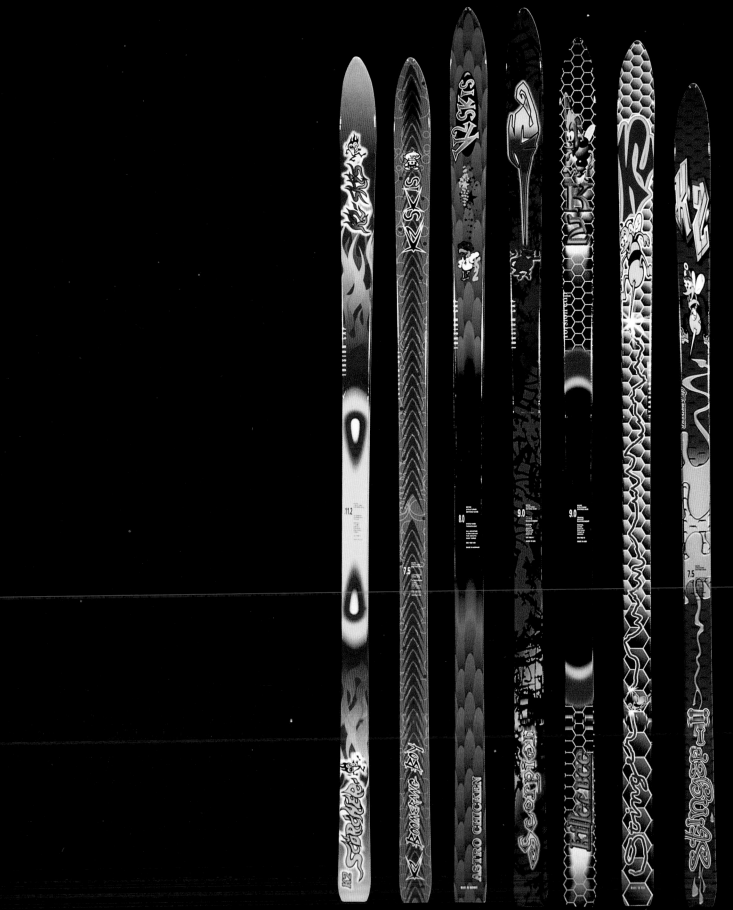

CLIENT
K2 Japan

DESIGN FIRM
Modern Dog

ART DIRECTORS
Michael Strassburger,
Vittorio Costarella,
George Estrada

DESIGNERS
Michael Strassburger,
Vittorio Costarella,
George Estrada

ILLUSTRATORS
Michael Strassburger,
Vittorio Costarella,
George Estrada

MODERN DOG'S CONCEPT FOR A LINE OF SKIS MARKETED IN JAPAN WAS
DRIVEN BY CHARACTER APPEAL AND THE NEED TO ADAPT THEIR DESIGNS
TO THE NARROW CONFINES OF THE SKIS' VERTICAL FORMAT.

K2 Japan came to Modern Dog to commission ski designs because they thought the firm could deliver an American, West Coast–driven look that would appeal to Japanese youth. However, Modern Dog's designers found themselves designing skis they felt looked very Japanese. In reality, their designs are a unique blend of "East meets West," combining Modern Dog's knack for appealing to the youth market with the kinds of brightly colored cartoon characters that are often used to promote products in Japan.

The designers used the area at the tip of the skis to portray each cartoon character along with the K2 brand name. The back area of the skis contains the character-based name of the ski design. The designers, who also invented the names for each of the ski lines, created character-themed patterns such as a honeycomb for the "Stinger" and "Hornet" to link the name and the character's image across the length of the ski.

The skis were created exclusively for the Japanese market and have sold well there. However, they've also attracted interest from U.S. consumers.

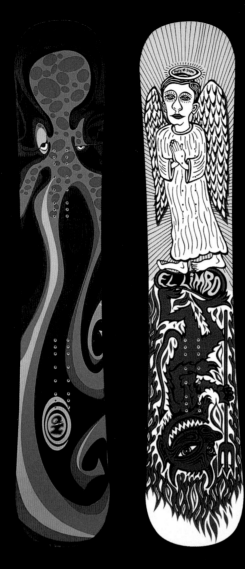

CLIENT
K2 Snowboards

DESIGN FIRM
Modern Dog

ART DIRECTORS
Michael Strassburger, Vittorio Costarella,
George Estrada

DESIGNERS
Michael Strassburger, Vittorio Costarella,
George Estrada

ILLUSTRATORS
Michael Strassburger, Vittorio Costarella,
George Estrada

MODERN DOG OFTEN WALKS A FINE LINE WHEN CONCEIVING SNOW-
BOARD DESIGNS THAT APPEAL TO THE REBELLIOUS NATURE OF TEENAGERS,
YET QUELL THE ANXIETIES OF THEIR PARENTS. ITS DESIGNERS CAME UP
WITH A "HEAVEN AND HELL" DESIGN THAT DIVIDES THE BOARD'S VERTICAL
FORMAT IN HALF TO DEPICT THE GOOD AS WELL AS THE "BAD BOY" SIDES
OF ADOLESCENT MALES. ANOTHER BOARD, FEATURING A SQUID DESIGN,
ALLOWED THEM TO ADAPT THE TENTACLES TO FILL THE BOARD'S LENGTH.

When K2 commissioned Modern Dog to design a series of illustrated snowboards under the name "QI," the manufacturer want-
ed a line that would appeal to its youthful market without turning off parents, who would most likely to be funding their teens'
snowboard purchases. Although the designers were given free rein to come up with whatever they wanted, their designs need-
ed to bridge the generation gap, as well as work successfully on the snowboard's vertical format.

Modern dog took a streetwise approach with the graffiti-like squid design it developed for one board design. After rendering the
squid's head at the board's tip, it was relatively easy to create an abstract design that suggests tentacles for the rest of the board.

To appeal to the "bad boy" side of adolescent males, the designers also developed a "heaven and hell" illustrated board. The
duality of their concept was easily adapted to the board's vertical format, with "El Limbo" serving as the line of demarcation.

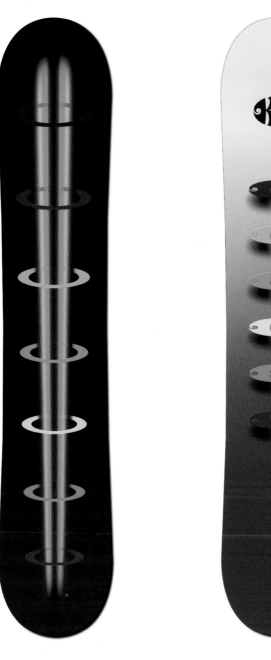

MORGAN LAFONTE
SNOWBOARD DESIGN

CLIENT
K2 Snowboards

DESIGN FIRM
Modern Dog

ART DIRECTOR
Michael Strassburger

DESIGNER
Michael Strassburger

ILLUSTRATOR
Michael Strassburger

MODERN DOG PORTRAYED THE METAPHYSICAL IN A BEAM OF ENERGY, SUR-
ROUNDED BY RINGS OF AURAS, TO COMMUNICATE ASPECTS OF THE NEW
AGE PHILOSOPHY OF PRO SNOWBOARDER MORGAN LAFONTE. THEIR
DESIGN ADAPTED BEAUTIFULLY TO THE ELONGATED FORMAT OF A SNOW-
BOARD BEARING HER NAME.

The Morgan LaFonte snowboard design is one of a dozen pro models Modern Dog was commissioned to create to commem-
orate well-known snowboarders. Each snowboard's design motif is inspired by each pro's personal accomplishments and beliefs.

Because Morgan LaFonte ascribes to new age philosophies that focus on spiritual auras, Modern Dog sought to portray the
metaphysical in the beam of energy that emanates from one end of the snowboard to the other. The rings that surround the
beam represent waves of auras. Their concept lent itself perfectly to the verticality of the board.

The topside of the snowboard displays the K2 brand and "Morgan," with the letters stacked vertically along the length of the board.

CREATING A NEW BIKE DESIGN FOR GARY FISHER MOUNTAIN BIKES
REQUIRED THE DESIGNERS AT TREK TO COME UP WITH A LOGO AND BRAND
IDENTITY APPLICATION THAT COULD BE READ AT HIGH SPEEDS AND FIT
INTO THE LIMITED AREA OF THE BIKE FRAME WHERE THEY WOULDN'T BE
HIDDEN BY THE RIDER.

The Gary Fisher brand originated about twenty years ago when Fisher started to popularize the sport of mountain biking. Because Fisher's name is so closely linked with the sport, Trek produces a line of bikes under the Gary Fisher name.

Coming up with a design for a Gary Fisher bike frame requires developing graphics that suggest speed and fun, while simultaneously reinforcing the Gary Fisher name and brand characteristics. Trek designer Eric Lynn achieves all of this with his design of the Fisher 200X-Caliper bike. Working with the Fisher logotype, designed by Thirst, Lynn applied it to the portion of the frame where it would be least likely to be hidden by the rider and most easily read while the bike is in motion. "Our best opportunity for exposure is when people are riding down the road or in a race," explains Lynn. Because the logo was the most static piece in the bike's design, Lynn used the other parts of the bike frame to create a design that suggests the flowing movement of traveling over an undulating terrain. The bike's color scheme of yellow and red is derived from the colors of the Gary Fisher racing team. "That tends to trickle into the line in pretty big doses," says Lynn who, in the case of the 200X-Caliper, spiked this combination with accents of dark blue.

CLIENT
Gary Fisher

DESIGN FIRM
Trek Bike Corporation

ART DIRECTOR/DESIGNER
Eric Lynn

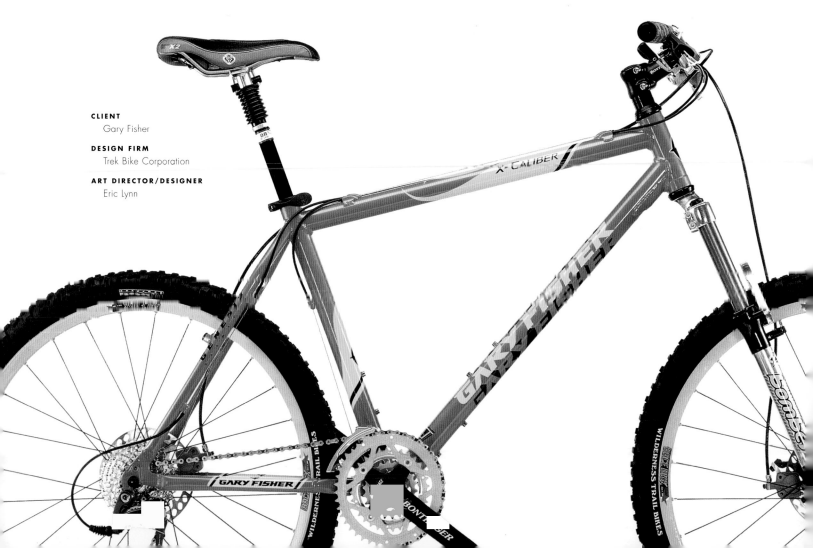

CLIENT/DESIGN FIRM
UltraWheels

ART DIRECTOR
Mike Matheny

DESIGNER
Erin Laub

LEGIBILITY, HIERARCHY, AND THE SUGGESTION OF SPEED ALL FACTORED INTO THE DEVELOPMENT OF A BRAND IDENTITY FOR A NEW LINE OF INLINE SKATES AND ITS PRODUCT APPLICATION. OTHER CONSIDERATIONS INCLUDED DEVELOPING A LOGO THAT WOULD FIT ON A VISIBLE, YET LIMITED, AREA OF THE SKATE.

UltraWheels' Biofit skate is promoted as a top-of-the-line product that promises maximum comfort and fit; in fact, the Biofit tagline is "designed from the inside out." Mike Matheny, UltraWheels art director, and his design team sought to echo this tagline with their design of the Biofit logotype, with its "wraparound fit" letter "O." Other considerations that went into the Biofit logotype design were its legibility and the suggestion of speed, accomplished by giving the letterforms an italicized slant.

The Biofit logotype also needed to fit on the arc of the skate. "The family or line name is most important to us on the skates we design," says Matheny, explaining that the arc above the wheels is the largest area of visibility on a skate.

Although the UltraWheels logo is of secondary importance, it still achieves a level of prominence in the skate's design. The UltraWheels design team also used a "U" icon to represent the brand in areas such as the skate wheels, where space is restricted.

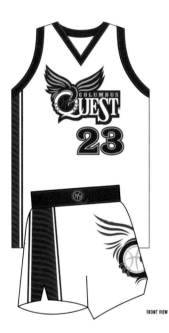

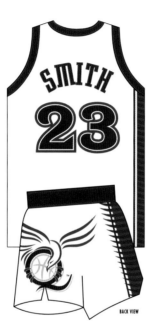

FRONT VIEW

BACK VIEW

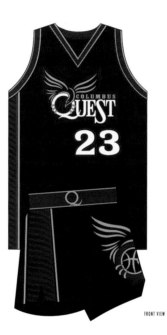

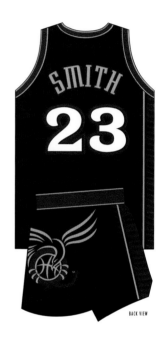

FRONT VIEW

BACK VIEW

CLIENT
Columbus Quest

DESIGN FIRM
Rickabaugh Graphics

ART DIRECTOR
Eric Rickabaugh

DESIGNER
Eric Rickabaugh

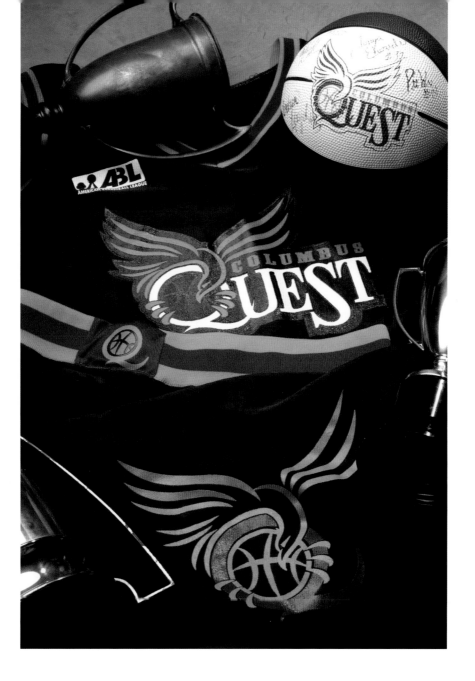

THIS SYSTEM OF GRAPHIC COMPONENTS WORKS EQUALLY WELL TOGETHER AS EACH OF THE COMPONENTS DO SEPARATELY, PROVIDING A FLEXIBLE IDENTITY SYSTEM FOR A PRO BASKETBALL TEAM.

When executives from Columbus Quest, an ABL basketball team for the city of Columbus, Ohio, contacted Rickabaugh Graphics, they wanted a logo for the new team that would work equally as well on uniforms, sports equipment, and souvenir merchandise. The firm not only developed an identity for the team, it also came up with the concept of using an eagle seizing a basketball for mascot appeal. When Quest officials gave their okay to this idea, firm principal Eric Rickabaugh designed a versatile logo that would look just as dynamic on a souvenir hat or basketball as it would painted on the team's home court.

To apply the identity to the team uniform, Rickabaugh needed to break the logo down into smaller components: the "Q" with the basketball in its center and the eagle and the "Q". These graphic elements worked better in small places, such as the center of the uniform's waistband, and added variation, within the identity theme, to the uniform design.

Rickabaugh Graphics also conceived the Columbus palette of gold, red, and navy blue. The bright red and gold work equally as well on the team's navy away uniform as it does on the home uniform's white background.

CLIENT
Klein Bicycle

DESIGN FIRM
Trek Bike Corporation

ART DIRECTOR/DESIGNER
Eric Lynn

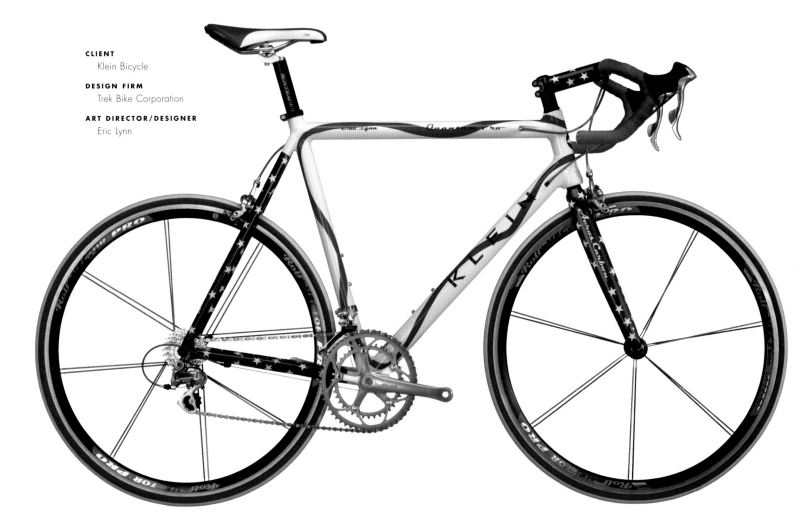

A PATRIOTIC THEME IS ADAPTED TO A RACING BIKE DESIGN FOR THE UNITED STATES POSTAL SERVICE'S MASTER TEAM BY CONFIGURING THE STARS AND STRIPES OF THE AMERICAN FLAG TO WRAP AROUND A BICYCLE FRAME.

When designing a racing team bike, designer Eric Lynn says visibility is one of the most important factors to take into consideration. "We were looking for something that would really stand out in the crowd," he explains. So when commissioned to design a bike for the United States Postal Service's master team, Lynn drew his inspiration from the American flag and brought the USPS's colors of red, white, and blue into a graphic motif that features the flag's stars and stripes.

Because the team's sponsor, Klein Bicycles, would be applying the graphics to the bicycles with a painstaking process called debossing Lynn wasn't able to supply digital art for decals. Instead, he created detailed drawings of the design's application on the frame, which the manufacturer followed to his specifications.

CLIENT
All Girls Skate Jam

DESIGN FIRM
What!design

CREATIVE DIRECTOR
Amy Strauch

DESIGNER
Aaron Carmisciano

ILLUSTRATOR
Derek Aylward

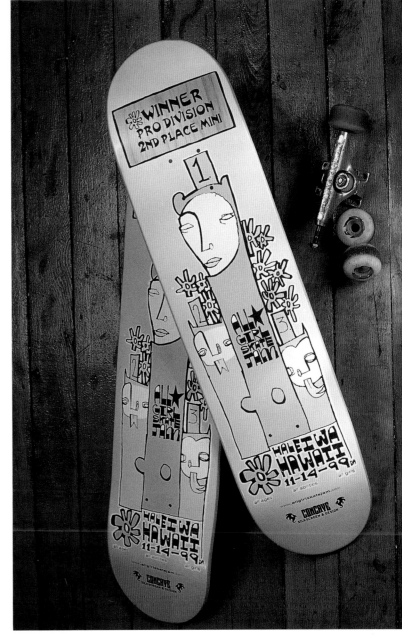

IN ADDITION TO MEETING THE CHALLENGE OF DESIGN-
ING TO FIT THE ODD DIMENSIONS OF A SKATEBOARD,
WHAT!DESIGN'S IMAGERY BLENDS EDGINESS AND ATH-
LETICISM WITH A TOUCH OF FEMININITY.

Commissioned to design a series of trophies for the All Girls Skate Jam, an international competition for girls skateboard-
ing, What!design's Amy Strauch decided that a skateboard would be the perfect trophy for a skateboard champion. From
there, it was a matter of developing a design that expressed the mix of edginess, athleticism, and femininity unique to
female skateboard enthusiasts. The design also needed to work within the board's vertical format and limited palette of
three colors.

Working with designer Aaron Carmisciano and illustrator Derek Aylward, Strauch and her team came up with an enig-
matic image of a woman that suggests the flowers and colors of the competition's Hawaiian venue. Aylward's raw-edged
rendering style and irreverent touches captured an attitude that struck a chord with the trophies' recipients. "They loved the
trophy. They thought it was a great design," says Strauch. The positive response has generated other skateboard projects
for Strauch and the designers of What!design.

CLIENT
Airwalk

DESIGN FIRM
Juice Design

ART DIRECTOR/DESIGNER/PHOTOGRAPHER
Brett Critchlow

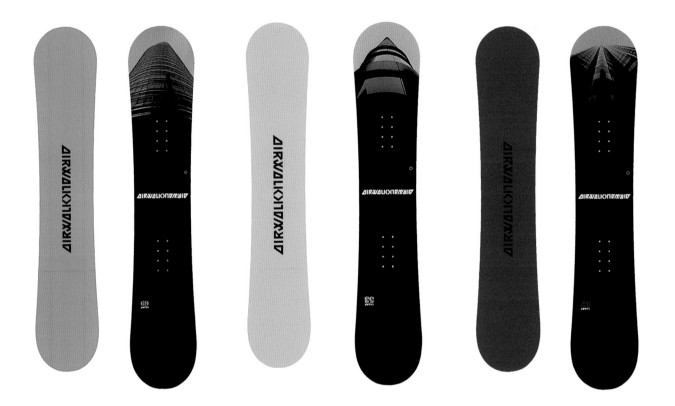

THE VERTICAL THRUST OF LANDMARK SKYSCRAPERS WAS WELL SUITED TO
MAKE THE MOST OF THE ELONGATED FORM OF THESE SNOWBOARDS.

Meeting his client's request to deliver something "dark but punchy" led designer Brett Critchlow of Juice Design to come up with a series of snowboard designs based on skyscrapers. "I love buildings," says Critchlow, who photographed a range of skyscrapers in his hometown of Pittsburgh, as well as in his current home, San Francisco. The rest were shot during a trip to New York City.

The boards provided the perfect canvas for the strong, vertical thrust of the skyscrapers, which appear on the topside of the boards. Critchlow used Photoshop to adjust tone and transition of each photo into a solid black background that runs from the back to the front of the board.

The "punch" was delivered on the underside of each board, with a graphic interpretation of the Airwalk name printed in black against a bright color field.

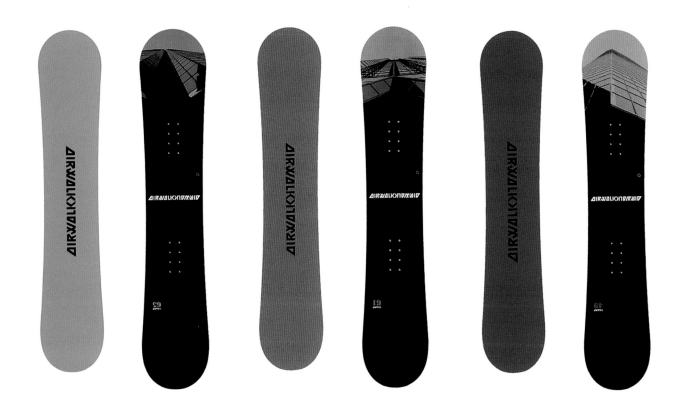

CLIENT
Alpine Shop

DESIGN FIRM
Phoenix Creative Co.

DESIGNER
Deborah Finkelstein

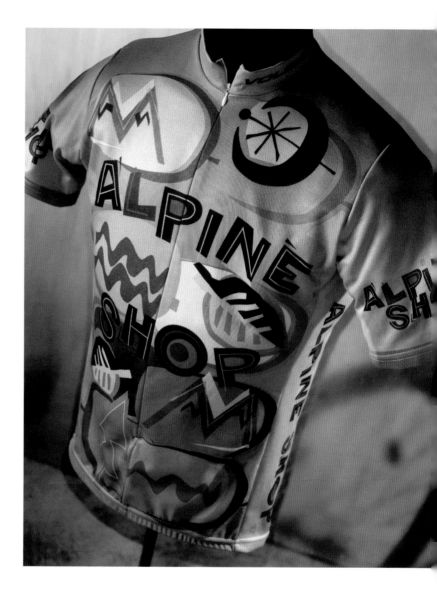

PHOENIX CREATIVE MET THE CHALLENGE OF INCORPORATING ASPECTS OF A SPONSOR'S LOGO INTO A DESIGN FOR A BICYCLE TEAM JERSEY BY BREAKING THE LOGO DOWN INTO GRAPHIC COMPONENTS THAT COULD BE RECONFIGURED TO MEET THE CONTOURS OF THE HUMAN FORM.

Designing a uniform for a bike team sponsored by the Alpine Shop, an outdoor shop based in St. Louis, Missouri, involved taking the shop's identity and translating that into eye-catching graphics that conformed to the configurations of a bike jersey. Working with a template provided by the jersey's manufacturer, Phoenix Creative designer Deborah Finkelstein took the elements of the Alpine Shop's logo, and repeated and reconfigured them on the front of the jersey in a way that makes a colorful statement in step with the Alpine Shop's identity. The Alpine Shop logo, which Finkelstein also designed, appears on the back of the jersey.

One of Finkelstein's greatest challenges was in re-creating the colors of the identity's seven-colored logo with the die-sublimation process used by the jersey's manufacturer. "It's very different from any printing process I've ever worked with," she explains. Her other challenge was getting the imagery to line up with seams and openings, particularly the zippered front, where graphics needed to be aligned on opposite sides of the jersey's center zipper. "You don't always have perfect alignment when you're dealing with fabric," she explains. "I worked very closely with the manufacturer."

CLIENT/DESIGN FIRM
Wilson Sports

DESIGNER
Doug Thiel

A MULTILEVEL TIER OF BRAND IDENTITIES, ALL-IMPORTANT TO BUILDING CONSUMER RECOGNITION, IS INCORPORATED INTO THE DESIGN OF WILSON'S FATSHAFT GOLF CLUBS. THEIR APPLICATION INVOLVED LOGO DESIGNS AND APPLICATIONS THAT WOULD FIT ON A RANGE OF CLUB HEADS AND SHAFTS IN AN ELEGANT AND APPROPRIATE MANNER.

For Wilson Sports, displaying the Wilson name is the most important aspect of designing graphic applications for any of its sports equipment. "We must continue to build consumer recognition, trust, and equity in our brands," explains Jeff Kortenkamp, director, graphic services, for Wilson. In the case of Wilson's FatShaft golf clubs, the Wilson "W" is incorporated into the design of the head of its Deep Red driver as a graceful graphic element, along with the Wilson logo. On other club heads, the Wilson "W" appears as a monogram in the corner.

The FatShaft logotype, expressing speed and motion, was designed to be easily read on a moving club and from a distance. Although the use of FatShaft or other sub-brand is secondary to the Wilson name, it helps to distinguish this top-of-the-line brand from other Wilson golf clubs. Other components of the identity include an oval that helps define the edge of the golf head's molded indentation, and the initials "F.S." The variety of graphic elements that comprise the FatShaft identity allowed for a variety of placement options on shafts and a range of club heads.

CLIENT
Pacific Market International

DESIGN
Belyea

ART DIRECTOR
Patricia Belyea

DESIGNER
Ron Lars Hansen

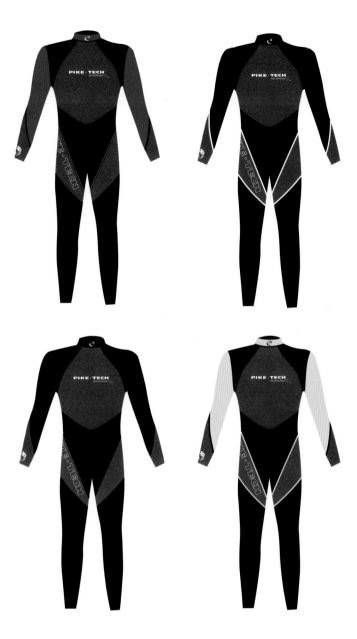

DEVELOPING A DESIGN THAT WOULD WORK ON THE BODY-CONFORMING LINES OF A WET SUIT REQUIRED BELYEA TO DEVELOP GRAPHICS THAT WOULD FIT THE SUIT'S COLLAR, CHEST, SLEEVES, LEGS, AND EVEN ITS ZIPPER PULL.

Pacific Market International designs most of their wet suits in house, patterning them after top-brand suits. But in the case of suits to be sold at mega-retail outlets, Belyea was awarded the job of creating graphics that would flatter the suits.

Working with flat sketches, the Belyea design team began by researching the year's fashions for wetsuit graphics. They then developed design elements for the suit's collar, chest, sleeve, thigh, and zipper pull. From there, the design team developed lettering for the Pike Tech logo and a wave motif, keeping the design simple and sporty.

The design was applied to five full-length wet suits and then modified for a full line of short suits. Throughout the process, the designers experimented with applying graphics to areas as limited as the narrow zipper pull. "Taking the sizing up and down is easy on the computer," explains firm principal Patricia Belyea. "It's easy to know what's out of bounds. It just doesn't feel right."

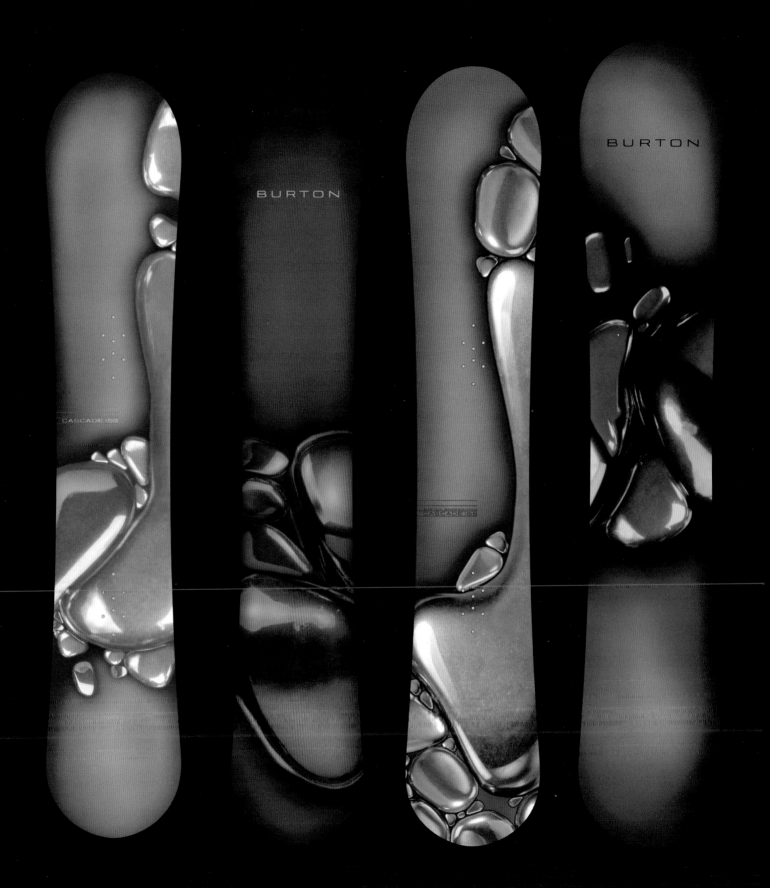

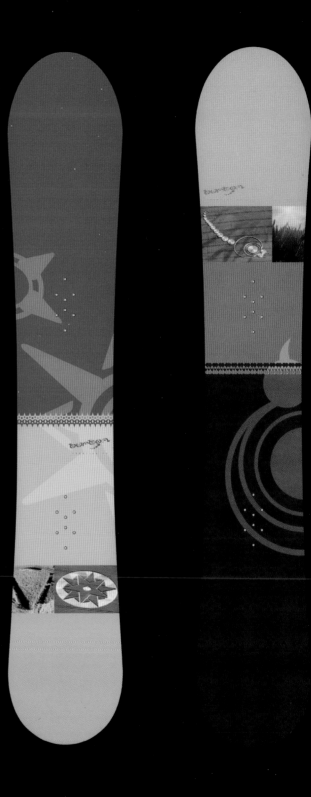

CLIENT
Burton

DESIGN FIRM
Jager Di Paola Kemp Design

CREATIVE DIRECTOR
Michael Jager

ART DIRECTOR
Lance Violettej

DESIGNERS
Malcolm Buick, Ruby Lee, Geoff McFetridge,
Mark Michaylira, Joe Peila, Shintaro Tanabe,
Todd Wender

WITH OVER 140 NEW BOARDS TO DESIGN EACH SEA-
SON, AND A SHAPE AND SURFACE THAT ONLY DEVIATES
BY MERE MILLIMETERS EACH YEAR, JAGER DI PAOLA
KEMP PULLS INSPIRATION FROM THE MOST UNLIKELY
SOURCES TO CREATE DESIGNS THAT ARE FRESH, COOL,
AND WANTED BY BOTH KIDS AND ADULTS.

As the design firm for Burton snowboards, Jager Di Paola Kemp Design tries to develop board concepts every year that have broad appeal. The designs they produce need to be agreeable to the conservative tastes of parents buying snowboards as gifts for their kids, as well as to a young, counter-culture constituency that regards snowboarding as a winter extension of skate-boarding.

To satisfy this range of tastes, the firm develops a variety of board designs that are in step with current design trends and employ semi-abstract, connotative imagery. The abstractions they work with allow for a variety of design interpretations that work on the snowboards' vertical surface, and by avoiding representational art, they're able to skirt controversial subject matter.

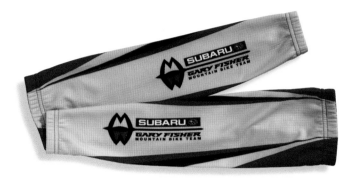

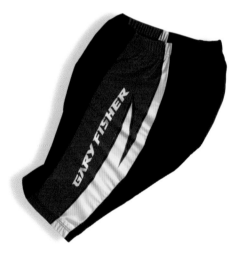

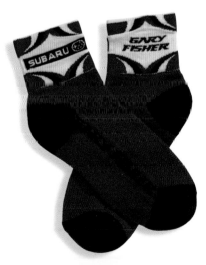

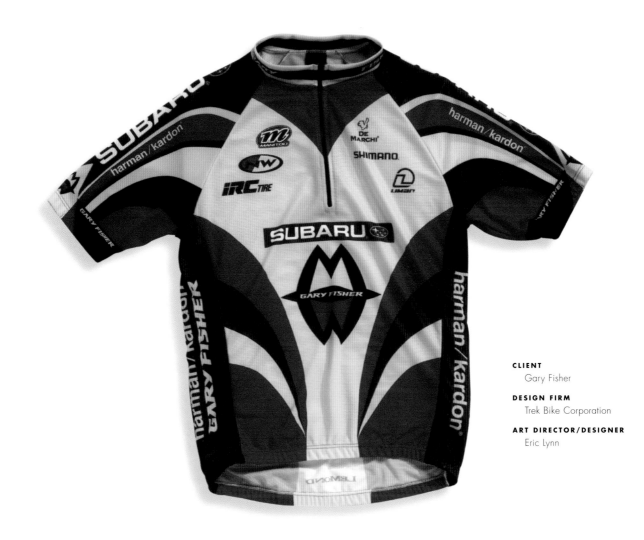

CLIENT
Gary Fisher

DESIGN FIRM
Trek Bike Corporation

ART DIRECTOR/DESIGNER
Eric Lynn

DESIGNING A TEAM UNIFORM FOR THE GARY FISHER MOUNTAIN BIKE RACING TEAM INVOLVED MUCH MORE THAN INCORPORATING THE GARY FISHER BRAND COLORS INTO A RACY JERSEY DESIGN. THE GARY FISHER LOGO, AS WELL AS THOSE OF THE TEAM'S SPONSORS, NEEDED TO BE FACTORED INTO THE DESIGN AND CONFIGURED TO FIT THE ODD SHAPE OF THE JERSEY AS WELL AS A VARIETY OF OTHER TEAM GARMENTS.

The uniform for the Gary Fisher mountain bike racing team incorporates all of the attributes of the Gary Fisher brand—its yellow-and-red color scheme and the double-peaked logo that evolved from the original mark Fisher conceived when he first popularized mountain biking in the early 1980s. "We call it the double mountain," says Eric Lynn, Trek designer responsible for the team's uniform design, adding that the logo depicts mountains reflected in water.

In addition to applying the Gary Fisher logo and colors to the team jerseys and other gear, Lynn also needed to include the logos of the team's sponsors, a multilevel tier of companies assigned to a level of visual prominence based on their contribution to the team. After the Gary Fisher logo and logotype, Subaru, the team's primary sponsor, is featured most prominently on the team's jersey and gear, along with Subaru's corporate blue color.

It was Lynn's job to combine these three eye-catching colors and incorporate the logos into the team's jersey design. To emphasize the human form, and create a sense of motion, he alternated the three colors in a series of curvilinear shapes on the team's jersey and shorts. The Gary Fisher logo and logotype as well as those of the primary sponsors appear in the areas of the jersey with highest visibility. Even the uniform's socks and sweatband bear the Fisher and Subaru colors and logos.

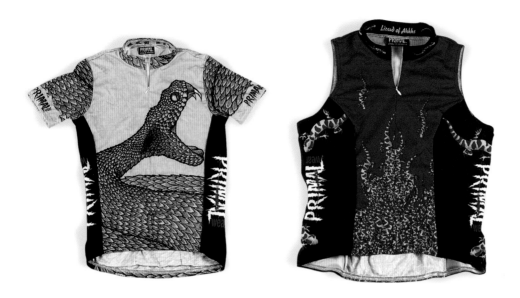

PRIMAL WEAR DESIGNER ALANN BOATRIGHT IS PROOF THAT IT TAKES A
DEDICATED CYCLIST TO UNDERSTAND WHAT TYPES OF IMAGERY WILL
APPEAL TO CYCLING ENTHUSIASTS, AND THEN WORK WITH THOSE IMAGES
WITHIN THE CONFINES OF BIKE JERSEYS, BRA TOPS, AND SHORTS. WITH
THE ADDED ELEMENT OF FABRICS THAT STRETCH, CAUSING GRAPHICS TO
DISTORT, THE CHALLENGE IS THAT MUCH GREATER.

CLIENT/DESIGN FIRM
Primal Wear

DESIGNER
Alann Boatright

ILLUSTRATOR
Alann Boatright

Dedicated cycling enthusiasts set themselves apart from sometime cyclists with spirited bike wear designed by Primal Wear partner and designer/illustrator Alann Boatright. A mountain bike enthusiast, Boatright has created a sensibility for the Primal Wear line that strikes a common chord with fellow cyclists. Although his earlier designs tended to gravitate towards skeletons, dragons, aliens, and other youth-oriented imagery, in recent years Boatright has found that natural-themed images are gaining in popularity, particularly reptiles and amphibians.

Adapting reptile themes and other types of imagery to the confines of a bike jersey required a special process. Boatright started with a pen-and-ink rendering for the degree of detail and organic quality it gives to his designs. Color was applied to his scanned drawings in a computerized drawing program. Because of the popularity of the brand, the Primal Wear logo (which Boatright designed and has become an icon for mountain bikers) is an important component of Primal Wear's garments, always appearing within side panels on jerseys, bra tops, and shorts.

Boatright adapted the five colors available in the jersey's die sublimation printing process to achieve bright colors. "Everybody wants bright," says Boatright, pointing out that high visibility is an important factor in biking safety. "They want to be seen on the road. They want to be seen in the woods during the deer hunting season."

BURTON MOTO PIPE GLOVE

CLIENT
Burton

DESIGN FIRM
Jager Di Paola Kemp Design

CREATIVE DIRECTOR
Michael Jager

ART DIRECTOR
Jim Anfuso

DESIGNERS
Jared Eberhardt, Meghan Pruitt, Ursula Zaba

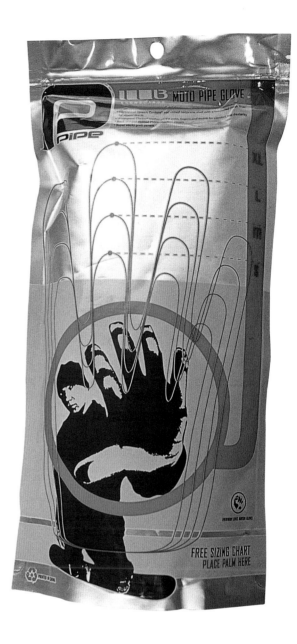

FACED WITH THE CHALLENGE OF INCORPORATING A SIZING CHART WITHIN
THE CONFINES OF A SNOWBOARD GLOVE PACKAGE, JAGER DI PAOLA KEMP
CAPITALIZED ON THE SURPRISE OF DISTORTION BY PLACING THE CHART
WITHIN THE EXTENSION OF AN EXAGGERATED HAND TO ACHIEVE ATTEN-
TION-GRABBING SHELF PRESENCE.

The raw, industrial sensibility of packaging for Burton's Moto Pipe Glove is designed to appeal to snowboarders, a group of athletes with a reputation for pushing the edge.

Jager Di Paola Kemp's design concept starts with an unusual Mylar bag with a metallic quality similar to that of the industrial anti-static bags used for computer parts. The zip-top, resealable bag can stand on its own or be hung from a peg.

The bag's Mylar surface required flexo printing, a process that can create problematic image reproduction. The Jager Di Paola Kemp design team was challenged to develop graphics that could be easily printed with this process on the bag's front panel. Their solution was a graphic reduction of a snowboarder. A distorted view emphasizes his raised hand and provides a starting point for a "handy" sizing chart.

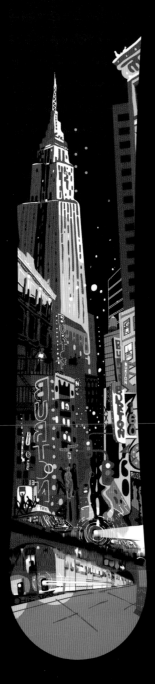

CLIENT
Burton

DESIGN FIRM
Jager Di Paola Kemp Design

CREATIVE DIRECTOR
Michael Jager

ART DIRECTOR
Lance Violettej

DESIGNERS
Malcolm Buick, Ruby Lee,
Geoff McFetridge,
Mark Michaylira, Joe Peila,
Shintaro Tanabe, Todd Wender

CITY NIGHTLIFE SCENES RENDERED IN A STYLE THAT SMACKS OF ANIMÉ, GAVE THE DESIGNERS AT JAGER DI PAOLA KEMP DESIGN AN OPPORTUNITY TO INCORPORATE THE VERTICALITY OF THE URBAN LANDSCAPE INTO A SERIES OF SNOWBOARD DESIGNS AND MAKE THE MOST OF ITS ELONGATED SURFACE.

Jager Di Paola Kemp Design is responsible for designing all of Burton's snowboard lines. Every year, the design firm strives to develop a variety of options that reflect current trends and appeal to a range of tastes in its development of new board graphics.

One of the lines the firm recently designed draws its inspiration from city nightlife. The tall, vertical thrust of buildings and neon signs lent itself perfectly to the vertical format of the boards. The semi-abstract illustration style the design team chose to use draws its inspiration from animé. Although the Burton logo doesn't appear on the boards, the Burton name is displayed prominently on the neon signs.

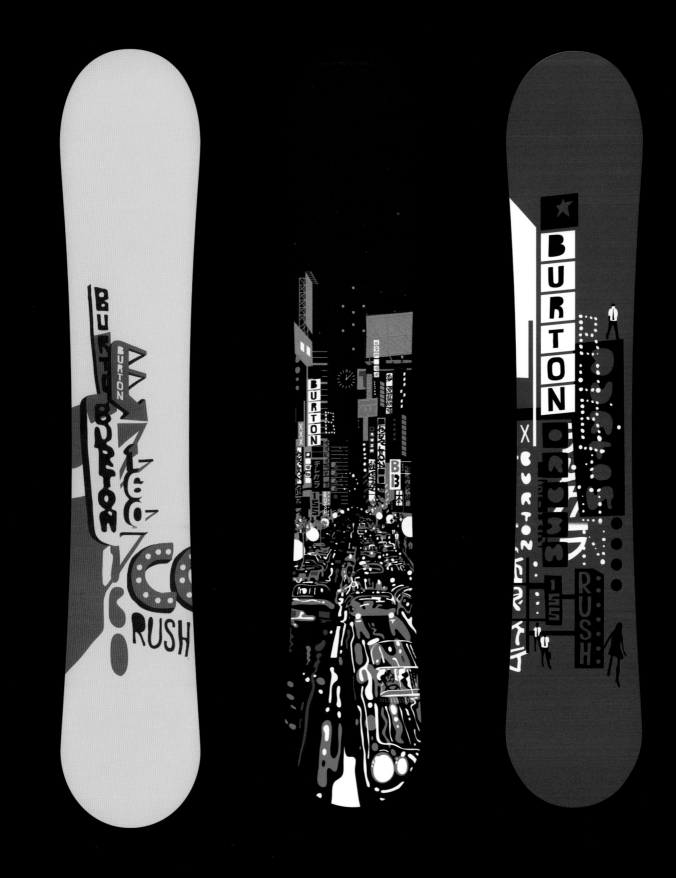

CLIENT/DESIGN FIRM
Giro Sport Design

DESIGNER
Eli Atkins

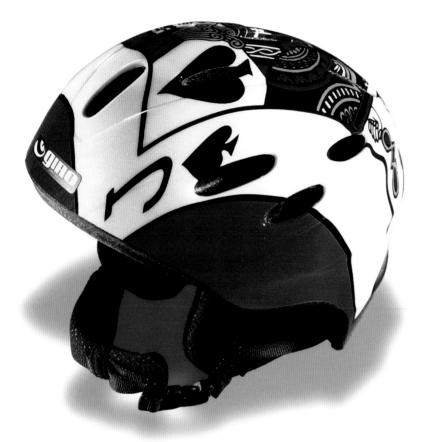

MAKING AN IMAGE OF A PLAYING CARD CONFORM TO THE CURVED SUR-
FACE OF A SNOWBOARD HELMET INVOLVED GIRO SPORT DESIGNER ELI
ATKINS'S ARTFUL DISTORTION, WHICH ACHIEVED RECOGNITION OF THE
IMAGERY ON ALL SIDES OF THE HELMET.

For Eli Atkins of Giro Sport Design, developing an image-based design for a snowboard helmet
starts with conceiving a design that snowboarders will respond to. "When our marketing department
said they wanted to demonstrate our silk-screen capabilities by doing a 'skateboard-like' graphic,
the Jack of Spades was a shoe in,'" says Atkins.

Because the helmet's vents are placed on the front and sides of the helmet, Atkins chose to wrap the
card over the top. The skewing of the image happened as a byproduct of the molding process.
Although Atkins sometimes "pre distorts" an image to compensate for the stretching that occurs when
it's molded, in this instance he decided to let the card image stretch. "I decided it added to the atti-
tude of the piece," Atkins relates.

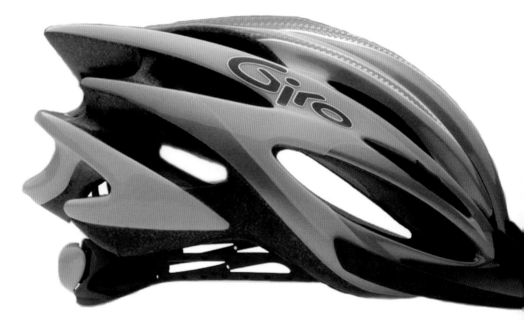

CLIENT/DESIGN FIRM
Giro Sport Design

DESIGNER
Eli Atkins

THE STRUCTURE OF A BIKE HELMET, WITH ITS MANY VENT OPENINGS, PRO-VIDES LITTLE OPPORTUNITY FOR THE PLACEMENT OF A LOGO OR GRAPHICS, YET GIRO SPORT ACHIEVES A SENSE OF SPEED AND POWER IN ITS HELMET DESIGN FOR THE ONCE RACING TEAM.

Because bike helmets are designed with weight and ventilation in mind, the lack of surface area often makes it difficult to find a place for the manufacturer's logo, let alone any kind of graphic application. In fact, when Giro Sport Design invents a new helmet design, Giro designer Eli Atkins and the firm's industrial designers collaborate to ensure that the Giro logo will have a place and work with the helmet's structure.

In the case of his design for the ONCE racing team, Atkins not only found a place for the Giro logo, he also developed an aggressive, eye-catching design for the team's helmet that incorporates the ONCE colors of gold and black. The spiky shapes he created look sleek and sexy and serve to accent the lines of the helmet.

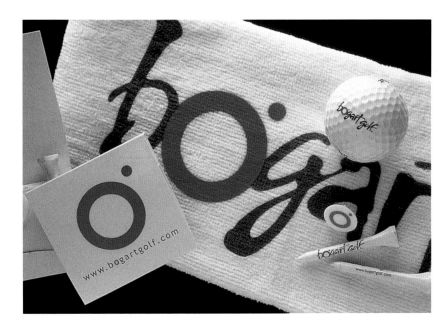

CLIENT
Bogart Golf

DESIGN
Hornall Anderson Design Works

ART DIRECTOR
Jack Anderson

DESIGNERS
Jack Anderson, Henry Yiu, James Tee, Holly Craven, Mary Chin Hutchison

A LOGO THAT'S EASILY BROKEN DOWN INTO MODULAR COMPONENTS SERVED AS THE BASIS FOR A VERSATILE IDENTITY THAT RIDES WELL ON TOWELS, GARMENTS, AND EVEN GOLF GEAR SUCH AS BALLS AND TEES.

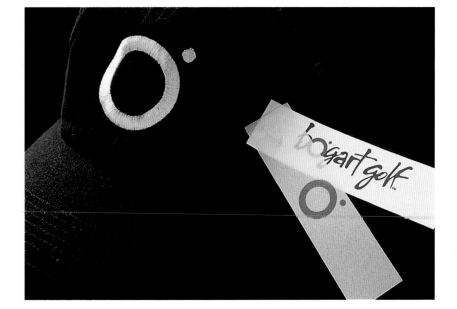

Golf balls, tees, and towels have little in common, least of all their shape, yet Hornall Anderson Design Works was faced with designing an identity for Bogart Golf that would work equally well on all of these items as well as on a cap and garment hangtags.

The design team started with the premise that they would need a versatile mark that could be broken down into components that would fit a variety of shapes and sizes. They created a jaunty, casually styled script for the Bogart name with distinctive "O" as its focal point. The full name reads well on items such as a golf towel, while the "O" plays well on smaller items such as garment hangtags.

PACKAGING FOR INLINE SKATE ACCESSORIES

CLIENT
Rasp

DESIGN FIRM
Design Guys

CREATIVE DIRECTOR
Steve Sikora

DESIGNERS
Mitch Morse, Steve Sikora

THE DESIGN GUYS NEEDED TO DEVELOP A NAME AND BRAND IDENTITY THAT WAS FLEXIBLE ENOUGH TO BE EASILY ADAPTED TO A NUMBER OF DIFFERENT PRODUCTS WHEN THEY CONCEIVED THE PACKAGING FOR A RANGE OF INLINE SKATE ACCESSORIES.

When a manufacturer of inline skate accessories contracted with Design Guys to help them in their re-branding efforts, the design firm realized they were tackling a multitiered challenge. Conceiving a name and overall look that would appeal to inline skaters was an important component in the equation, but being able to translate that into packaging that would display well and work for a range of items was equally as important. Communicating the superior quality of their client's products was also a factor in the re-branding strategy.

The Design Guys creative team first conceived the name "Rasp" to express the do-it-yourself attitude that spawned the creation of inline skates. To create a presence in skate shops, where skate accessories typically hang from hooks on a wall with other products, the Design Guys created a packaging concept based on an enlarged, industrial-shaped "R." Text stressing the product's superiority is printed on the reverse side. Printing the boards on industrial chipboard in red and black helped to project a raw and aggressive image that appeals to inline skaters.

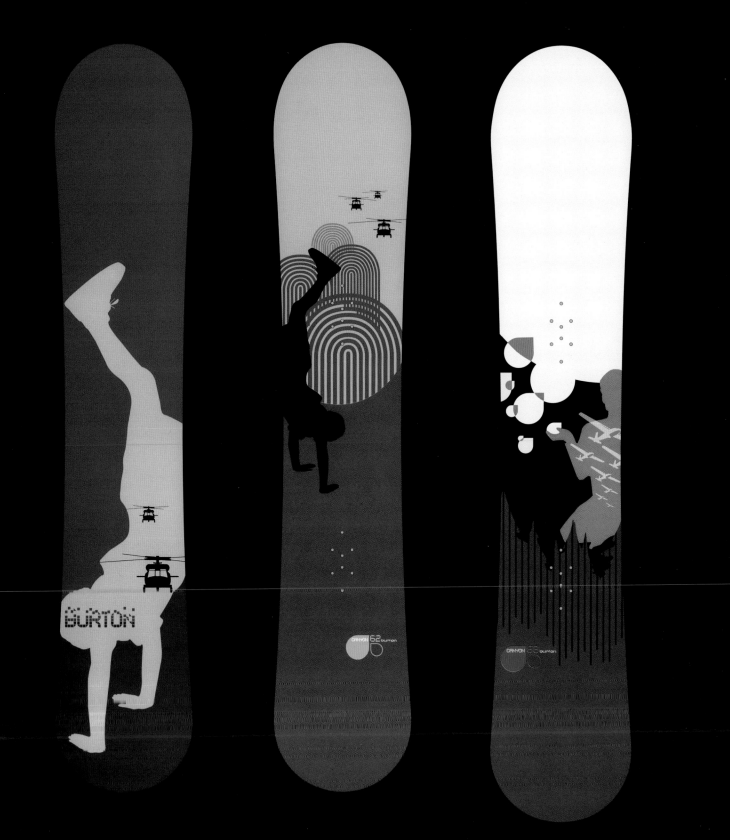

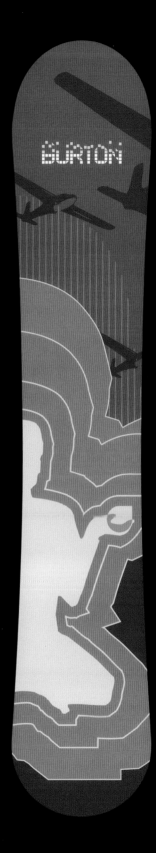

CLIENT
Burton

DESIGN FIRM
Jager Di Paola Kemp Design

CREATIVE DIRECTOR
Michael Jager

ART DIRECTOR
Lance Violettej

DESIGNERS
Malcolm Buick, Ruby Lee, Geoff McFetridge,
Mark Michaylira, Joe Peila, Shintaro Tanabe,
Todd Wender

APPEALING TO A DEMOGRAPHIC OF YOUTHFUL MALES PROMPTED
THE DESIGNERS AT JAGER DI PAOLA KEMP DESIGN TO COME UP
WITH A THEMED SERIES OF SNOWBOARDS THAT INCORPORATE
IMAGES OF AIRCRAFT. GRAPHICALLY REDUCED, SEMI-ABSTRACT
IMAGERY ALLOWED FOR FLEXIBILITY IN FASHIONING DESIGNS
THAT FIT THE CHALLENGING DIMENSIONS OF A SNOWBOARD.

When Jager Di Paola Kemp designs a snowboard line for Burton, the firm's design
team tries to develop a design theme that will appeal to their target demographic
that can be applied in a variety of configurations to several boards. JDK strives to
arrive at design concepts that are fresh. "The challenge is to always push the limits
and not let the product become stale or clichéd," says principal David Kemp.

The design firm also tries to come up with a design that will create a response in
their target audience, frequently young males ranging from ten to twenty. Boards
aimed at this demographic often incorporate imagery that will appeal to males, as
in the case of a recent line the firm designed that incorporates silhouettes of aircraft
flying in formation. The images are combined with other graphic elements to add
visual interest and create motifs that work effectively on the long, narrow shape of
the board.

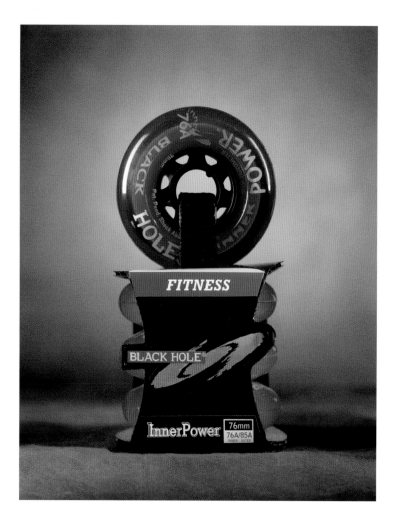

CLIENT
Black Hole/Roller Blade

DESIGN FIRM
Design Guys

CREATIVE DIRECTOR
Steve Sikora

DESIGNERS
Gary Patch, Scott Thare, Steve Sikora

BLACK HOLE'S INLINE SKATE WHEEL PACKAGING LOOKS COOL AND USES
CREATIVE ENGINEERING TO ALLOW CUSTOMERS TO SEE AND SPIN A
WHEEL, WHILE ACHIEVING BASIC RETAIL DISPLAY AND STORAGE NEEDS
WITH A MINIMUM OF MATERIALS.

Black Hole's inline skate wheel packaging is as much an engineering triumph
as it is a cool design. The concept developed out of the need for the product
to be sold from hanging pegs as well as stand alone on shelves or in cases.

Design Guys, the firm behind this innovative design, developed the packaging's
structure from Coroplast, a strong and flexible material normally used for signage.
The Coroplast packaging strip is woven through three wheels, looped around a "hero" wheel
that's exposed at the top, and then threaded back through the three interior wheels and into the
base. The packaging concept required no glue and exposed the product so it could be spun
and touched. Colorful graphics that match the colors of the wheel complete the design concept.

ALL GIRL SKATE JAM SKATEBOARDS

CLIENT
All Girl Skate Jam

DESIGN FIRM
What!design

CREATIVE DIRECTOR
Damon Meibers

ILLUSTRATOR
Derek Aylward

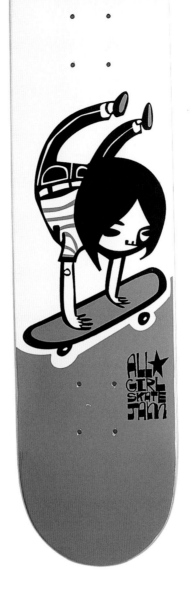
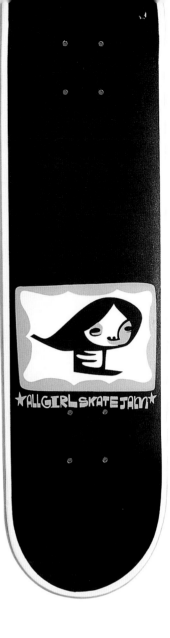

WHAT!DESIGN HELPS ALL GIRL SKATE JAM REACH ITS MARKET OF WOMEN SKATEBOARDERS WITH ITS DESIGN OF A LINE OF A CHARACTER-DRIVEN SKATEBOARDS THAT PROJECT A STREETWISE, YET FEMININE LOOK. GRAPHICS WERE PURPOSELY MADE BOLD AND MINIMAL TO ACHIEVE RECOGNITION ON THE UNDERSIDE OF THE BOARD, WHICH IS ONLY SEEN IN FLASHES.

"This is a client that lets us do pretty much whatever we want," says What!design firm principal Amy Strauch of skateboard manufacturer, All Girl Skate Jam. Given the fact that Strauch is a snowboarder and Derek Aylward, who illustrated the boards, is a skateboarder, it can be said that the What!design team has a fairly good grip on what their audience will respond to.

Given free rein to develop a look they felt would appeal to that audience, the What!design team wanted to strike a chord that makes it clear the boards are intended for women, while staying away from an ultra-feminine design. The character-driven designs they developed work with the boards' verticality and project an edgy quality that's in step with their young audience. Chunky, streetwise type completes the look, working equally as well in a stacked configuration as it does set in a line.

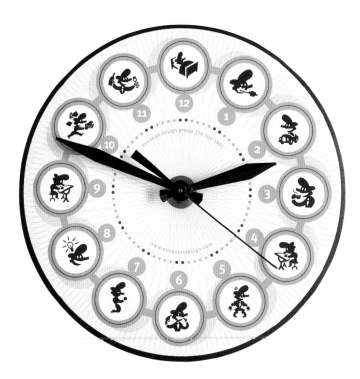

SELF PROMOTION | 02

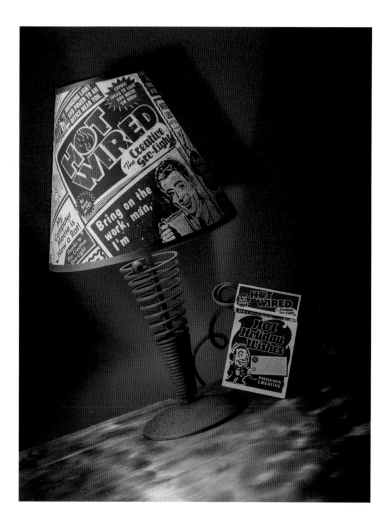

CLIENT/DESIGN FIRM
Phoenix Creative Co.

DESIGNER
Deborah Finkelstein

PHOENIX CREATIVE'S PRACTICE OF GENERATING HOT-THEMED SELF-PROMOTIONS PROMPTED THE CREATION OF THIS "HOT WIRED" LAMP. DESIGNING A LAMP THAT FIT THIS THEME REQUIRED COMING UP WITH "HOT" SLOGANS AND IMAGES THAT CONFORMED TO THE SHAPE OF THE LAMP'S SHADE. A FIFTIES LOOK HELPED THE CORNY SLOGANS AND IMAGES GEL.

Building on a hot-themed promotional strategy that ties in with the firm's name and flame-shaped logo, Phoenix Creative conceived this "hot-wired" lamp as a holiday gift for its clients and studio friends. After locating a lampshade maker, Phoenix Creative designer Deborah Finkelstein and her design team sourced out a lamp and lampshade that they liked. From there, they took the shade apart, and created their own template for the design of the shade.

Using the template as a guide, Finkelstein combined clip art with illustrations created by staff and some of her own graphic inventions to create a lampshade that not only reminds clients of the firm's innovation and creativity, but also, its willingness to meet their demands with sayings like, "Bring on the work." The art was screen printed onto a substrate specified by the shade manufacturer. Phoenix Creative attached the lampshades to the lamps along with matching, retro-themed tags that reinforce the firm's message.

Phoenix's light-hearted approach made the lamp a "keeper" and a conversation piece that Finkelstein frequently sees as a fixture in her clients' offices.

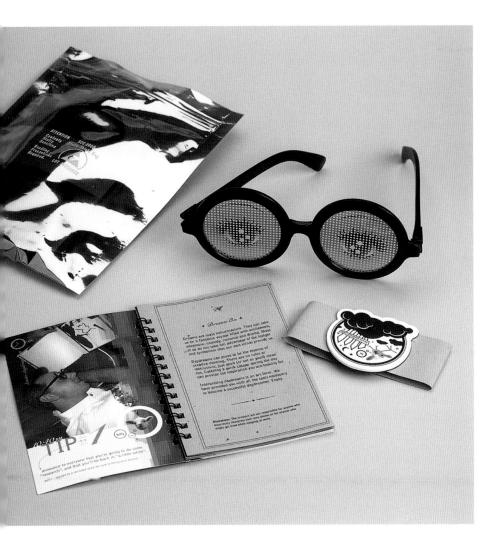

CLIENT/DESIGN FIRM
Morris Creative

CREATIVE DIRECTOR
Steven Morris

DESIGNER
Tom Davis

ILLUSTRATOR
Tom Davis

A SELF-PROMOTION THAT INCLUDED NOVELTY GLASSES, A BROCHURE, AND A REFRIGERATOR MAGNET CHALLENGED MORRIS CREATIVE TO DEVELOP A UNIFYING CONCEPT THAT COULD BE EFFECTIVELY APPLIED TO ALL THREE VEHICLES AND THEIR PACKAGING.

Steven Morris takes pride in the fact that his firm's self-promotional mailings don't include any information about the firm and don't even include the firm's name. "We call them 'stealth promotions,'" explains Morris.

"How to Interpret Daydreams" is a case in point. The promotion's intent is to entertain clients, while showing off the firm's creative capabilities. The promotion consists of a booklet offering tips on how to get away with sleeping on the job. Steven Morris staff members show how it's done in photographs where their shut eyes are hidden behind "open-eye" glasses.

A tip-giving lamb pops up throughout the booklet and on a refrigerator magnet that helps to secure the booklet's bellyband. Other components of the promotion include a pair of glasses exactly like the ones depicted on the staff members in the booklet. "It shows that the firm can take a brand concept and carry it out through many applications," says Morris of the promotion. The offbeat quality of the piece deserved unusual packaging, so the Steven Morris design team sourced out anti-static, zip-lock bags, used for protecting computer motherboards, to contain the promotion.

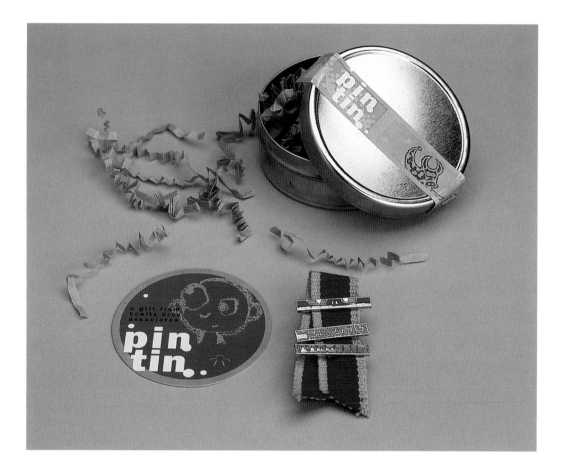

CLIENT/DESIGN FIRM
Boelts Bros.

DESIGNERS
Jackson Boelts, Kerry
Stratford, Eric Boelts

BOELTS BROS. MET THE CHALLENGE OF COMING UP WITH DESIGNS FOR A
CLIENT GIFT OF TINY LAPEL PINS BY CREATING A SERIES OF INTRIGUING,
SEMI-ABSTRACT IMAGES. THE PINS' TINY FORMAT REQUIRED DESIGNS THAT
INCORPORATED SIMPLE GEOMETRIC SHAPES AND BRIGHT COLORS, WHICH
WOULD REGISTER FROM A DISTANCE.

Wanting to thank clients with a gift of their own making led the designers at Boelts Bros. to come up with the idea of design-
ing a collection of three enameled pins, gift packaged in a metal tin. However, the desire to create something subtle, yet visu-
ally intriguing, led them to the decision to design within a tiny area and an unusual format—the pins measure one inch in
length and just one eighth of an inch in width. The designers were further limited to a palette of three colors for each pin and
had to design within the constraints of the enameling process, which required a raised outline around each color area.

Boelts Bros. came up with concepts that make the most of limited space, creating images of a "crazy face," spotted dog, and
alligator. The designs were conceived with enough ambiguity to register as colorful abstract designs at first glance, and upon
closer inspection, as whimsical faces and animals. Their playfulness makes them as appealing as they are intriguing.

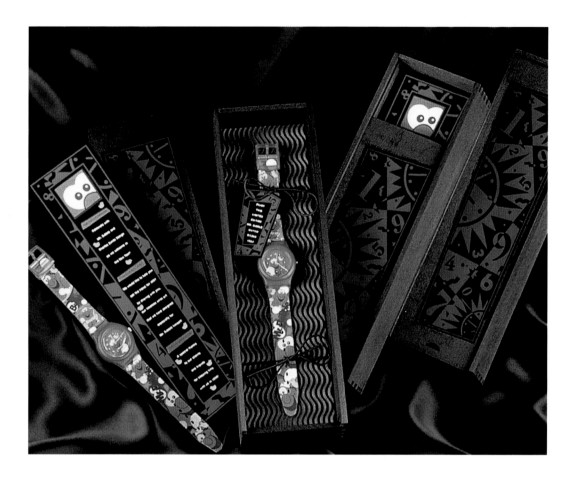

CLIENT/DESIGN FIRM
Zunda Design Group

CREATIVE DIRECTOR
Charles Zunda

ART DIRECTOR
Todd Nickel

A CLIENT GIFT, A MR. BUBBLE WATCH OF THEIR OWN, PROMPTED THE ZUNDA GROUP TO DEVELOP A THEMATICALLY LINKED GIFT PACKAGING AND A CARD. THEIR CHALLENGE INVOLVED COMING UP WITH A THEME APPRO-PRIATE TO THE GIFT OF A CHARACTER WATCH, AND MAKING IT WORK ACROSS THE BOARD ON THE PACKAGES' EXTERIOR, AND INTERIOR, AS WELL AS ITS CARD INSERT.

A client-commissioned project of designing a watch that celebrates Mr. Bubble soap prompted Charles Zunda of Zunda Design to make the most of proven success, and purchase 500 of the watches to give to clients as a holiday gift.

"Then it was a matter of coming up with a theme," says Zunda, who arrived at a time-related motif and message for the watch's gift card and tag. The Zunda design team also sourced out a small, black wooden box with a sliding lid to house the watch. The box's lid was screen-printed, and its interior lined with a wavy, fluted board.

The watch, which features the Mr. Bubble character on the watch face and a bubble-inspired design on the wrist straps, was well received by clients who recalled the 1960s and childhood memories of baths with Mr. Bubble.

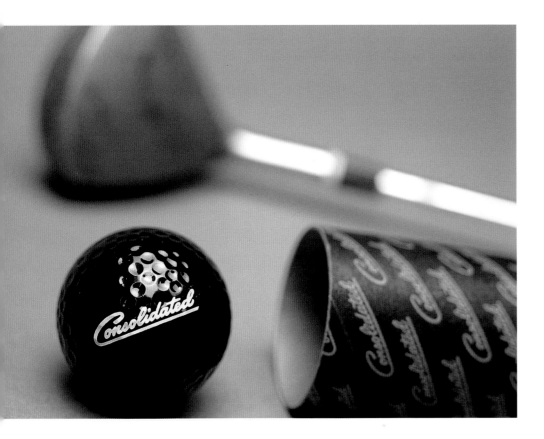

CLIENT
Consolidated Papers

DESIGN FIRM
Petrick Design

ART DIRECTOR
Robert Petrick

DESIGNER
Robert Petrick

WRITER
Robert Petrick

ECONOMICALLY PACKAGING A GOLF BALL AND DESIGNING A TINY BROCHURE
THAT STILL CONVEYED INFORMATION IN A LEGIBLE MANNER WERE JUST
A FEW OF THE CHALLENGES PETRICK DESIGN FACED WHEN DESIGNING A
GOLF-THEMED PAPER PROMOTION FOR CONSOLIDATED PAPERS.

What do you do with 3,000 golf balls imprinted with your company name? If you're Consolidated Papers, you ask Petrick Design to recycle them into a paper promotion. Firm principal, Robert Petrick, was further challenged with a tight budget for the project.

Petrick worked on coming up with a golf-themed concept that would appeal to designers. He decided to develop an eight-panel, accordion-fold brochure—a lampoon of designers' penchant for wearing black, entitled "How to Win at Golf: Simple Pointers in Black and White." "The idea is, if you look good enough, nobody really cares how you play," explains Petrick. A condensed version of golf basics is printed in five-point type to fit on half of the brochure's scant, 1-1/4 x 10 format. Alternating panels state "Just Wear Black."

Petrick's second challenge was to find an inexpensive way to package the golf ball and its insert. He decided to use a cylindrical, chipboard tube when he recalled that Consolidated had the capability of manufacturing tube mailers. From there, the Consolidated logo was printed on the outside of the tube, for a minimal, industrial look. Petrick retrofitted a narrower tube inside the outer tube to prevent the golf ball and its insert from rolling around, to ensure that the promotion's recipients got the insert and the golf ball in the proper order.

CLIENT/DESIGN FIRM
Evenson Design Group

CREATIVE DIRECTOR
Stan Evenson

DESIGNERS/ILLUSTRATORS
John Krause, Mark Sojka

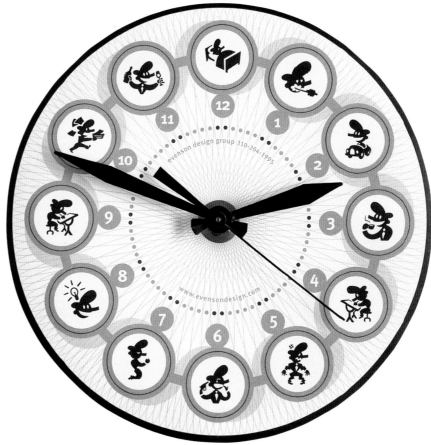

THE CIRCULAR CONFIGURATION OF A CLOCK'S NUMERALS PROVIDED THE PERFECT OPPORTUNI-
TY FOR EVENSON DESIGN TO PROMOTE ITSELF AS A DESIGN FIRM THAT WORKS "AROUND THE
CLOCK" TO PLEASE ITS CLIENTS. THE DESIGNERS CREATED A "DESIGNER" CHARACTER DEPICT-
ED IN A VARIETY OF SITUATIONS WITHIN A TINY CIRCULAR FORMAT THAT ADAPTED ITSELF WELL
TO THE DIFFERENT NUMERAL SLOTS ON THE CLOCK FACE.

To celebrate the new millennium, Evenson Design Group thought a clock would be a "timely" gift for their clients, and would serve to remind them of the firm's design capabilities. From there, the design team decided that showing a designer working around the clock would be the best way to characterize their work ethic.

Their literal interpretation of "around the clock" means that every numeral on the clock face depicts a designer working, struggling for an idea, or rushing to have something ready, with just a few hours remaining to relax. The design team was challenged to show a variety of activities on a very small scale, and had to represent them with an illustration technique that pared visual information down to a bare minimum. A circular format for the illustrations and the numerals is repeated as a graphic theme on the clock's face.

The designer's entertaining and humorous antics made the clock an instant keeper. "People still have it up on their wall," says firm principal, Stan Evenson.

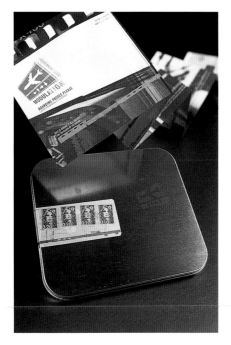

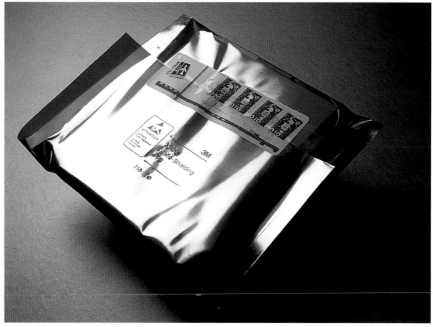

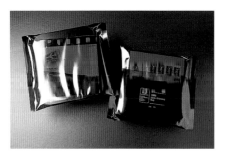

CLIENT/DESIGN FIRM
Iridium

CREATIVE DIRECTORS
Etienne Borsotto, Mario L'Ecuyer

ART DIRECTOR/DESIGNER
Etienne Bessette

COPYWRITERS
Stephen J. Hards, Etienne Bessette

ILLUSTRATOR
Etienne Bessette

PHOTOGRAPHERS
Iridium staff

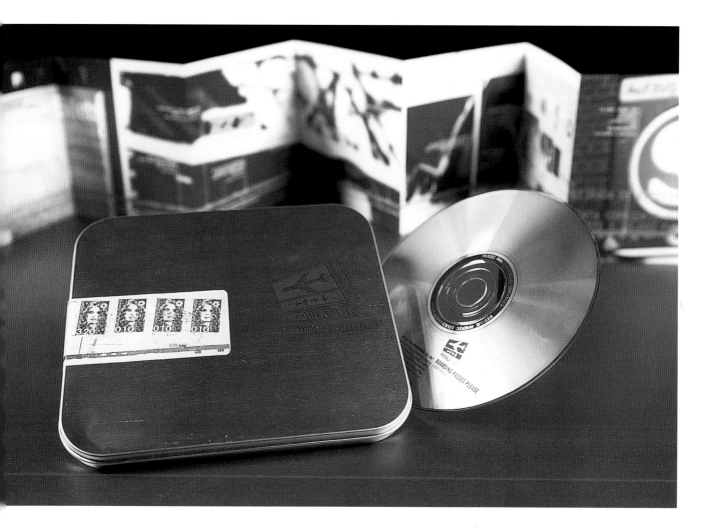

IRIDIUM CREATED A CD OF REMIXED MUSIC TO SHOW ITS CLIENTS HOW
EFFECTIVELY THE FIRM COULD CARRY A VISUAL THEME ACROSS A VARIETY
OF VENUES: THE CD, ITS PACKAGING, AND ITS FOLDED INSERT.

As a gift to its heavy mix of high-tech clients, Iridium produced an audio voyage to activate their imaginations—a CD of remixed music by a fictitious artist the firm dubbed "Modulation." To keep their clients guessing, and communicate the voyage theme, the designers entitled the CD "Boarding Passes Please" and designed a "flying" Modulation icon. Armed with disposable cameras, everyone on the Iridium design team contributed photographs to the collage that serves as a backdrop for thoughtful quotes from the famous and unknown that appear on the CD's accordion-folded insert.

To give the CD a special look and arouse curiosity in its recipients, the designers encased it in an anti-static envelope placed within a custom, screen-printed metal tin. The tin was sealed with a sticker using the stamp image of France's newest "Marianne" and mailed to clients and friends of the studio.

CLIENT/DESIGN FIRM
Morris Creative

DESIGNERS
Steven Morris, Dave Blank

ILLUSTRATOR
Steven Morris

COPYWRITERS
Steven Morris, Dave Blank

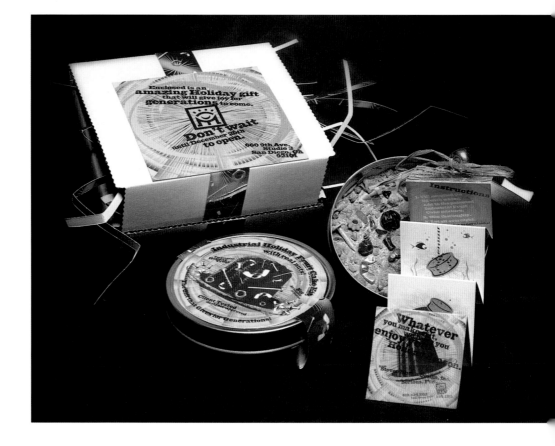

SENDING "INDUSTRIAL FRUITCAKE" TO CLIENTS AS A HOLIDAY GIFT REQUIRED MORRIS CREATIVE TO BRIDGE THE GAP BETWEEN EDIBLE AND NONEDIBLE AS WELL AS TO ESTABLISH A VISUAL THEME THAT COULD BE ADAPTED TO A CIRCULAR LID LABEL, CARTON LABEL, AND AN ACCOMPANYING INSERT.

Moving its headquarters to an industrialized area of San Diego prompted the designers at Steven Morris Design to send out a holiday self promotion in the form of a fruitcake kit with a distinctly industrial flavor. In addition to nuts, the fruitcake contains bolts, nails, and other pieces of hardware.

The label on the promotion's shipping carton gives the first hint of its "nutty" contents. To further peak its recipients' curiosity, the tin containing the kit's contents strikes a chord that's a cross between a traditional fruitcake tin and a car wax container. To unify the pieces in the promotion, the Steven Morris design team created a series of tie-dyed, psychedelic backdrops for the tin and carton's labels as well as the front panel of an accordion-folded insert that features illustrations rendered in the same palette.

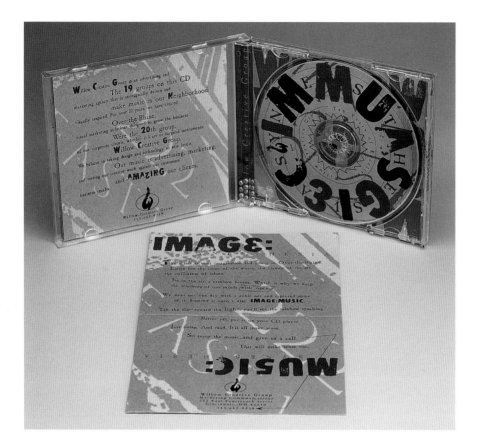

CLIENT/DESIGN FIRM
Willow Creative Group

CREATIVE DIRECTOR
Deborah Dent

ART DIRECTOR
Jim Mattingly

WRITER
Mark Aronson

PHOTOGRAPHER
Doris Jeffers

USING SYNERGY AS A THEME, WILLOW CREATIVE EFFECTIVELY INTEGRATES THE MUSIC ON ITS CLIENT GIFT OF A CD WITH THE FIRM'S MESSAGE OF ITS DESIGN CAPABILITIES. THE SELF-PROMOTION'S AUDIBLE MESSAGE, REINFORCED BY RATTLING BEADS IN THE JEWEL CASE'S SPINE, MADE THE PIECE A STANDOUT IN ITS RECIPIENTS' MAIL.

Although imagery is typically showcased in a design studio's self-promotion piece, Willow Creative Group decided to send its current and potential clients a CD collection of music from groups that appear at local nightspots in the lively entertainment district where they're based. Although the CD's message is music, the self-promotion piece effectively showcases Willow's creativity and packaging skills by successfully integrating graphic design with a musical theme.

Willow's creative team used the theme of "synergy" as a means of blending music with design. To further emphasize the coming together of these two entities, the piece is designed so that colors differentiate each message. Even on the disc, "image" is printed in red, while "music" appears in blue. A palette of khaki and olive green provides a neutral backdrop for the piece's accent colors, and Willow's "synethesia" message. Although the colors are different, the text is layered and formatted so the messages overlap.

Willow's creative team interjected interactivity by including ten copper beads in the jewel case's spine to represent the ten years the firm has been in business. The rattling beads intrigued curious recipients, who immediately opened the CD's mailer to get to the source of the noise.

CLIENT/DESIGN FIRM
Bird Design

CREATIVE DIRECTOR
Peter King Robbins

DESIGNER
Peter King Robbins

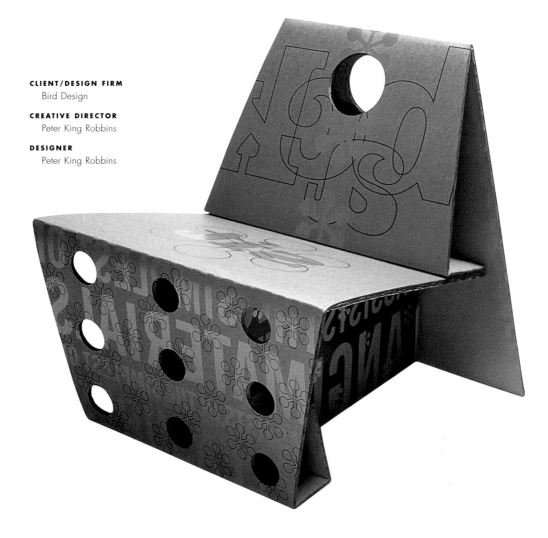

THE GIFT OF A CORRUGATED CHAIR PROMPTED BIRD DESIGN'S PETER KING ROBBINS TO PLAY UP THE SIMPLICITY INHERENT IN THE ACT OF SITTING DOWN IN HIS APPLICATION OF DECORATIVE MESSAGES THAT INSTRUCT THE RECIPIENT TO "SIT," AND MORE IN HIS DESIGN OF THIS CORRUGATED CARDBOARD CHAIR, INTENDED AS A GIFT FOR CLIENTS. THE TYPOGRAPHIC MESSAGES CREATED A SUBTLE PATTERN THAT WRAPS AROUND THE CHAIR MUCH LIKE PATTERNED UPHOLSTERY FABRIC.

With its holiday promotion and gift for 1999, Bird Design decided it was time to get down to basics. "What can be more simple than the pleasure of sitting down?" asks firm principal Peter King Robbins. To give their clients a place to experience this pleasure, Bird Design sent them a chair, shipped in a 3 x 4 foot package with assembly instructions.

Made of corrugated cardboard, the chair communicates the firm's message with the simplest of materials. Printing on the corrugated surface limited the colors that could be applied and Robbins' image and design possibilities to solid shapes and type. The typographic treatment Robbins chose reinforces the chair's message of simplicity with its designation of "back" and "sit" and invites recipients to use the chair. The approach also provided a means of interplaying the pattern of typographic characters with the chair's circular cutouts. Robbins specified the cutouts to create visual interest and so recipients could better appreciate the chair's construction.

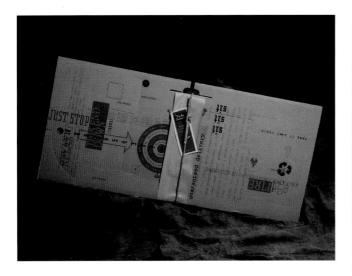

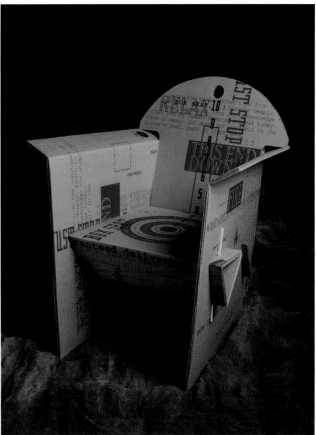

CLIENT/DESIGN FIRM
Phoenix Creative Co.

DESIGNER
Deborah Finkelstein

AS A TIE-IN WITH THE FIRM'S NAME, THE HOLIDAY GIFT OF AN ASSEMBLE-YOURSELF CHAIR PROMPTED PHOENIX CREATIVE TO CALL THE CHAIR THE "HOT SEAT." PHOENIX'S TYPOGRAPHIC THEME INCORPORATED OTHER WORDS AND MESSAGES AND ALLOWED FOR PLENTY OF FLEXIBILITY IN ADAPTING A DESIGN TO FIT THE CHAIR'S UNUSUAL SHAPE.

Every year, Phoenix Creative tries to conceive self-promotional holiday gifts for its clients that tie in with the firm's name and its flame-shaped logo. Creating a "hot seat" chair was a natural in a progression of hot-themed self-promotions. To elaborate on the "hot seat" theme, the chair's designer Deborah Finkelstein put a target on the seat, but from there, the graphic applications are typographic messages that tend to soothe. "We thought our clients had had a tough year, so they needed to sit down and relax," she explains. Clever sayings, such as "this end down" also play upon the industrial look of the chair's corrugated cardboard construction.

The typographic approach allowed Finkelstein to create a graphic theme that easily wrapped around the chair's hard-to-accommodate shape, one that was a given from the manufacturer of the chairs. Finkelstein was further challenged to create art that could be printed on two sheets of cardboard, on two sides with just two pieces of film. Messages that appear on the front of the chair are angled and repeated on the back.

Despite its corrugate cardboard construction, the chair is surprisingly sturdy. When assembled with two chopsticks, it holds up to 300 pounds. The message printed next to the chopsticks says: "In case of Chinese food, take out."

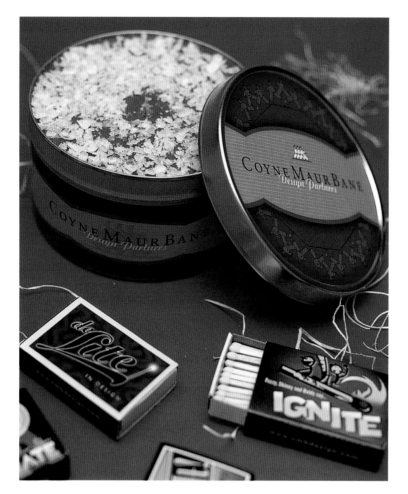

CLIENT/DESIGN FIRM
CMB Design Partners

DESIGNERS
Jeff Bane, Brad Maur,
Chris Guzman, Kari Caldwell,
Davida Treiman-Seastrom

ILLUSTRATORS
Jeff Bane, Brad Maur,
Chris Guzman, Kari Caldwell,
Davida Treiman-Seastrom

A GIFT OF A HOLIDAY CANDLE CHALLENGED CMB DESIGN PARTNERS TO DEVELOP A CUSTOM
PACKAGE AND THEME THAT COULD BE APPLIED TO THE CANDLE'S CYLINDRICAL CONTAINER AS
WELL AS A SET OF MATCHBOXES. THE DESIGNERS UNITED THE SERIES WITH A RETRO LOOK
THAT WORKS JUST AS EFFECTIVELY FOR CLIENT-DRIVEN SLOGANS ON THE MATCHBOXES AS IT
DOES FOR THE CANDLE'S GIFT PACKAGING.

CMB Design Partners holiday gift to clients and studio friends includes a custom packaged candle with the firm's name on it
and a series of boxed matches on which the firm delivered its promotional message and showed off its design skills. Slogans
such as "illuminate your ideas" and "burning the midnight oil" are rendered in a retro style that helps to unify the collection.
The boxes were customized in-house with printed labels wrapped around purchased matchboxes.

The custom-made candle is housed beneath the matches, packaged in a tin with the firm's name on its circular lid and wrap-
around label. The CMB design team developed a retro design for the tin's labels that's in step with the look achieved by the
matchboxes. The matches and the candle arrived in a chipboard gift box sealed with a label bearing the same imagery as
the candle tin.

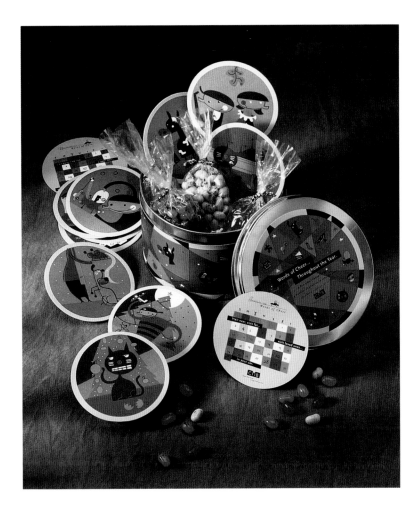

CLIENT/DESIGN FIRM
CMB Design Partners

DESIGNERS
Jeff Bane, Brad Maur, Paul Coyne

ILLUSTRATOR
Jeff Bane

A SET OF HOLIDAY COASTERS, PACKAGED WITH CANDY IN A SPECIAL TIN,
CHALLENGED CMB DESIGN PARTNERS TO DEVELOP A GRAPHIC THEME AND
IMAGERY THAT SUCCESSFULLY LINKED THE COLLECTION AND ALSO WORKED
EFFECTIVELY WITHIN THE COASTERS' CIRCULAR FORMAT.

For a holiday gift and self-promotion, CMB Design Partners bought 500 two-pound tins and cus-
tomized them with their own label designs to serve as a special container for a gift of coasters and
packaged candy. Although the candy was quickly consumed, the coasters have staying power, serv-
ing as a reminder of the firm's work as they shield desks and table tops from coffee mugs and soft
drink cans.

Each of the twelve coasters is printed on 110-lb. cover stock and features a Christmas scene, illus-
trated in a charmingly whimsical style by CMB principal Jeff Bane. The coasters also serve another
purpose—a calendar for each month of the year is printed on the reverse side of each. A limited
palette of fully saturated colors, punched with accents of black and white, helps to unify the collec-
tion of coasters and tie them in with the tin's label designs.

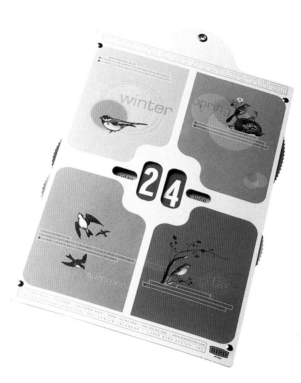

CLIENT/DESIGN FIRM
Bird Design

CREATIVE DIRECTOR
Peter King Robbins

DESIGNER
Peter King Robbins

BIRD DESIGN ESTABLISHED VISUAL CONTINUITY IN ITS DESIGN OF A SERIES OF BIRD-THEMED CLOCKS BY BRINGING VINTAGE ILLUSTRATIONS INTO A CONTEMPORARY DESIGN CONTEXT. PATTERNED BACKGROUNDS HELPED TO UNIFY THE SERIES, WHILE PROVIDING GRAPHIC INTEREST AND VARIETY.

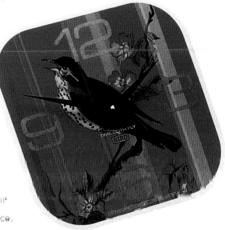

Firm principal Peter King Robbins wanted to subtly remind clients of his firm with a holiday gift. So rather than print his firm's name of Bird Design directly on a product, he chose to design a bird-themed clock and calendar, which would be sent to clients as a coordinated set.

Robbins drew visual inspiration from his collection of vintage bird books and found a wealth of beautifully detailed color illustrations of birds, copyright free, because the reproduction rights had fallen within the public domain. Robbins scanned and outlined the birds, placing an illustration of a robin against a contemporary striped background of his own creation to form a decorative clock face. The other birds were treated similarly with Robbins bringing the nostalgic images into a contemporary design format.

CLIENT
Candlewood Suites

DESIGN FIRM
Greteman Group

CREATIVE DIRECTOR
Sonia Greteman

ART DIRECTORS
Sonia Greteman, James Strange

DESIGNER
James Strange

ILLUSTRATOR
James Strange

THE GIFT OF A HOLIDAY CANDLE AND ITS PACKAGING PRESENTED THE CHALLENGE OF THEMATICALLY LINKING A TIN CONTAINER, THE CANDLE, A TRI-PANEL INSERT, AND MATCHES. THE GRETEMAN GROUP UNITED THE SERIES BY DEVELOPING A "LIGHT UP YOUR LIFE" LOGO AND CANDLE MOTIF THAT PROVIDED THE FLEXIBILITY NECESSARY TO WORK ON A NUMBER OF ODD-SHAPED ITEMS.

To let others know of their client's donation to Big Brothers and Big Sisters of America, the Greteman Group designed this gift of a candle. Sent during the Christmas holidays, the promotion was called "Light Up Your Life," a double entendre that worked for both the candle and the impact Big Brothers and Big Sisters have on the lives of children.

Packaged in a tin containing wood chips, the candle also ties in with the Candlewood hotel chain's name. The tin and its contents, the candle, a tri-panel insert, and matches, are visually linked with a candle motif and a Light Up Your Life logo, rendered in a similar style. The candle and matches were customized with self-adhesive labels.

ENTERTAINMENT GRAPHICS | 03

P22 WANTED TO ENGAGE POTENTIAL CUSTOMERS BROWSING THE CD RACKS AT MUSIC STORES, SO THEY ENCOURAGED INTERACTIVITY BY CREATING AN INTRIGUING AND MINIMALISTIC CD PACKAGE THAT'S TOTALLY TRANSPARENT. INFORMATION IS PRINTED DIRECTLY ON A CLEAR COMPACT DISC, RIGHT-READING AND BACKWARD, DEPENDING ON HOW YOU LOOK AT IT.

With Bobo's CD design, what you see is what you get. "I've always felt that CDs have been over-packaged," says designer Richard Kegler, as an explanation for doing away with the paper inserts that are so often used to do double duty as cover and a means of listing CD tracks, lyrics, and credits.

Kegler's minimalist approach involved producing the CD on a transparent rather than metallic disc. From there, copy was kept to a minimum, so that only the essentials—track titles, credits, and Bobo member's names and photos would be printed on the disc. To encourage interactivity with consumers, he alternated placement of the text so that some portions are printed on the front of the CD, while others are printed on the back.

Kegler covered the hole created by the plastic disc holder in the center by having the manufacturer affix a holograph of a hypnotic spiral to the center of the jewel case's front panel. From there, a five-pointed star, representing each of Bobo's five members, emanates from the center.

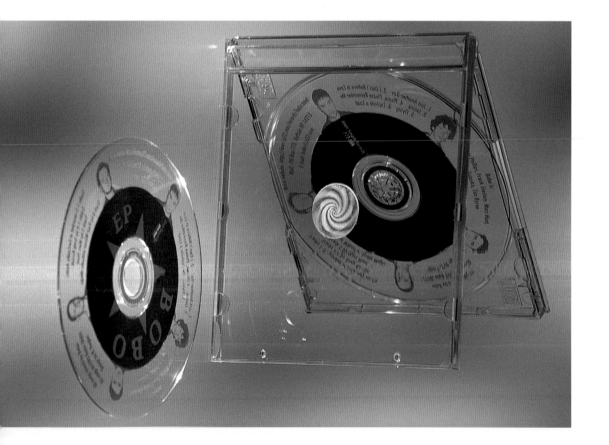

CLIENT
Atom Smash Records

DESIGN FIRM
P22

ART DIRECTOR
Richard Kegler

DESIGNER
Richard Kegler

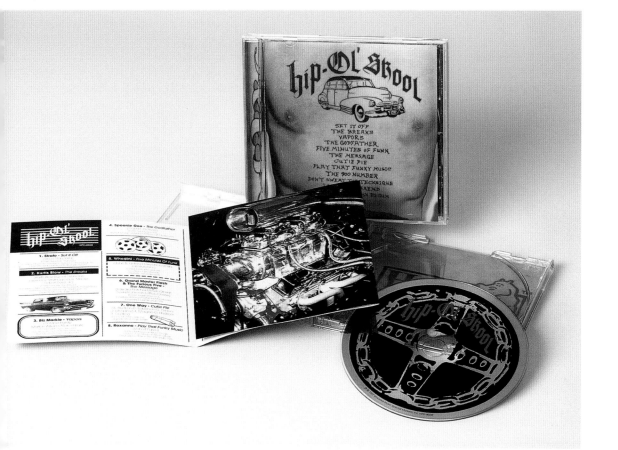

CLIENT
MCA Records

DESIGN FIRM
Modern Dog

ART DIRECTOR
Vartan

DESIGNER
Michael Strassburger

ILLUSTRATOR
Michael Strassburger

WHEN FACED WITH DEVELOPING A CONCEPT THAT WOULD WORK ON ALL THE CD PACKAGING COMPONENTS FOR *HIP OL' SKOOL*, MODERN DOG DEVELOPED A VISUAL THEME THAT'S BASED ON THE CULTURE OF EARLY HIP-HOP MUSIC. THE CULTURAL ICONOGRAPHY THEY CAME UP WITH PROVIDED THE DESIGN THE FLEXIBILITY THEY NEEDED TO PLACE IMAGES, SUCH A STEERING WHEEL FASHIONED FROM A CHAIN, ON THE CIRCULAR FORMAT OF THE DISC.

Designing CD graphics and packaging for *Hip Ol' Skool*, a collection of early hip-hop music, prompted the designers at Modern Dog to think about the type of consumer that would want to listen to this collection and what they're like. After some research and deliberation, they concluded that the audience was mostly male, urban, likely to have a tattoo, and would relate to cars.

The CDs folded insert shows the *Hip Ol' Skool* title and collection of songs on its front panel. Thanks to Photoshop, the designers were able to depict this information, along with a rendering of a vintage car, as though it had been tattooed on a man's chest. To link the disc to its insert, the designers chose to emphasize its circular format by depicting a steering wheel made from a chain.

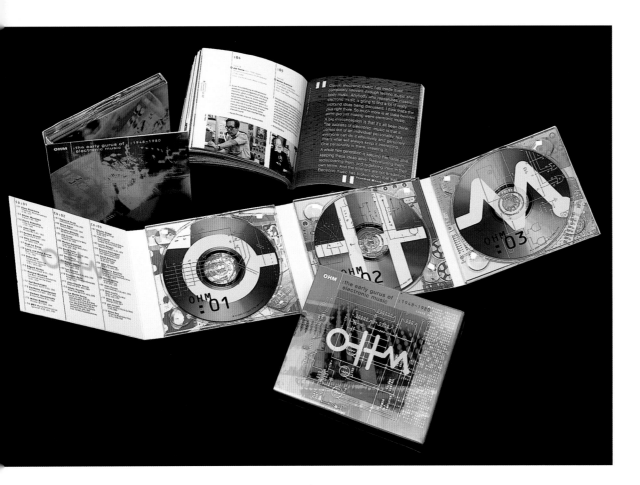

CLIENT
Ellipsis Arts

DESIGN FIRM
Stoltze Design

DESIGNERS
Clifford Stoltze,
Tammy Dotson

UNIFYING THE THREE DISCS IN THIS CD COLLECTION WAS ACCOMPLISHED BY DESIGNING A LOGO THAT'S READ WHEN THE DISCS ARE ALIGNED IN SEQUENCE. THE DESIGN WORKS EQUALLY AS WELL, BROKEN DOWN ON EACH DISC AS IT DOES, LINKING THEM AS A SET.

OHM is a CD-ROM collection of early electronic music that's purchased with an accompanying book documenting the history of the genre. Taking their lead from the historical nature of the collection, designers Clifford Stoltze and Tammy Dotson developed a design based on the circuitry used to create the theramin, the earliest known electronic instrument. The line art for the circuitry diagram, printed in white, serves as the backdrop for the jewel case's cover.

The OHM logo the firm designed was inspired by this circuitry and runs across all three of the discs in the collection. When this firm develops a design for a CD and its packaging, Stoltze says they make a point of coming up with a design for the disc that's an integral part of the total concept. "For me, that's one of the fun things about doing a CD design," he states. In this case, configuring the OHM to work just as effectively on all three discs dictated how the final logo would look.

CLIENT
Scully Records

DESIGN FIRM
BlackCoffee Design, Inc.

DESIGNERS
Mark Gallagher, Laura Savard

PHOTOGRAPHY
Dave Bradley Photography

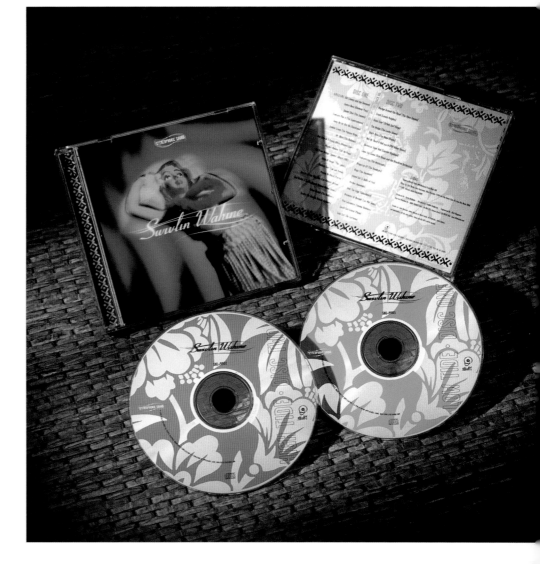

WHEN FACED WITH THE CHALLENGE OF UNITING THE COVER, DISCS, AND THE INSERT FOR THIS CD COLLECTION OF SURF MUSIC, BLACKCOFFEE DESIGN CHOSE A NOSTALGIC HAWAIIAN THEME, SUPPORTED BY AUTHENTIC PATTERNS AND A RETRO HAWAIIAN HULA DOLL.

Swivlin Wahine, a two-disc, surf and rock music compilation, contains tracks from both traditional and contemporary bands. To appeal to both audiences, and communicate the surfing theme in the CD's packaging, the designers chose to go with a Hawaiian motif and a retro look.

The CD's front panel makes an immediate visual connection with its title through a Photoshop-augmented image of a swiveling Hawaiian hula doll that bobs with movement when perched on the dash or beneath the rear window in a car. The hula-doll is a classic that makes an immediate impact on all age groups. To complement this nostalgic image, the designers developed custom typography that recalls the fifties and sixties for the *Swivlin Wahine* title.

The Hawaiian theme is carried into the interior panels of the insert and discs with a simple Hawaiian pattern printed in a palette of tropical colors: yellow, fuchsia, and turquoise.

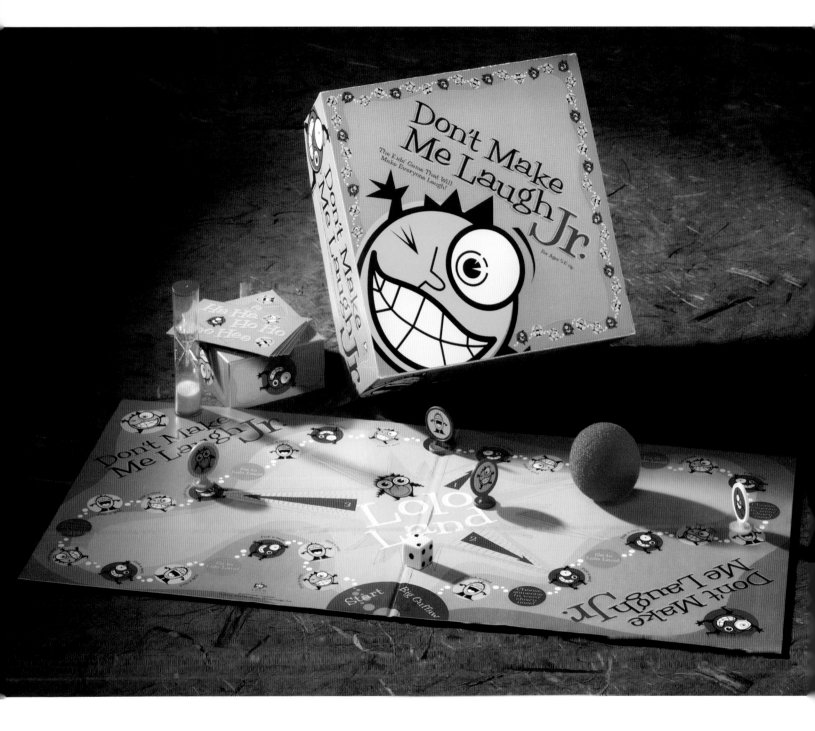

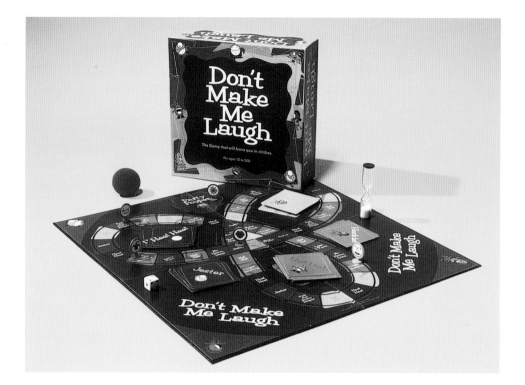

CLIENT
Lolo Company

DESIGN FIRM
Steven Morris Design

ART DIRECTOR
Steven Morris

DESIGNER
Steven Morris

ILLUSTRATOR
Steven Morris

STEVEN MORRIS DESIGN CONQUERED A TRI-FOLD CHALLENGE WHEN THE FIRM DEVISED A DESIGN STRATEGY FOR DON'T MAKE ME LAUGH. THEIR FLEXIBLE SYSTEM, BASED ON STYLIZED ILLUSTRATIONS AND A LIVELY PALETTE, ENABLED THE DESIGNERS TO DEVELOP AN ENGAGING PACKAGE AS WELL AS COORDINATED GAME COMPONENTS.

Steven Morris of Steven Morris Design says coming up with a design concept for the Don't Make Me Laugh board game presented a two-fold challenge. "It's a package design project and it's also an interactive design project," he explains. Morris needed to come up with a design for the packaging that would help it move off the shelf, and yet link effectively with game-related graphics that would engage and prompt an emotional response from game players.

He started with the game board, developing a design based on the game's challenges and progression of steps. Cartoon-like characters for the game board and game pieces were also developed with the game's humorous theme in mind, as well as a bright palette of primary and secondary colors.

Morris chose a typeface for the game's logotype that would engage its audience on a number of levels. Its casual quality captures a sense of fun and relaxation as well as nostalgia. "The concept for the game comes from a fifties game show called 'Don't Make Me Laugh,'" says Morris, who included boomerang patterns and other subtle retro elements in the game board's design.

Don't Make Me Laugh Jr. is a simplified adaptation of Don't Make Me Laugh geared to a younger audience. The game's appeal to a younger audience is achieved with a greater focus on its characters and a lighter, brighter palette.

CLIENT
RCA Victor

DESIGN FIRM
Red Herring Design

ART DIRECTOR
Carol Bobolts

DESIGNER
Rex Bonomeili

PHOTOGRAPHERS
Chuck Stewart, various

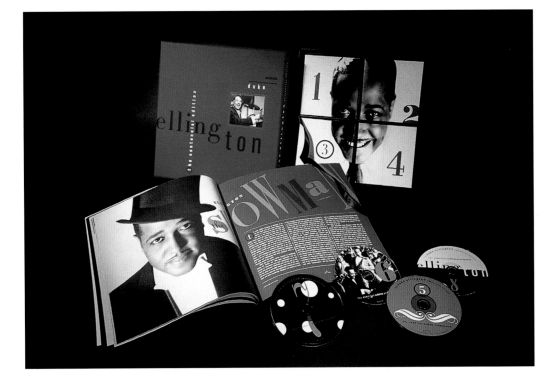

THE DESIGNERS AT RED HERRING DESIGN DREW THEIR INSPIRATION FROM
THE CIRCULAR FORMAT OF THE COMPACT DISC WHEN THEY DECIDED TO
USE CIRCLES AS A THEME TO VISUALLY LINK THE TWENTY-FOUR DISCS THAT
COMPRISE THIS BOXED SET OF DUKE ELLINGTON'S MUSIC.

When RCA Victor decided to publish *The Duke Ellington Centennial Edition*, the recording company wanted a box set that would be so comprehensive every Duke Ellington fan would want it. The result is a twenty-four-disc collection plus book documenting every Duke Ellington recording RCA Victor had ever made. The challenge for Red Herring Design in designing a package for this collection was to come up with a concept that would organize the components and a design theme that would unify the materials in the set, while communicating the essence of the music of Duke Ellington.

The designers decided to house the discs separately in baby packs that, together, form a picture of Ellington and the era of his music, the 1920s and '30s. Black-and-white photographs of Ellington and his band plus vintage typefaces and typographic ornaments create a period look. To bring these nostalgic elements into a more contemporary venue, Red Herring's designers added unusual photo crops, bold graphics, and other typefaces, including Bodoni, which was used to number the discs. The circularity of the Bodoni numerals plus dots and outlined circles create a graphic theme that repeats the circular format of the discs. In many instances, the designers even incorporated the hole in the center of the compact disc into the disc's design. A palette evocative of the twenties and thirties complements the black-and-white photos and further unifies the collection.

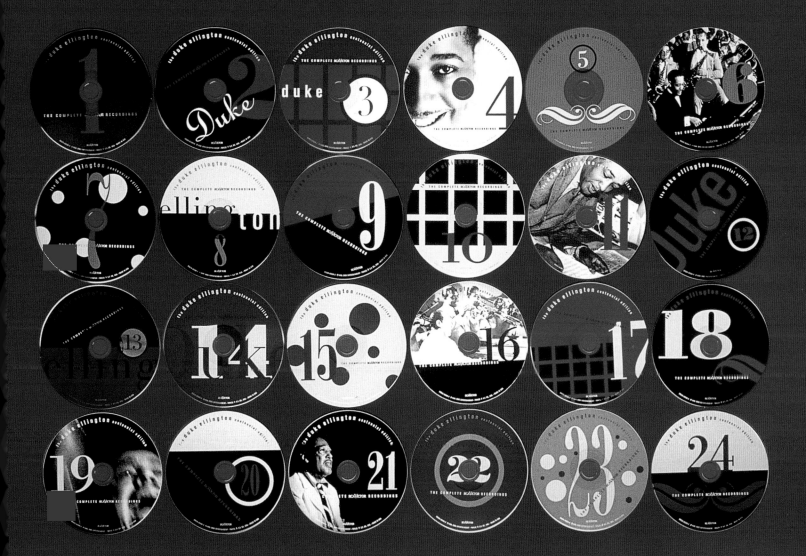

CLIENT
Cranium Inc.

DESIGN FIRM
Giorgio Davanzo Design

DESIGNER
Giorgio Davanzo

ILLUSTRATOR
Gary Baseman

CREATING A VISUAL THEME THAT WORKS JUST AS EFFECTIVELY ON GAME PIECES, A GAME BOARD, AND PACKAGING CAN BE A DAUNTING TASK. GIORGIO DVANZO DESIGN TACKLED THIS CHALLENGE BY USING PLAYFUL ILLUSTRATIONS, TYPOGRAPHY THAT COMMUNICATES A SENSE OF FUN, AND A CONSISTENT PALETTE TO UNITE THE VARIOUS COMPONENTS OF THE CRANIUM BOARD GAME.

Cranium was designed by former Microsoft executives to challenge adults, yet give everyone a chance to shine. The game is based around four activity categories: Creative Cat, Star Performer, Word Worm, and Data Head. Cranium challenges players to hum, whistle, sketch, sculpt, and more to advance around the board.

The challenge of designing the game board, cards, and other game accessories as well as its packaging was tackled by designer Giorgio Davanzo of Giorgio Davanzo Design. To assist him in the game's development, Davanzo commissioned illustrator Gary Baseman to render the game's characters and Davanzo's concept of the Cranium logo, a brain encircled by a Saturn-like ring.

The character illustrations and their colored background serve as the unifying theme for the game. Davanzo took Baseman's illustrations and positioned them on each of the board's four quadrants. The quadrant format also appears on the most prominent panel of the game's packaging. Typography that expresses a sense of fun completed Davanzo's packaging concept for Cranium.

CREATING A JUNIOR VERSION OF CRANIUM REQUIRED A DESIGN STRATEGY AND VISUAL APPROACH THAT WOULD BE FLEXIBLE ENOUGH TO WORK ON ALL COMPONENTS OF THE GAME AND ITS PACKAGING, AND ENGAGE CHILDREN. A CONSISTENT PALETTE OF BRIGHT COLORS AND WHIMSICAL CHARACTERS PROVIDED KID APPEAL AS WELL AS UNIFYING ELEMENTS.

Based on the success of Cranium, Cranium Inc. decided to do a junior version of the game. Cadoo is based on the same principal as Cranium, but requires players to earn a place on the game board. The first player to achieve a straight line wins the game.

Like Cranium, Gary Baseman's whimsical cartoon characters act as a unifying element, appearing on Cadoo's packaging: a carrying case, game board, and accessories. However, in Cadoo, the characters are depicted in a more child-like setting on the game board and packaging. Cadoo also comes with gadgets geared to kids, such as decoder glasses for reading hidden print on the game cards. A brighter palette, spiked with lime green, helps to add to Cadoo's kid appeal and unify the game pieces.

According to the game's designer, Georgie Stevens, the board graphics, illustrations, and other game components have been tested in focus groups to be sure game was fun and engaging. "The response to the game has been phenomenal," he states.

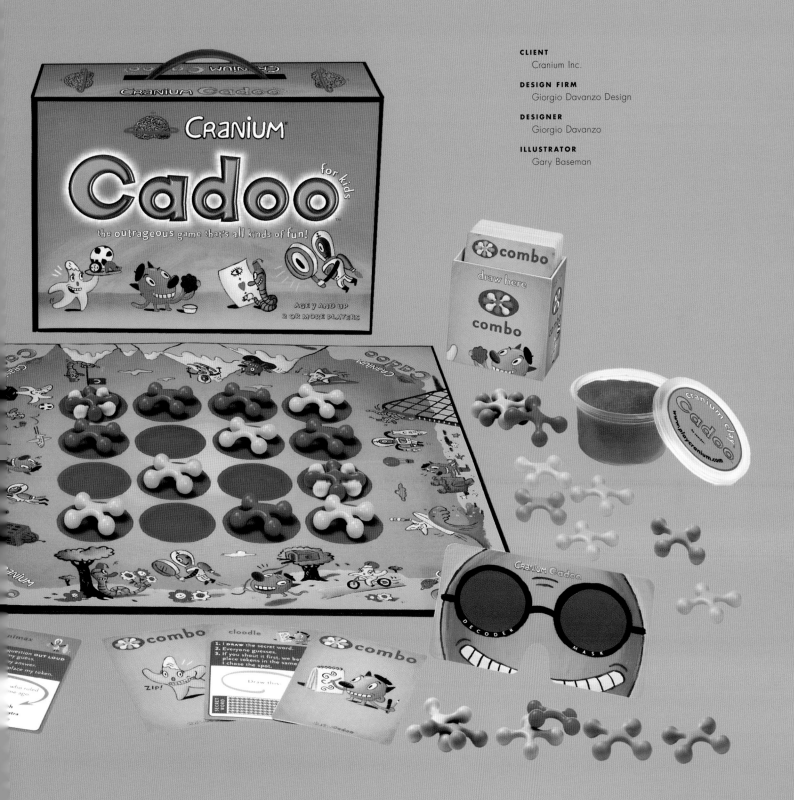

CLIENT
Cranium Inc.

DESIGN FIRM
Giorgio Davanzo Design

DESIGNER
Giorgio Davanzo

ILLUSTRATOR
Gary Baseman

CLIENT
American Boyfriends

DESIGN FIRM
#1+ Design

ART DIRECTOR
Matt Goad

DESIGNER/ILLUSTRATOR
Matt Goad

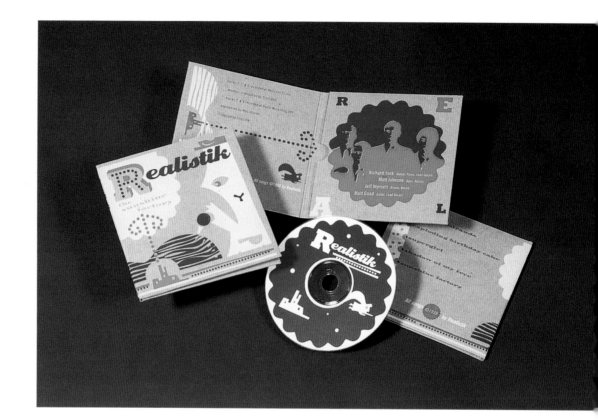

DESIGNER/ILLUSTRATOR MATT GOAD USED THE "SUNSHINE FACTORY" AS THE BASIS FOR DEVELOPING A VISUAL THEME THAT LINKS THE VARIETY OF COMPONENTS IN THIS CD PACKAGE. A CHIPBOARD JACKET FURTHER ENHANCES THE CDS INDUSTRIAL THEME AND MAKES IT STAND OUT AMONG THE MYRIAD OF JEWEL CASES THAT CLUTTER OUR COLLECTIONS.

Because the lead song on the pop band Realistik's first CD release is "Sunshine Factory," the CD's package designer, Matt Goad, decided to develop a graphic theme based on workers, a factory, and the sun. Goad's semi-abstract illustration on the front of the jacket depicts a worker with his hand on a throttle attached to a guitar. At the center of the guitar is a factory with smoke from its smokestack pointing in the direction of the Realistik logo. Behind the logo, Goad placed a billowy yellow sun.

The cover's sun shape is repeated on the jacket's interior, behind a silhouetted rendering of the band members as well as on the compact disc. To provide a rustic, neutral background for the primary colors of his illustration, Goad chose a chipboard jacket. Because the process of screen-printing his illustration and graphics on the chipboard limited his ability to print halftones, Goad's design catches the eye with intriguing imagery and unexpected simplicity.

BECAUSE THE GAME STRANGE BUT TRUE? IS BASED ON CREEPY NEWS STO-
RIES, THE DESIGNERS AT MORRIS CREATIVE USED A WACKY, YET CONSIS-
TENT, ILLUSTRATION STYLE AND A MEDIA MOTIF TO GET ACROSS THE
GAME'S THEME AND ESTABLISH A VISUAL LINK THAT UNITES THE GAME'S
PACKAGING AND ITS ARRAY OF INDIVIDUALLY ILLUSTRATED CARDS.

Based on strange stories that have actually appeared in the news, Strange But True? requires play-
ers to separate reality from fiction by reading tabloid headlines about unusual events and guessing
which ones are for real.

The game's packaging hints at the wacky nature of the events that serve as the basis for the game
with a scattering of oddball characters and media-related images on its front panel. The same images
also appear on the game cards packaged within. A background motif of concentric circles reinforces
the game's media theme and serves as a unifying element on the game cards and packaging.

CLIENT
Lolo Company

DESIGN FIRM
Morris Creative

ART DIRECTOR
Steven Morris

DESIGNERS
Steven Morris,
Cynthia Jacobsen

ILLUSTRATOR
Steven Morris

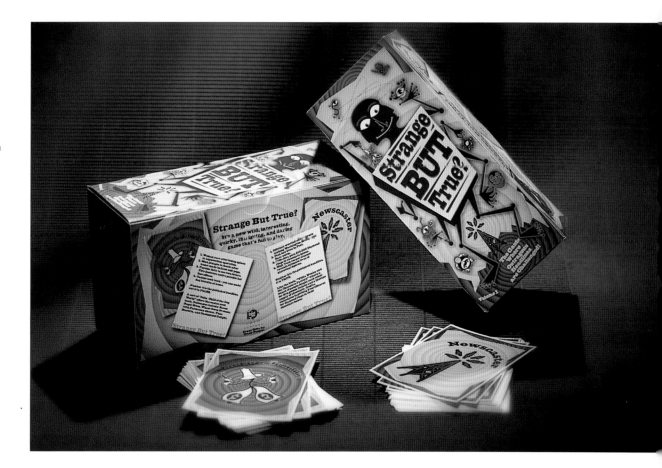

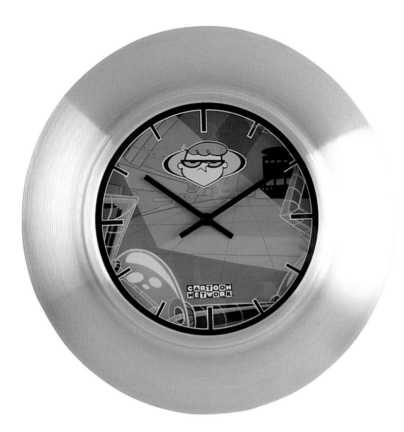

CLIENT/DESIGN FIRM
Cartoon Network

CREATIVE DIRECTOR
Gary Albright

DESIGNER
Todd Fedell

WHEN FACED WITH THE CHALLENGE OF DESIGNING A CLOCK TO PROMOTE THE POPULAR "DEXTER" SERIES, THE CARTOON NETWORK'S DESIGN TEAM DEVELOPED A GRAPHIC APPROACH THAT SUCCESSFULLY BRINGS TOGETHER ALL OF THE ESSENTIAL ASPECTS OF THE CARTOON SERIES WITHIN THE CONFINES OF THE CLOCK FACE'S CIRCULAR FORMAT.

The cartoon character Dexter is a boy genius who has a secret laboratory in his closet. When he retreats into his closet, the lab comes to life along with Dexter's fantasy creations. This popular character was immortalized on a clock given to the press and media executives to promote the Cartoon Network, and is also available for sale on the network's Web site.

In developing a design for the clock, the Cartoon Network design team wanted to give Dexter's face the highest level of prominence. Filling the rest of the clock face required creating an abstract design that suggests the environment of Dexter's lab. Tubes and glass bubbles hint at the sci-fi inventions that Dexter produces within his lab's pristine blue walls. A brushed-metal casing completes the clock's contemporary, streamlined look.

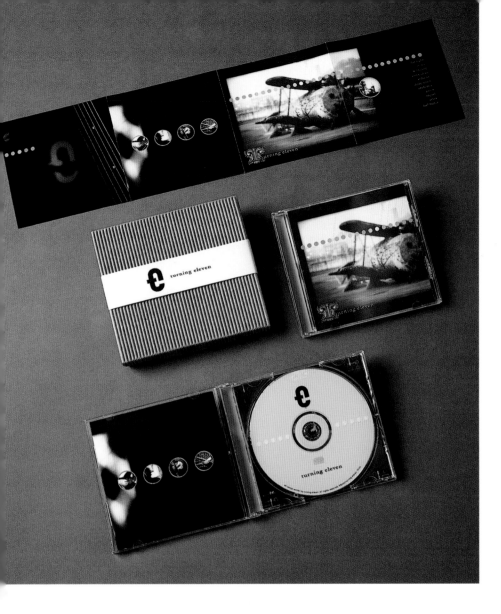

CLIENT
Turning Eleven

DESIGN FIRM
Lift Communications, Inc.

ART DIRECTOR
Amy Johnson

DESIGNER
Amy Johnson

PHOTOGRAPHER
Chris Lawson

DESIGNING A CD PACKAGE IS A CHALLENGE IN ITSELF, BUT LIFT COMMUNICATIONS NEEDED TO DESIGN PACKAGING FOR A BAND'S INTRODUCTORY CD THAT WOULD DO DOUBLE DUTY AS A PRESS KIT. THE FIRM'S SOLUTION INCORPORATES PHOTO CROPS THAT HELP TO VISUALLY CONNECT THE CD'S JEWEL CASE INSERT WITH ITS COMPACT DISC AND ANOTHER BOX THAT COMMANDS ATTENTION AND COORDINATES WITH THE INSERT'S NOSTALGIC IMAGERY.

To introduce Turning Eleven to record distributors and the media, the band's debut album needed more than just a nicely packaged CD. Lift Communications was enlisted to not only design the CD's packaging, but develop an identity for the band and press kit box as well.

The designers first developed a logo for Turning Eleven, designing an icon that suggests a lowercase "t" that's morphed into an uppercase "E." The logo appears on the disc and as a reflected image on a photo of a guitar that's featured on the CD's insert. The insert also features a black-and-white photo of a vintage bi-plane. Lift's Amy Johnson chose this image because it implied "taking off." When the jewel case is opened, the second panel on the insert echoes the circular format of the compact disc with its series of close crops of band members' singing and playing.

To catch the attention of the press, Lift Communications packaged the CD in an outer box made of fluted cardboard, wrapped with a belly band bearing the band's name and logo.

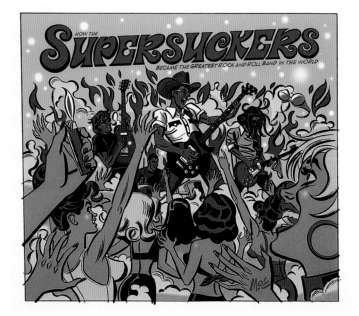

CLIENT
Sub Pop Records

DESIGN FIRM
Sub Pop Records

ART DIRECTOR
Jeff Kleinsmith

DESIGNER
Mitch O'Connell

ILLUSTRATOR
Mitch O'Connell

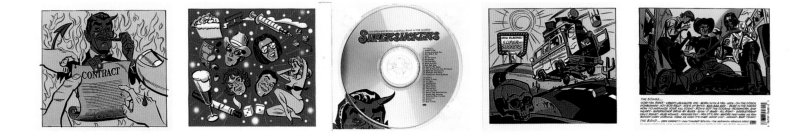

A VISUAL NARRATIVE PRESENTED IN A SERIES OF PULP-STYLE ILLUSTRATIONS
CREATES A STYLISTIC THEME, ESTABLISHED ACROSS A SERIES OF PANELS,
IN THE PACKAGING FOR THIS CD.

The Supersuckers CD tells the story of a band (with the same name) that's tempted into making a deal with the devil in exchange for success and fame. In addition to telling this sordid tale through a compilation of songs, the packaging's illustrations tell the story as well.

The CD's cover illustration depicts the group surrounded by adoring fans. Its comic-book rendering style immediately establishes the fact that this is a narrative—a pulp story that's not real, but a parody based on the "Supersuckers" moniker. From there, the packaging unfolds into a series of illustrated panels. It immediately becomes apparent that the band has made a contract with the devil, signed in blood. Ensuing illustrations of a van traveling across the desert and a panel depicting women, drugs, gambling, and other excesses tell the rest of the wordless story.

CLIENT
Radioactive Records

DESIGN FIRM
Sagmeister, Inc.

ART DIRECTOR
Stefan Sagmeister

DESIGNER
Motoko Hada

ILLUSTRATOR
Motoko Hada

PHOTOGRAPHERS
Dan Winters, Danny Clinch

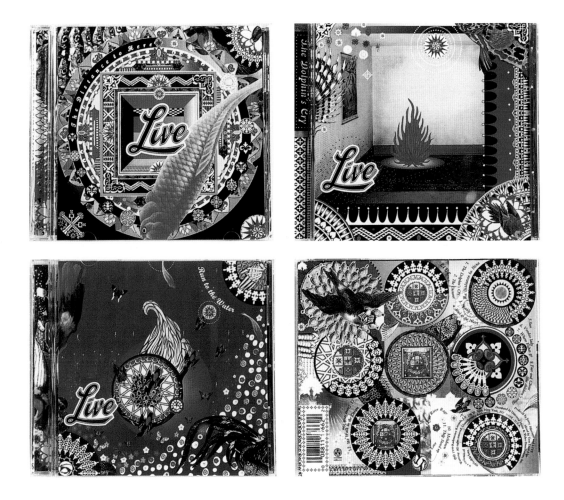

TO UNIFY A CD DISC COLLECTION OF MUSIC WITH AN EASTERN FLAVOR
WITH ITS SQUARE JEWEL CASE, SAGMEISTER, INC. CAPITALIZED ON THE
EASE OF FITTING A CIRCLE WITHIN A SQUARE BY FOCUSING ON THE CIR-
CULAR SHAPE OF THE HINDU MANDALA. IMAGES FROM NATURE INCORPO-
RATED INTO DIGITAL COLLAGES PROVIDED RICH AND FLEXIBLE IMAGERY AS
WELL AS AN OPPORTUNITY FOR CREATING VARIETY WITHIN A VISUAL
THEME.

Because Live's music has an Eastern flavor, Sagmeister, Inc. decided to develop a look for the band's
series of three CDs that's based on the Hindu mandala, a symbol for the universe. Sagmeister design-
er Motoko Hada brought the mandala into a contemporary venue by embellishing its circular shape
with intricate patterns and repeating circles. This design theme is carried into all aspects of the pack-
aging, including the discs, and helps to unify the series.

Although all three CDs have a similar look, each is distinctly different in its cover design. Hada tried
to develop a design for each that incorporates images from nature and ties in with the CD title. A
case in point is "Run to the Water," which depicts bubbles and fish in a cover design that makes
everything seem as though it's floating on a deep-red, watery background.

CLIENT
Aerobleu for Verve Records

DESIGN FIRM
Less Than 7

ART DIRECTOR
Brooks Branch

DESIGNER
Patricia Lie

COPYWRITER
Gene Lees

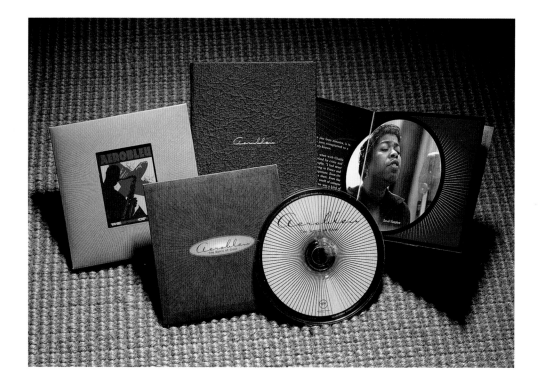

FOR THE AEROBLEU JAZZ COMPILATION, LESS THAN 7 DEVELOPED A GRAPH-
IC THEME THAT WORKS ON THE CIRCULAR FORMAT OF THE CD DISC AS
WELL AS ITS SQUARE JEWEL CASE INSERT. STYLISTIC TREATMENTS THAT
RECALL THE ART DECO MOVEMENT OF THE 1930S AND 1940S SERVE TO
FURTHER UNIFY THE COMPONENTS THAT COMPRISE THIS CD COLLECTION
OF SONGS BY VINTAGE JAZZ MUSICIANS.

The *Aerobleu* compilation, a collection of rare cuts from various well-known jazz artists, has its roots in "Aerobleu" a story about a pilot in the late 1940s who frequented jazz clubs all over the world. Less Than 7's Brooks Branch, who invented the *Aerobleu* story and also loves jazz, compiled the CD collection and designed its packaging as well.

The *Aerobleu* themes of flight and jazz are conveyed on the CD's cover with its depiction of a musician and vintage airplane. The packaging for the compact disc and the disc itself bear the distinctive *Aerobleu* logo, an elegant script that recalls the forties with its deco-like sensibility. A booklet that accompanies the CD features photos of its jazz artists, cropped to the same circular format and dimensions of the disc. Fine, emanating lines serve as a unifying element for all of the pieces and rein-force the package's aesthetic of refinement and artistry.

PULSE PROGRAMMING CD DESIGN

CLIENT
Aesthetics

DESIGN FIRM
VSA Partners

DESIGNER
Hans Seeger

PHOTOGRAPHER
Bart Witowski

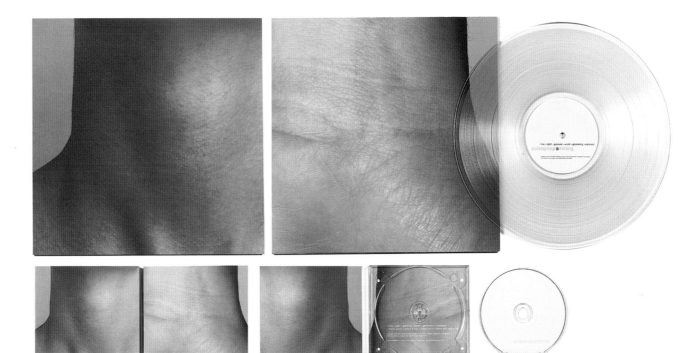

VSA PARTNERS CAPITALIZED ON THE ATTENTION-GETTING POWER OF NAKED SKIN TO COMMUNICATE THE NATURE OF PULSE PROGRAMMING'S MUSIC. THE PHOTOGRAPHS OF PULSE POINTS THEY COMMISSIONED ALSO PROVIDED A THEMED SERIES FOR THE PANELS THAT COMPRISE THE JEWEL CASE INSERT FOR THIS CD. A TRANSPARENT CD DISC FURTHER ENHANCED THEIR THEME OF "TOTAL EXPOSURE."

Sometimes pictures speak louder than words. A case in point is the CD packaging for Pulse Programming's self-titled musical release. VSA Partner's Hans Seeger developed the packaging's design concept, which features extreme close-ups of a neck and wrist on the front and back, and interior panels of the CD's jewel case. In fact, it becomes hard to distinguish one from the other. According to Seeger, Bart Witowski's photographs accomplish much more, serving to express the warm, ambient quality of Pulse Programming's music.

To not detract from Seeger's minimalist concept, the disc is made from transparent plastic and contains only essential information, presented as unobtrusively as possible.

CLIENT
Arts & Entertainment Television Network

DESIGN FIRM
Red Herring

DESIGNER
Matthew Bouloutain

PACKAGING A GLOBE IN A WAY THAT WOULD ENGAGE NETWORK EXECUTIVES AND PROMOTE A DOCUMENTARY ABOUT A 1907 ROAD RACE PROVIDED A LOGISTICAL AS WELL AS VISUAL CHALLENGE FOR THE DESIGNERS AT RED HERRING.

To promote "Peking to Paris," a ten-hour documentary on a 1907 road race, the Arts & Entertainment Television Network (AETN) wanted to let top executives at cable companies know about the program as well as create awareness for AETN. The promotion needed to generate excitement about the network in order to get cable systems not yet advertising to add the channel to their systems.

AETN contracted with Red Herring to design an high-impact mail promotion that would include a videotape of the documentary as well as an informative brochure about AETN. To ensure the package they designed wouldn't be ignored, Red Herring's Matthew Bouloutain conceived a promotion that incorporates a globe at its center. The globe not only symbolizes traveling from Peking to Paris, it also echoes the newly created History Channel International logo, which features a globe. Bouloutain retrofitted the box containing the globe with an insert printed with vintage cars and other race-related memorabilia. A circular die-cut in the insert helped to stabilize the globe, while other die-cuts served as holders for the videotape and brochure.

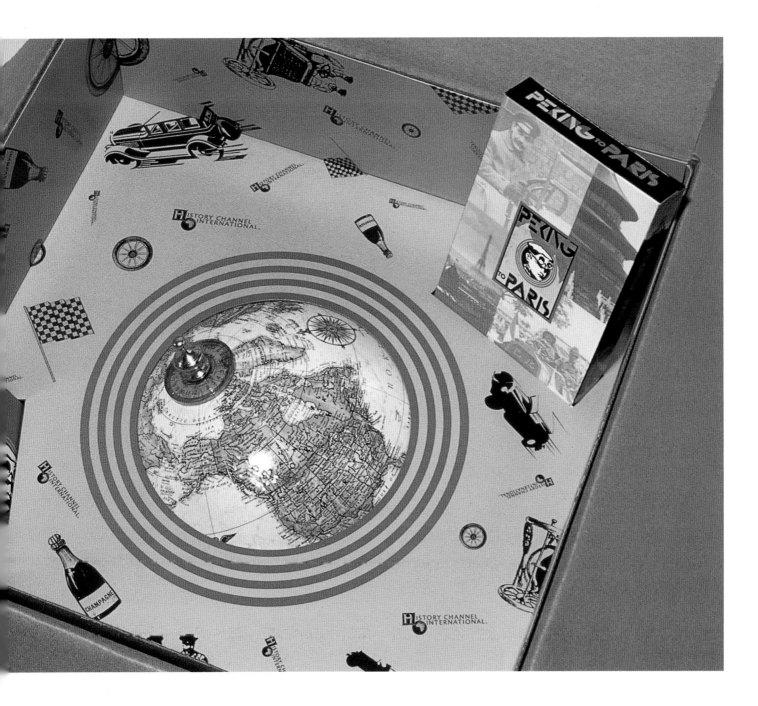

ACHIEVING VISUAL CONTINUITY FOR A GROUP OF SIMILARLY THEMED MUSI-
CAL CDS COULD HAVE YIELDED A BORING SAMENESS. BUT STOLTZE DESIGN
AVOIDED THIS PITFALL BY DEVELOPING A GRAPHIC VOCABULARY THAT
ALLOWS FOR VARIETY, YET CONSISTENCY, ON ALL OF THE CDS IN THIS
COLLECTION.

CLIENT
Hay House/Windham Hill

DESIGN FIRM
Stoltze Design

DESIGNERS
Clifford Stoltze,
Tammy Dotson,
Wing Ngan

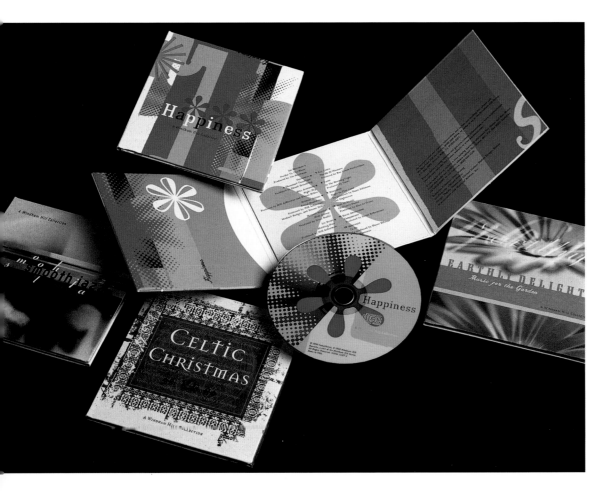

In spite of their client's request for a "standard look," coming up with a packaging concept for a
series of themed inspirational music for the self-help/transformational market led the designers at
Stoltze Design to do more than design a template where different titles could be dropped in. "We
proposed that all twelve CDs be different, but the packaging have an attitude that would hold the
CDs together as a series," says firm principal Clifford Stoltze.

The CDs work well together because of their shared graphic vocabulary and collaged imagery, but
are equally effective on their own. For each design, Stoltze and his team developed concepts that
could be carried from the packaging's front panel into the eco-sensitive interior panels. Graphic
themes are also carried onto the disc. A case in point is "Happiness," where the central theme of
the asterisk and enlarged, screen-dotted background image, is applied on every element of the pack-
age and its contents.

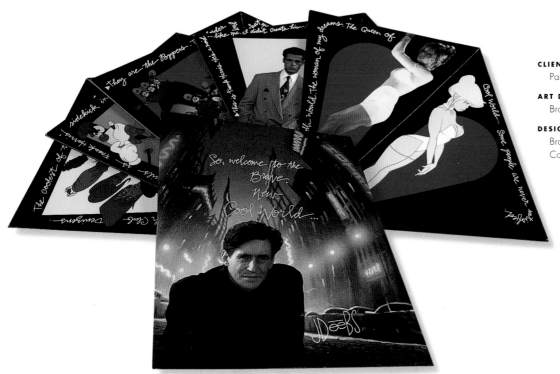

CLIENT/DESIGN FIRM
Paramount Pictures

ART DIRECTOR
Brooks Branch

DESIGNERS
Brooks Branch, Lane Livingston, Kaiser
Communications

TRANSLATING THE LOOK AND FEEL OF *COOL WORLD*, A BLEND OF TRADITIONAL FILM AND ANI-
MATED IMAGERY, INTO A SALES KIT REQUIRED COMING UP WITH A PACKAGE DESIGN THAT
PUSHES THE PARAMETERS OF THE TYPICAL, RECTANGULAR BOX.

To promote the film *Cool World*, which starred Brad Pitt, Gabriel Byrne, and Kim
Bassinger, Paramount Pictures sent out a sales kit that depicted clips from the
film. Because the film is an odd mix of animation and live action, designer
Brooks Branch wanted to do something unusual. The oblong, disproportioned
sets for the movie gave Branch the idea of creating an oblique-angled box to
house the kit.

"The creation of the box was a mathematical challenge," relates Branch,
adding that a CAD program was used to determine its angles and dimen-
sions. The box's inserts, unique clips from the film laminated onto museum
boards, are also an odd mix of animation and live shots, juxtaposed
in some cases, on triangular-shaped boards. To tie-in with the film's use
of animated imagery, the photo boards were set atop a bed of shredded
comic pages.

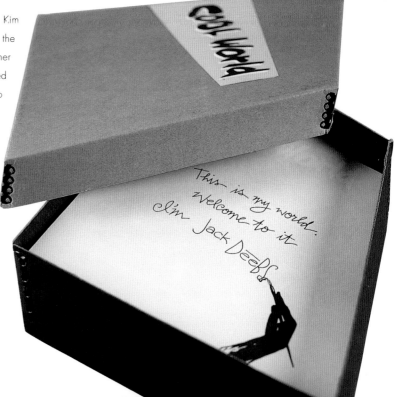

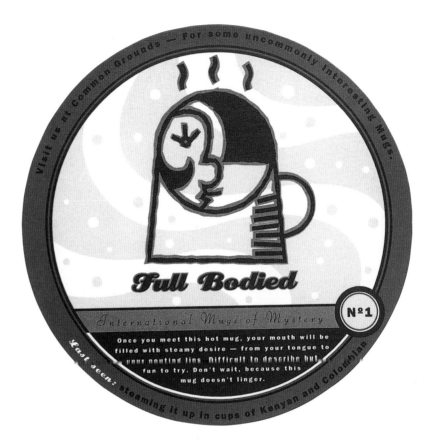

Visit us at Common Grounds — For some uncommonly interesting mugs.

Full Bodied

International Mugs of Mystery

Nº1

Once you meet this hot mug, your mouth will be filled with steamy desire — from your tongue to your pouting lips. Difficult to describe but fun to try. Don't wait, because this mug doesn't linger.

Last seen: steaming it up in cups of Kenyan and Colombian

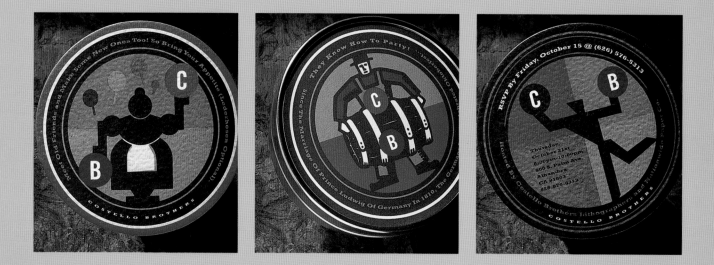

DESIGNING A SERIES OF COASTERS TO PROMOTE AN OCTOBERFEST PARTY
REQUIRED ERBE DESIGN TO ADAPT THE PARTY INFORMATION AND A GER-
MAN THEME TO THE CONFINES OF A CIRCULAR FORMAT.

Hosting an Octoberfest party for clients prompted Costello Brothers Lithographers to hire Erbe Design
to design an invitation that would impress and draw the local design community to their event. As a
metaphor for the beer drinking that takes place at Octoberfest, firm principal Maureen Erbe and
designer Raoul Ramirez decided to use a series of coasters to promote the event.

The designers also wanted to stress Octoberfest's German heritage, so they drew their inspiration
from German trade symbols from the turn of the century. Each of the coasters is an adaptation of a
symbol with information running in a circle surrounding it. To create a coordinated package, the
coasters share the same format, graphic treatment, and palette.

The coasters were housed in a tin that takes recipients through a sequence of "what, where, and
when," starting with the tin label, which states; "They know how to party."

CLIENT
Costello Brothers Lithographers

DESIGN FIRM
Erbe Design

ART DIRECTOR
Maureen Erbe

DESIGNERS
Maureen Erbe, Raoul Ramirez

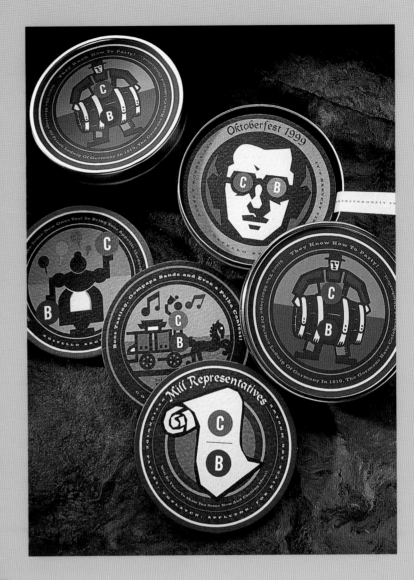

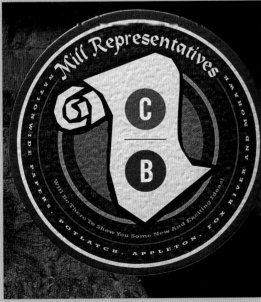

CONFORMING A SERIES OF COFFEE-RELATED CHARACTERS TO THE DIMEN-
SIONS OF A COASTER REQUIRED WHIMSICAL ILLUSTRATIONS THAT WORKED
WELL WITHIN THE CIRCULAR FORMAT AND APPEALED TO CUSTOMERS AS A
COLLECTIBLE.

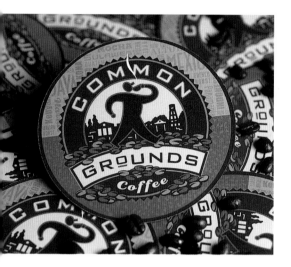

Common Grounds, a coffee house based in Sacramento, California, needed an identity to appeal to upscale urbanites wanting to enjoy a good cup of coffee in casual surroundings. CMB Design Partners started by creating a logo, an illustration contained in a circular configuration of text, that conveys the coffee house's casual atmosphere in a trend-savvy style.

To create free publicity for their client, the CMB design team came up with the concept of a series of coasters that, in addition to reinforcing Common Grounds identity, would also be coveted as swipe-able items. Each of the coasters in the "Mugs of Mystery" series is based on a coffee-related attribute that can also be ascribed to an individual. Clever illustrations that characterize mugs of coffee as people are supported with descriptions of each. The circular format, rendering style, and palette of browns and beiges, helps to unify the series and tie it in with the Common Grounds logo.

In addition to the coaster series, the other applications of the Common Grounds identity included signage, T-shirts, coffee mugs, and gift items.

CLIENT
Common Grounds

DESIGN FIRM
CMB Design Partners

DESIGNER
Jeff Bane

ILLUSTRATOR
Jeff Bane

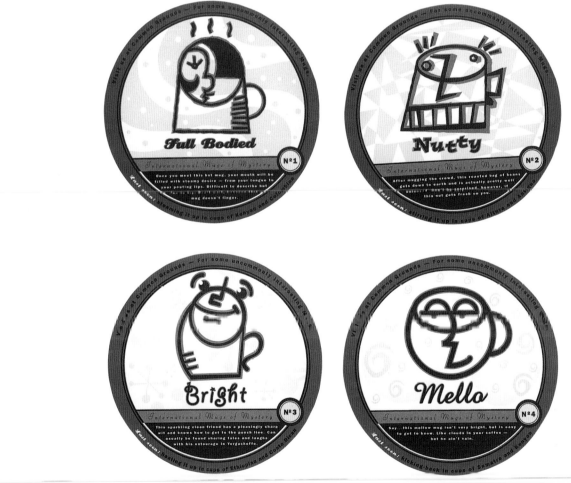

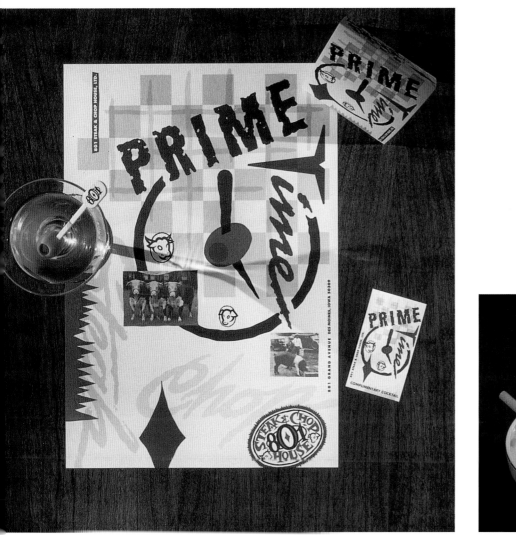

CLIENT
801 Steak & Chop House

DESIGN FIRM
Sayles Graphic Design

ART DIRECTOR
John Sayles

DESIGNER
John Sayles

ILLUSTRATOR
John Sayles

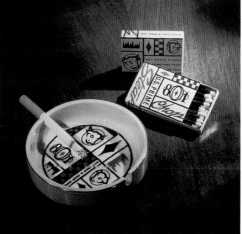

CREATING A RESTAURANT IDENTITY FOR THE 801 STEAK & CHOP HOUSE THAT WOULD ADAPT
TO THE SHAPES OF ASHTRAYS, MATCHBOOKS, SWIZZLE STICKS, AND INTERIOR APPLICATIONS
CHALLENGED SAYLES GRAPHIC DESIGN TO DEVELOP A VERSATILE SYSTEM THAT INCORPORATES
THE RESTAURANT NAME, A CHECKERBOARD PATTERN, AND IMAGES OF HOG AND STEER HEADS.

Because Iowa has a long-standing reputation for producing some of the world's finest prime beef and pork, the 801 Steak & Chop House is a place where patrons can dine on steaks and chops said to rival the best to be found anywhere. John Sayles, the designer of the restaurant's upscale identity, sought to create an atmosphere for 801 that is at once elegant and rustic, vintage yet trendy. The identity needed to work in all areas of the restaurant—on menus, signage, and barware.

To accommodate all of these applications, Sayles developed a system of icons: the numerals 801, steer and hog heads, plus a graphic palette that includes a checkerboard pattern as well as "Steak" and "Chops" hand-rendered in a casual script. A sophisticated palette of dark green, dark red, and tan helped to evoke the feeling of a 1920s steakhouse. The versatility of this graphics system allowed Sayles to easily customize swizzle sticks, ashtrays, matchbooks, and other restaurant items with the 801 look, by allowing him to pick and choose, and configure to fit, the various elements in the system.

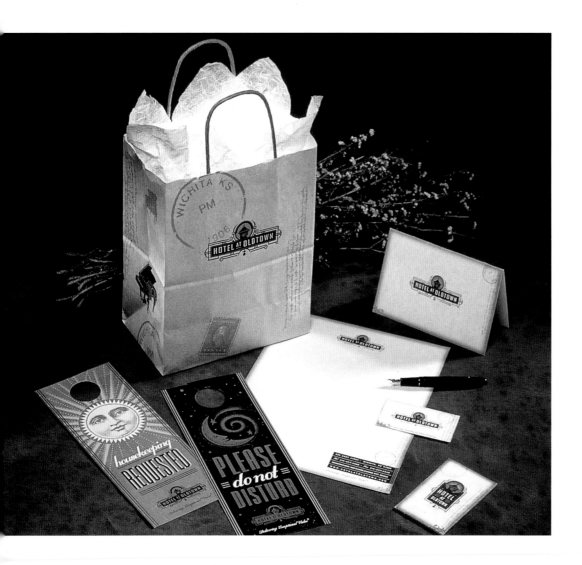

CLIENT
Hotel at Old Town

DESIGN FIRM
Greteman Group

CREATIVE DIRECTOR
Sonia Greteman

ART DIRECTORS
Sonia Greteman, James Strange

DESIGNERS
Sonia Greteman, James Strange

THE GRETEMAN GROUP INCORPORATED OLD-FASHIONED IMAGERY AND A
COLOR PALETTE IN STEP WITH THE HOTEL AT OLD TOWN'S IDENTITY INTO A
DESIGN THAT CONFORMS TO THE DIMENSIONS OF THE HISTORIC HOTEL'S
DOOR HANGERS.

The Hotel at Old Town's distinctive clock tower is a prominent feature of the historic building, a restored, century-old warehouse in the heart of Wichita's redbrick district. The Greteman Group design team chose to focus on the clock tower as the basis for the hotel's identity, rendering it and combining it with a typographic treatment that echoes the hotel's historic venue.

The hotel's door hangers were also given a vintage look to tie in with its identity. Although they display the hotel's logo at the bottom, the most prominent features are the images of the sun and the moon that resemble old engravings. Each appears on opposite sides of the hanger to indicate whether patrons are up and out, or still sleeping. Vintage typography and a color scheme of black, white, and tan help to tie the door hangers in with the antique look of the hotel's other identity materials.

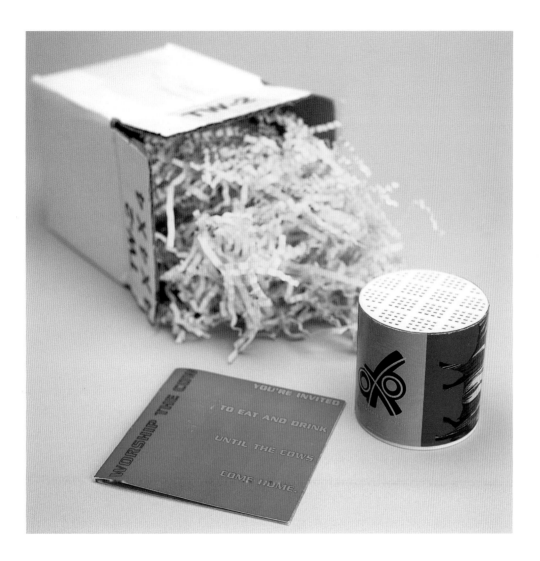

CLIENT
Oxo

DESIGN FIRM
Michael Salisbury LLC

CREATIVE DIRECTOR
Michael Salisbury

ART DIRECTOR
Michael Disbennet

DESIGNER
Michael Disbennet

A "MOOING" INVITATION TO A RESTAURANT OPENING PIQUES THE CURIOSITY OF ITS RECIPI-
ENTS AND HINTS AT THE TYPE OF CUISINE BEING OFFERED. ITS DESIGNER WAS CHALLENGED
TO COME UP WITH A THEME THAT COULD BE APPLIED TO A CYLINDRICAL NOISE MAKER AS WELL
AS THE INVITATION'S INSERT.

To promote the opening of Oxo, a beef and seafood restaurant based in Las Vegas, the restaurant owners wanted to host a party for supporters and those in a position to give the restaurant a favorable review. They hired Michael Salisbury LLC to come up with a promotional campaign and design an invitation to the event.

Taking his lead from the restaurant's beef-themed name and menu, Salisbury created an invitation that literally "moos." The mailing consisted of a cylindrical "moo maker" that makes a mooing sound whenever it's inverted. Salisbury customized the moo makers with a wrapper printed with alternating panels of the Oxo logo and images of a painted cow. An accompanying insert invites recipients to "eat and drink until the cows come home."

The mooing invitation was sent in a plain, white box, arousing the curiosity of its recipients, and prompting them to open the package without delay.

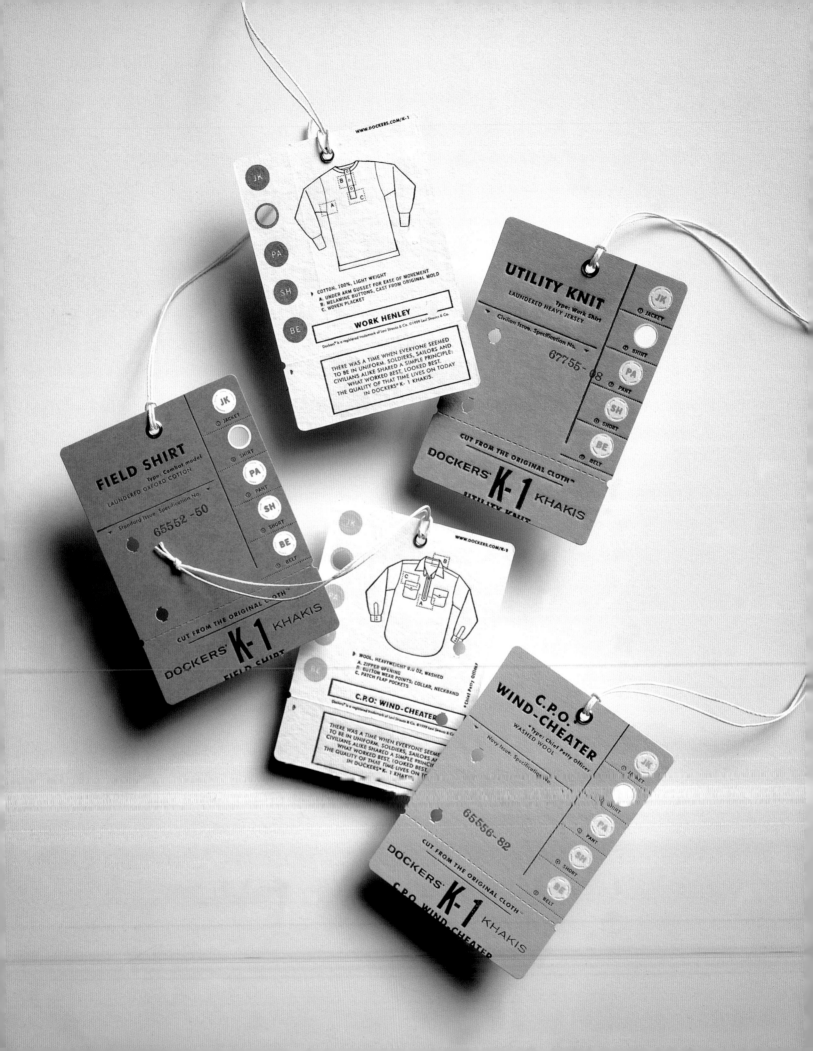

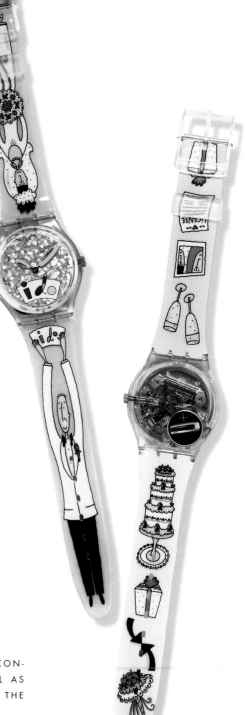

CLIENT
Swatch

DESIGN FIRM
Thompson Studio

ART DIRECTOR
Emily Thompson

DESIGNER
Emily Thompson

ILLUSTRATOR
Emily Thompson

TO CREATE A WATCH WITH A WEDDING THEME, EMILY THOMPSON CON-
CEIVED A DESIGN TO APPEAL TO BOTH BRIDE AND GROOM AS WELL AS
DEVELOPED A WEDDING MOTIF THAT WOULD WORK EQUALLY WELL ON THE
WRIST STRAPS AND WATCH FACE.

When commissioned to design a watch that could be marketed to couples as a boxed set
of coordinated men's and women's watches, illustrator/designer Emily Thompson came
back with conceptual sketches that were wedding themed. Swatch decided, from there, to develop a single "wedding watch"
that could be worn by either the bride or groom or both on the big day.

One of her concepts portraying a bride and groom appears on the topside of the watch. Illustrating the groom with arms raised
above his head holding an "I Do" sign allowed Thompson to fill the longest strap of the wristband. The bride's upswept hair-
do and veil help to fill the space on the other band. Even the watch face is in support of a union with its "I Do" and wedding
rings watch hands.

The underside of the watch's wrist strap bears the other wedding concept Thompson initially developed, a series of wedding-
related items including a tiered cake, bouquet, and glasses of champagne.

CLIENT
Swatch

DESIGN FIRM
Thompson Studio

ART DIRECTOR
Emily Thompson

DESIGNER
Emily Thompson

ILLUSTRATOR
Emily Thompson

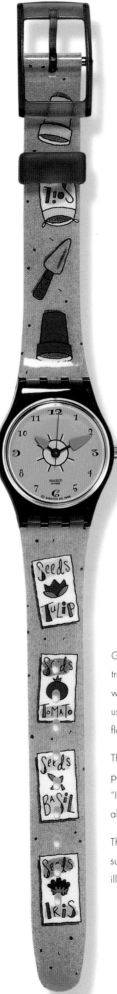

GIVEN A TEMPLATE OF A WATCH FACE AND STRAPS, EMILY THOMPSON ADAPTED HER ILLUSTRATIONS OF TINY SEED PACKETS AND GARDEN IMPLEMENTS TO WORK IN THE CIRCULAR FORMAT OF THE WATCH FACE AND CONTINUE SEAMLESSLY ALONG THE WATCHBAND.

Given free rein to come up with a watch design, designer/illustrator Emily Thompson decided to develop a gardening-themed watch. Provided with a printed watch template as her guide, she used pen-and-ink and watercolor to illustrate seed packets, a flowerpot, shovel, and soil bag.

Thompson worked on her illustrations at 100 percent scale, painstakingly hand-lettering each seed packet with its contents. "It wasn't that difficult," she recalls. "I think that's because I usually work small to begin with."

The circular watch face lent itself perfectly to an illustration of the sun at its center, against a sky-blue background. Thompson even illustrated the tiny shovels that serve as watch hands.

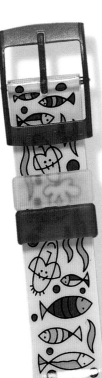

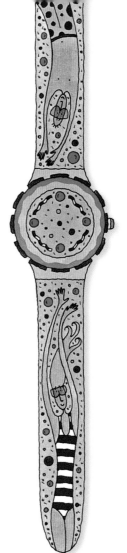

CLIENT
Swatch

DESIGN FIRM
Thompson Studio

ART DIRECTOR
Emily Thompson

DESIGNER
Emily Thompson

ILLUSTRATOR
Emily Thompson

ACCOMMODATING A SNORKELING DESIGN WITHIN THE CONFINES OF A WATCH REQUIRED ILLUSTRATOR/DESIGNER EMILY THOMPSON TO WORK TO SCALE IN PAINSTAKING DETAIL.

Emily Thompson's whimsical illustrations are frequently seen on greeting cards and in women's magazines. Swatch executives recognized that her lighthearted style and tendency to work small made her work well-suited for Swatch watches and they contacted Thompson after seeing her work in a talent directory. From there, they asked her to develop watch ideas based on several themes, including one that related to snorkeling.

Thompson submitted two concepts: One had figures swimming on the watch's wrist straps; the other, a pattern of fish, faces and seaweed, was the one Swatch chose. Thompson developed a watch dial that features fish-shaped watch hands to coordinate with the fish on the watch's wrist straps.

"Most designers submit their work at 200 percent scale," says Thompson. However, her ability to work small, allowed Thompson to develop her design at actual size so that Swatch could create a mock-up of her concept to allow her to see how it would actually look by gluing trimmed copies of her illustration directly onto a watch.

A VERTICAL SEQUENCE, REPRESENTING THE NUMERICAL COUNTDOWN USED TO START MOVIES AND TELEVISION SHOWS, FITS WELL IN THE NARROW CONFINES OF A NECKTIE DESIGN.

Lee Allison's "Picture Start" silk neckties recall how movies and TV shows used to start with a numerical countdown. Allison came up with the idea because he thought the sequence would fit perfectly on the long, narrow space of a necktie.

Getting his idea produced in silk jacquard required developing his concept in a way that would make the most out of its production as part of the fabric weave. The light and shaded areas behind each number are produced as a combination of two different colored threads, woven together to create a third color. Woven jacquard also limited each necktie's palette to three colors for each.

CLIENT
Lee Allison Company

DESIGN FIRM
Lee Allison Company

ART DIRECTOR
Lee Allison

DESIGNER
Steve Mayer

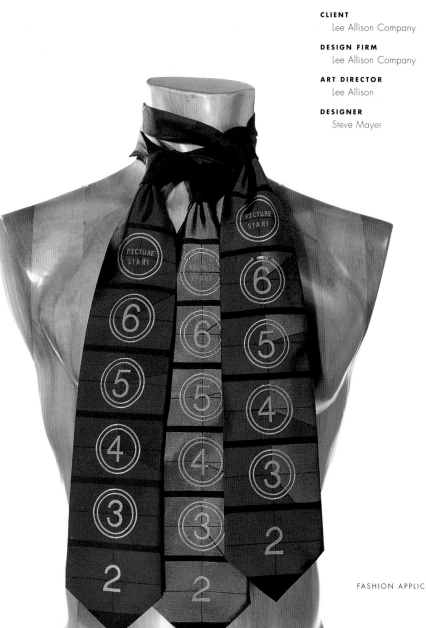

GYMBOREE FASHION IDENTITY

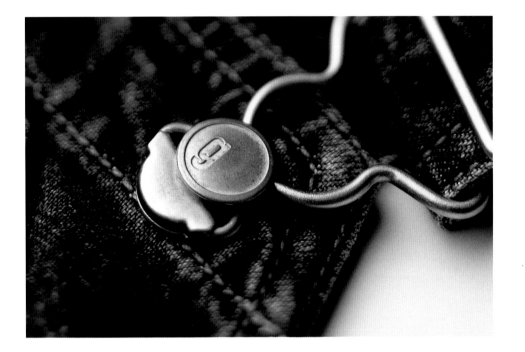

CLIENT
Gymboree

DESIGN FIRM
Michael Osborne Design

ART DIRECTOR
Michael Osborne

DESIGNER
Paul Kagiwada

ADAPTING A FASHION IDENTITY TO FIT A VARIETY OF KIDS' CLOTHING ITEMS AND PACKAGING—INCLUDING BUTTONS, GARMENT LABELS, AND SHOPPING BAGS—CHALLENGED MICHAEL OSBORNE TO DEVELOP A FLEXIBLE IDENTITY SYSTEM BASED ON PRIMARY SHAPES AND BRIGHT COLORS.

When Gymboree came under new management, updating the kid's fashion giant's brand identity was at the top of the list. Gymboree hired Michael Osborne Design, asking for a hip new design that would appeal to today's kids. But just as important was the need to develop a design that would work on a broad range of fashion venues that included hangtags, clothing labels, shopping bags, and other applications.

To convey a child-like sensibility, the designers started by combining primary shapes—circles and squares—with bright colors. Adding a lowercase "g" within a circle and the Gymboree name within another gave the designers a stand-alone icon as well as a word mark to work with as modular units.

From there, the designers combined the circular marks with squares and circles filled with colors and photographs of rubber ducks, baseballs, and other kid-related items. The result is a flexible series of components that allowed them to adapt the identity to small-scale applications—even to tiny items such as buttons.

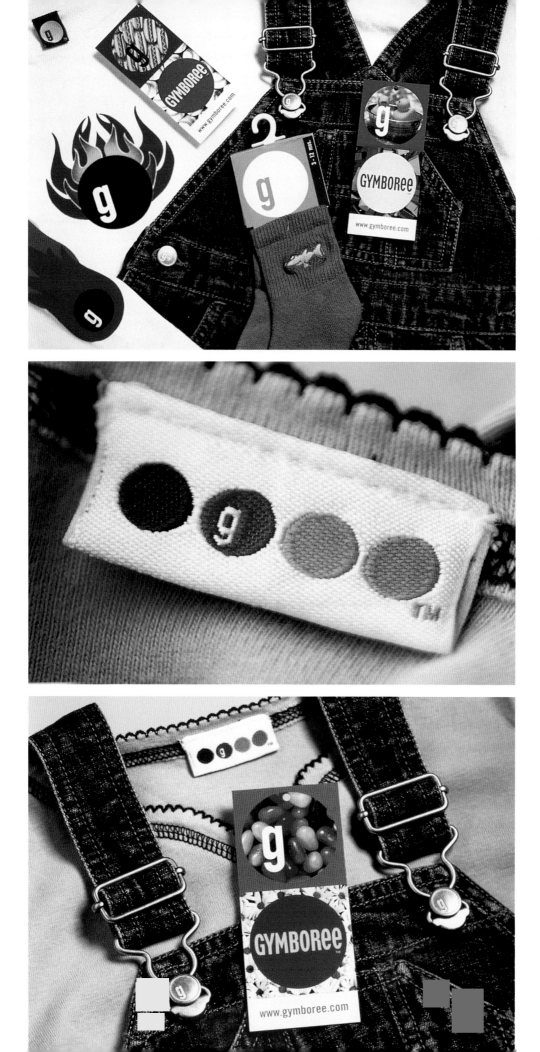

MODERN DOG'S WATCH DESIGN, WITH A RUSH HOUR THEME, REQUIRED DEPICTING A TRAIL OF ANGRY DRIVERS ON THE NARROW CONFINES OF THE WATCH'S WRIST STRAPS, AS WELL AS A CITY SKYLINE ON THE TINY FACE.

The designers at Modern Dog were flattered to learn that Swatch had selected them to design a watch with a theme of their own choosing. However, conveying a graphic theme on a small scale and making it work on the wrist straps as well as the face of a watch was a challenge.

The designers wanted to go with a pop-culture theme that would relate to the concept of time and lend itself to the firm's humorous rendering style. They soon realized that the narrow dimensions of the wristband would provide an ideal canvas for illustrating a trail of angry rush-hour motorists stuck in traffic.

Modern Dog's designers illustrated a city skyline on the watch's face so that motorists appear as though they're coming and going from the city. Even the hands of the watch are designed to look like buildings. When the wearer of the watch presses a button to light the watch face, the windows in the skyline's buildings glow, as though it's nighttime.

CLIENT
Swatch

DESIGN FIRM
Modern Dog

ART DIRECTOR
Vittorio Costarella

DESIGNER
Vittorio Costarella

ILLUSTRATOR
Vittorio Costarella

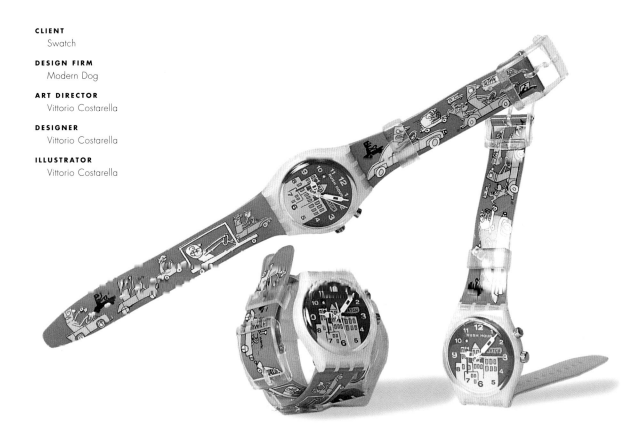

CLIENT
Issey Miyake, Inc.

DESIGN FIRM
Sayuri Studio

ART DIRECTOR
Sayrui Shoji

DESIGNER
Sayuri Shoji

WHEN FACED WITH THE CHALLENGE OF DESIGNING TO FIT THE LIMITED FORMAT OF A CIRCULAR CD AND ITS SQUARE JEWEL CASE, DESIGNER SAYRUI SHOJI FELT A MINIMALISTIC APPROACH, INCORPORATING TRANSPARENCY AND A LINEAR BLEND OF BRILLIANT COLOR, BEST EXPRESSED ISSEY MIYAKE'S PLEATS PLEASE LINE OF FOLDED CLOTHING.

Designer Sayuri Shoji decided that simplicity best expressed Issey Miyake's Pleats Please line of unusually folded clothing. So she conceived a package design for the Pleats Please promotional CD that's devoid of imagery or headline text. A rainbow-colored design for the jewel case and a line of type directing recipients to the Pleats Please Web site is all that's needed to catch the eye and arouse curiosity.

To achieve transparency and brilliant color, Shoji had the rainbow effect offset printed on clear acetate as an insert for the front panel of the jewel case. The insert's subtle stripes suggest the pleats that are an important component of the Pleats Please clothing line. A transparent compact disc allowed the light to shine through the jewel case and its contents.

TO CREATE A HIGH-TECH LOOK FOR A WATCH DIRECTED AT YOUNG MALES, JAGER DI PAOLA KEMP ESTABLISHED A SPHERICAL THEME AND FUTURISTIC TYPOGRAPHY AS THE MAINSTAYS OF A LOOK THAT COULD BE TRANSLATED INTO THE PRODUCT'S DESIGN, ITS PACKAGING, AND ENCLOSURES.

CLIENT
Timex

DESIGN FIRM
Jager Di Paola Kemp Design

CREATIVE DIRECTOR
Michael Jager

ART DIRECTORS
Richard Curren, Ryan Widrig

DESIGNERS
James Lindars, Coberlin Brownell

For Timex, Jager Di Paola Kemp Design developed a new brand called Helix that's aimed at the core-action, extreme athlete who wants multiple functions and reliability. The JDK design team felt a high-tech look would best reflect the high-tech nature of the product and appeal to their sports-minded demographic, as well as to other young males.

The JDK design team conceived a spherical format for the watch face with a space-age sensibility. To carry the look established by the watch into its packaging, the designers came up with a spherical package with a clear, plastic bubble top that serves as a means of displaying the watch in the retail environment. The product brochure that's included with the Helix is even printed in a circular format to tie in with the other identity materials.

In addition to designing the watch and its packaging, JDK also developed the Helix logo.

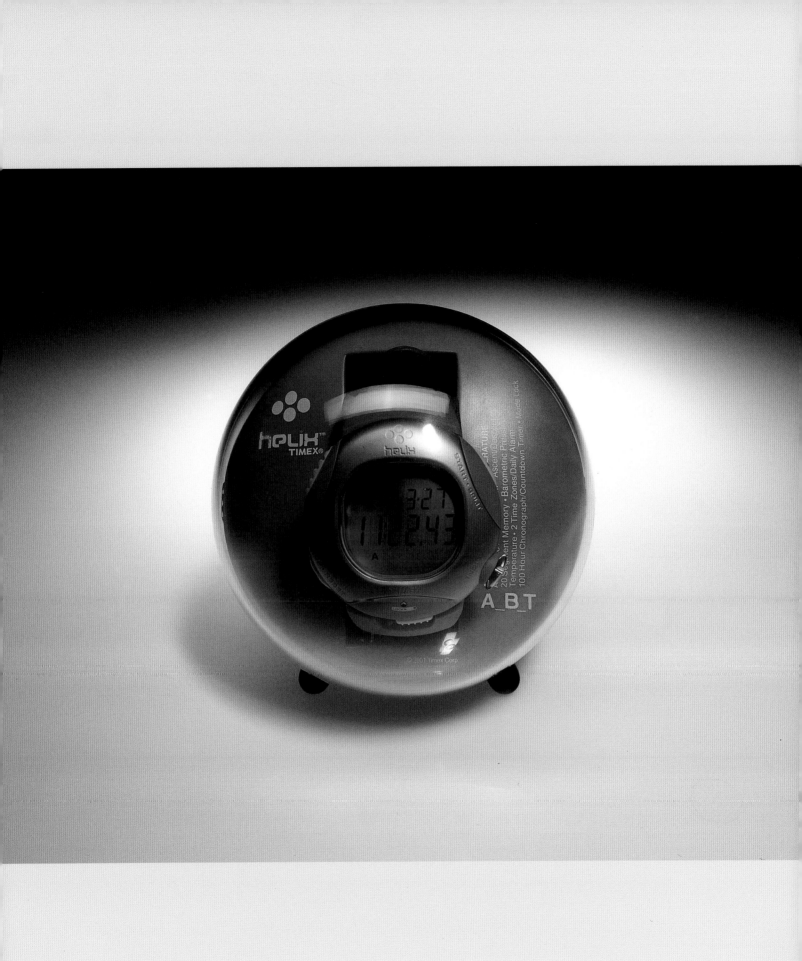

PROJECT
Fashion Identity

CLIENT
Dockers/Levi Strauss

DESIGN FIRM
Templin Brink Design

ART DIRECTOR
Gaby Brink

DESIGNERS
Gaby Brink, Jason Shulte

COPYWRITERS
Dann Wilkens, Jesse Zeifman

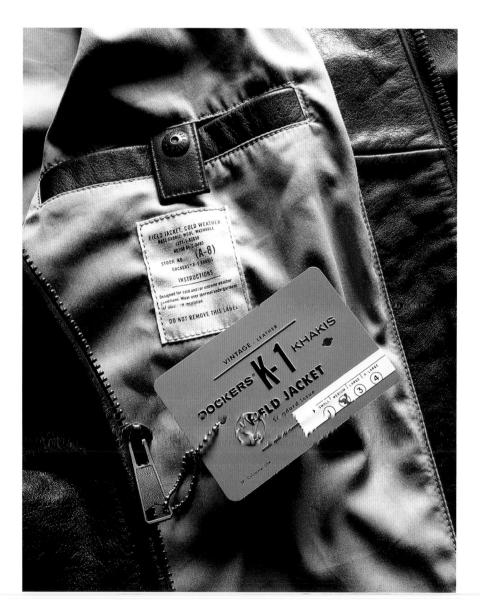

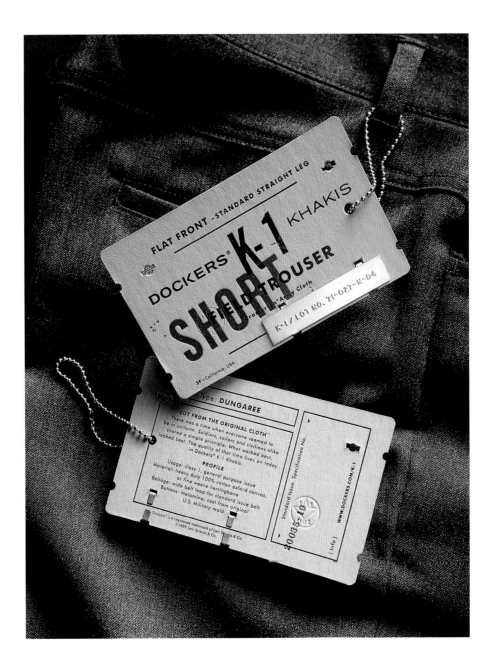

TEMPLIN BRINK'S BRAND IDENTITY FOR DOCKERS' K-1 LINE OF KHAKI GARMENTS TRANSLATES THE LOOK OF WORLD WAR II STANDARD-ISSUE GEAR INTO A FASHION IMAGE THAT WORKS ACROSS THE BOARD ON ALL FACETS OF THE BRAND'S APPLICATIONS, INCLUDING HANGTAGS, GARMENT LABELS—EVEN BUTTONS.

The identity for Dockers K-1 line of khaki garments has its roots in the origins of the fabric, when World War II GIs wore uniforms made of khaki. In fact, K-1's fashion designers actually looked at old, army-issued garments to fashion a line that allows for many applications of the K-1 identity, directly on the garments, as well as on hangtags and even buttons.

Templin Brink Design also followed the lead of the K-1 line's designers in their design of the K-1 identity and packaging, looking to the labels that appeared in World War II uniforms for inspiration. Their response was a no-nonsense, industrial look and copy that warns users to "not remove this label." Other phrases, such as "standard issue," support the theme and are handled as simply as the K-1 logo. Hangtags with metal ID numbers are attached to garments with beaded metal chains to accentuate their military/industrial look.

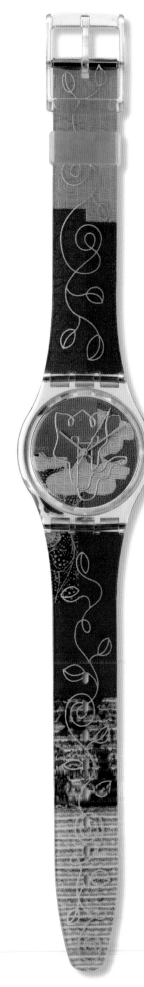

CLIENT
Swatch

DESIGN FIRM
Doppelgänger, Inc.

ART DIRECTOR
Adelina Bissolo

DESIGNER
Otto Steininger

ILLUSTRATOR
Otto Steininger

TRANSLATING THE SPIRIT OF INDIAN CULTURE INTO A WATCH DESIGN REQUIRED INJECTING MODERN FASHION SAVVY INTO TRADITIONAL INDIAN PATTERNS, COLORS, AND TEXTURES, AND ADAPTING THEM TO THE LIMITED AREA OF A WATCH FACE AND WRIST STRAPS.

Swatch is well known for producing a mix of art, design, and fashion in its watches. Achieving all of this, within the limited area of a watch face and wrist strap, was the challenge Otto Steininger faced when Swatch commissioned him to come up with a watch design with an Indian theme.

After researching Indian art, Steininger combined Mideastern-inspired motifs and textures into a digital collage with a vine-like motif that runs the length of both wrist straps. For a consistent look, an elephant head on the watch face is rendered in a similar manner. Steininger's energetic palette of blue, golds, and dark reds and contemporary illustration technique successfully blends new with old, bringing elements of India's rich heritage into a style-conscious venue.

CLIENT
Issey Miyake, Inc.

DESIGN FIRM
Sayuri Studio

ART DIRECTOR
Sayrui Shoji

DESIGNERS
Sayuri Shoji, Atsuko Suzuki

PHOTOGRAPHY
Shu Akashi, Sayuri Shoji

BREAKING AWAY FROM TRADITIONAL NOTIONS OF HOW A SHOPPING BAG SHOULD BE, AND THE LOGISTICAL CHALLENGES INVOLVED IN FABRICATING PLEATED VINYL SHOPPING BAGS, DIDN'T DETER DESIGNER SAYURI SHOJI FROM CREATING A CONCEPT THAT BEST CAPTURES THE INNOVATIVE SPIRIT OF FASHION DESIGNER ISSEY MIYAKE'S PLEATS PLEASE CLOTHING LINE.

Her client's request for something unusual and transparent led designer Sayrui Shoji to design these unusual pleated shopping bags for Issey Miyake's Pleats Please line of clothing. Rather than billboard the name of the clothing line, the shopping bags display the fashions themselves, reflecting the philosophy of simplicity and function that inspired the Pleats Please line.

As they are made of pleated polypropylene, the task of producing these unusual bags was a challenge. Shoji finally located Vinyl Technology, Inc., a company that specializes in the manufacture of plastic products, to produce the bags. The pleated plastic bags used no adhesives in their production, and when unfolded, echo Issey Miyake's clothing concepts. And, unlike most shopping bags, which are made of paper, these bags do a good job of showcasing the avant-garde fashion broker's line of colorful, pleated clothing.

□ □□□□ □ □ □

MOBILE GRAPHICS | 06

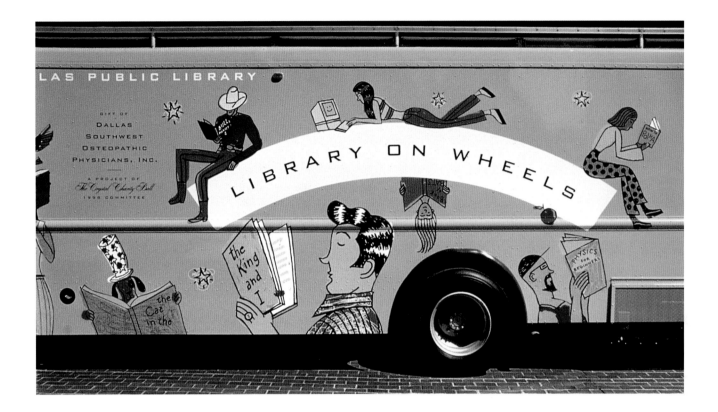

ADAPTING PEN-AND-INK ILLUSTRATIONS TO THE EXTERIOR OF A VAN
REQUIRED SULLIVAN PERKINS TO WORK CAREFULLY WITH A TEMPLATE OF
THE VEHICLE AND SOFTWARE THAT WOULD ENABLE LARGE-SCALE OUTPUT
WITHOUT LOSS OF CLARITY.

Dallas Public Library's "Library on Wheels" is a mobile ambassador to the local community, communicating its message of reading for knowledge and fun with lively illustrations of adults, children, and even pets enjoying books. The mobile library's bright colors and the contemporary illustration style of designer/illustrator Kelly Allen of Sullivan Perkins appeal to both young and old.

The theme of reading gave Allen the flexibility he needed to cover the thirty-six-foot-long van with a variety of individuals in a range of poses. Working with a photocopy template furnished to him by the van's manufacturer, Allen started with pen-and-ink drawings of each of the individuals. Allen scanned the renderings and brought them into a drawing program where color was applied. The vectorized illustration files were easily enlarged without loss of clarity when they were sent to be output as vinyl appliqués.

Allen chose a bright, eye-catching green as a background color for his illustrations. The printed and trimmed vinyl appliqués of each figure were then applied according to Allen's specifications to the green-painted van.

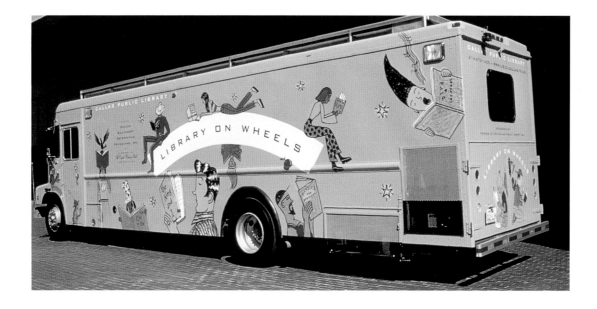

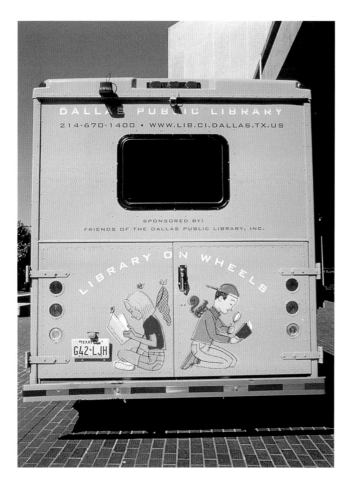

CLIENTS
Dallas Public Library/Friends of the Dallas
Public Library

DESIGN FIRM
Sullivan Perkins

DESIGNER/ILLUSTRATOR
Kelly Allen

WRITERS
Michael Langley, Mark Perkins

CLIENT
Urban Exposure Mobile Advertising

DESIGN FIRM
Sayles Graphic Design

ART DIRECTOR
John Sayles

DESIGNER
John Sayles

ILLUSTRATOR
John Sayles

DESIGNING A COLORFUL, EYE-CATCHING VAN PROVED TO BE THE BEST WAY FOR URBAN EXPOSURE TO PROMOTE ITS BUSINESS OF ADVERTISING THROUGH MESSAGE-BEARING VANS. SAYLES GRAPHIC DESIGN MET THE CHALLENGE BY DEVELOPING A LOGO THAT "POPS" ON THE VAN, WITHIN A PATTERN OF URBAN-THEMED IMAGERY.

Urban Exposure helps businesses create awareness of their products and services by offering them a chance to have their advertising message wrapped around a van. Of course, the company wanted to promote itself with its own fleet of message-bearing vans, so they contacted designer John Sayles to develop an identity for the firm that would work equally as well on letterhead and business cards as it would wrapped around a van.

The logo Sayles designed suggests that the vans drive through densely populated urban areas. (Urban Exposure claims to reach over two million people daily with each of their vans.) But creating a van to catch people's attention required much more than positioning the logo on a van. To create a colorful, eye-catching backdrop for the logo, Sayles incorporated illustrations of vans and people into a composition that suggests the urban landscape. Using a bright palette of primary colors, with touches of black and white, assured that the van would be noticed.

RIVES CARLBERG TRANSFORMS A SEMI INTO A MOBILE BILLBOARD FOR THE
HOUSTON CHRONICLE WITH A DESIGN THAT LINKS THE BOLD IMAGERY OF
A POPULAR COMIC STRIP CHARACTER WITH AN ADVERTISING THEME.

No ordinary semi promotes a newspaper in a way that grabs your attention quite the way the *Houston Chronicle* does with its comic depiction of a dog with a rolled newspaper in its mouth, borrowed from the comic strip "Mother Goose & Grimm," by Mike Peters. The truck trailer's design is the creation of Houston-based Rives Carlsberg.

Starting with a theme of "Touch the News That Touches You" led the Rives Carlsberg creative team to come up with the idea of showing a cartoon dog with a paper in its mouth with "A Touch of Humor" depicted as a torn headline. An exaggerated halftone dot was added to enhance the design's cartoon-like quality and provide a unifying backdrop between the dog and the tagline.

CLIENT
Houston Chronicle

DESIGN FIRM
Rives Carlberg

CREATIVE DIRECTOR
Gayl Carlberg

ART DIRECTOR
Michael Tucker

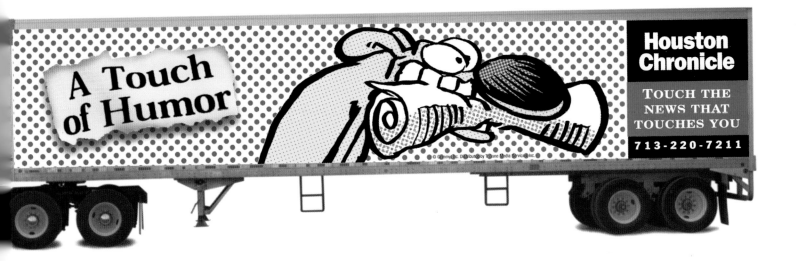

CLIENT/DESIGN FIRM
Kawasaki

KAWASAKI DEVELOPED A GRAPHIC APPROACH THAT
WORKS WITHIN THE CONFINES OF A MOTORCYCLE AND
ACHIEVES A SUCCESSFUL BLEND OF FORM AND FUNC-
TION BY INTEGRATING RACY GRAPHICS AND
ENHANCED AERODYNAMICS IN ITS DESIGN OF THE
NINJA ZX-12R SPORT MOTORCYCLE.

Designed by Kawasaki Japan, the Ninja ZX-12R sport motorcycle is the fastest motorcycle Kawasaki has ever built, attaining speeds of up to 199 miles per hour. It looks fast just sitting in the showroom.

The Ninja ZX-12R's speedy appearance is no accident. Arrow-shaped side mirrors and small wings to direct air coming off the front wheel are all part of its enhanced aerodynamic design. In fact, Kawasaki did such a good job of integrating appearance and performance, it's hard to determine how much of the design is based on pure visual appeal versus function. The Ninja ZX-12R also achieves an otherworldly look, thanks to twin headlights, shaped like a pair of alien eyes. Graphic applications on the bike, including its racy logo and "punk" colors of silver, pink, and lime green enhance its aggressive good looks.

CLIENT
Star Alliance

DESIGN FIRM
Pentagram

CREATIVE DIRECTOR
Justus Oehler

AN ALLIANCE OF FIFTEEN INDEPENDENT AIRLINES CALLED FOR A NEW
IDENTITY SYSTEM THAT RECOGNIZED THE NEW CORPORATION, AS WELL AS
ITS MEMBERS. PENTAGRAM MET THE CHALLENGE WITH AIRCRAFT GRAPHICS
THAT FEATURE THE LOGOS OF THE INDEPENDENTS AS WELL AS THAT OF THE
NEWLY FORMED CORPORATION.

The coming together of fifteen independent airlines prompted the newly formed alliance to seek advice from Pentagram's
London-based office on a new name and identity. Pentagram conceived the name of "Star Alliance" and developed a star-like
icon based on the star's long-standing, and internationally recognized, association with navigation and excellence, to serve
as the logo.

Pentagram's design team developed an identity system that incorporates the logos of the independent airlines. Because each
of the independents had significant equity invested its existing identity, Pentagram felt it was necessary to work them into a
system that recognized their autonomy and worked in tandem with the new alliance logo.

The new identity is best represented by the application of the independents' logos, like colorful postage stamps, on the fuse-
lage of the Star Alliance aircraft. The Star Alliance logo, appearing on the front of the aircraft and on its tail, anchors and
serves as a confirmation of the union of these entities.

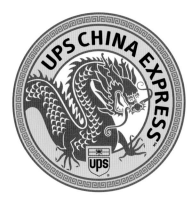

THE INAUGURAL FLIGHT OF UPS'S CHINA EXPRESS CALLED FOR GRAPHICS THAT COULD BE APPLIED TO ITEMS RANGING FROM TARMAC VEHICLES TO MUGS. DEEP DESIGN DEVELOPED A DRAGON MOTIF THAT COULD BE STRETCHED ALONG THE LENGTH OF AIRCRAFT FUSELAGE, OR WORK EQUALLY WELL RIDING ON A CIRCULAR EMBLEM ON PROMOTIONAL MERCHANDISE.

Establishing a business relationship with the People's Republic of China was an occasion for celebration for United Parcel Service. To mark the inaugural flight of the "China Express," UPS commissioned Deep Design to develop a special logo commemorating the event that could be applied to the aircraft, UPS tarmac trucks, and promotional merchandise such as T-shirts, hats, and mugs. In addition, the logo needed to appear as an official emblem on all of the press materials announcing the event.

The visual theme Deep Design developed for the China Express aircraft, trucks, and circular emblem focuses on a Chinese dragon, a symbol that the designers felt, after considerable research, would be most universally associated (by both Asians and Westerners) with China. The designers decided to illustrate a dragon's upper body and head as the primary component of the identity, using a portion of the dragon's tail to fill the vertical length of the airplane's fuselage. The identity also needed to be configured to work with the UPS logo on UPS trucks. "It was a lot of work to get it to fit everything," admits designer Heath Beeferman.

The designers chose a gold and red palette for the identity for their association with Chinese culture and because the colors provided a bright accent on UPS's black-and-white trucks and aircraft.

CLIENT
United Parcel Service

DESIGN FIRM
Deep Design

CREATIVE DIRECTOR
Rick Grimsley

ART DIRECTOR/DESIGNER
Heath Beeferman

ILLUSTRATORS
Heath Beeferman/Finished Art

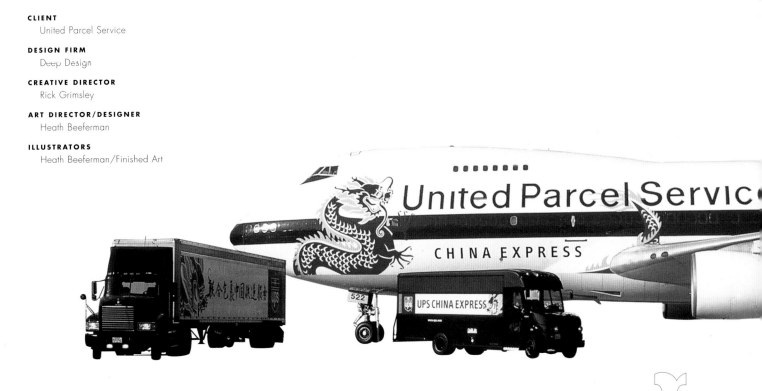

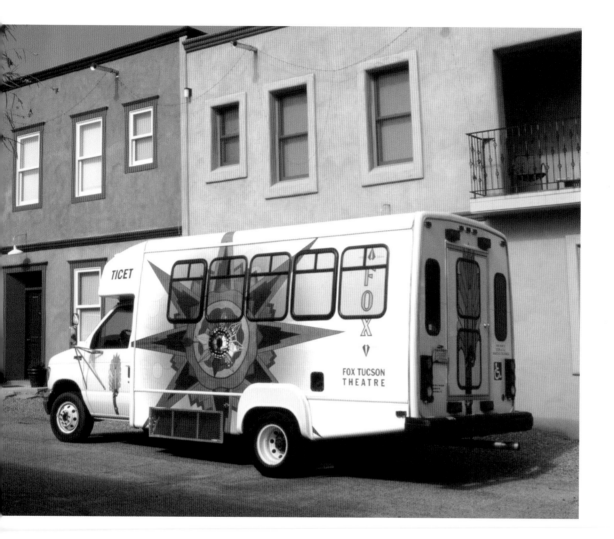

CLIENT
Fox Theatre

DESIGN FIRM
Boelts Bros. Associates

DESIGNERS
Kerry Stratford, Jackson
Boelts, Brett Weber

THE BASIS OF BOELTS BROS. ASSOCIATES' IDENTITY FOR AN ART DECO
THEATER BORROWS ELEMENTS FROM ITS ARCHITECTURE THAT ARE EASILY
ADAPTED TO A VARIETY OF APPLICATIONS. THE THEATER'S WALL SCONCES
FIT NICELY ON THE THEATER'S SHUTTLE VAN'S DOORS, WHILE ITS ELABO-
RATELY PAINTED CEILING MEDALLION FITS THE VAN'S ROOF AND SIDE
PANELS AS WELL AS THE TINY FORMAT OF LAPEL PINS.

Tucson's Fox Theatre, originally built in the 1920s, is undergoing a renovation to restore it to its original splendor. To help with
the restoration project, Boelts Bros. Associates created an identity for the theater that, in addition to appearing on stationery,
is featured on its shuttle van.

The Boelts Bros. design team looked to the Fox's art deco architecture as a theme for the identity, making the theater's dis-
tinctively painted ceiling and chandelier the focal point for their design scheme. Their adaptation of the theater's dramatic ceil-
ing is featured prominently on the shuttle van, along with adaptations of other art deco elements that appear within the theater.

The identity's medallion-like shape is particularly well suited to lapel pins, which were sold as a fundraiser.

CLIENT
W Hotels

DESIGN FIRM
Sayles Graphic Design

ART DIRECTOR
John Sayles

DESIGNERS
John Sayles,
Som Inthalangsy

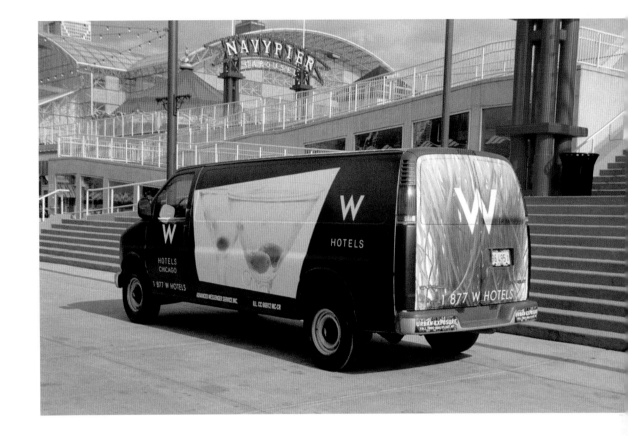

IN AN EFFORT TO PROMOTE W HOTELS AND REPEAT THE "W" THEME ON AN IMAGE-DRIVEN VAN, THE DESIGNERS AT SAYLES GRAPHIC DESIGN USED LARGE IMAGES THAT NOT ONLY WORKED WITH THE SHAPE OF THE VAN'S SURFACES, BUT GAVE THE VIEWER A TASTE OF THE PERSONALITY OF THE HOTEL.

With two hotels opening up in the Chicago area, W Hotels wanted to promote its identity in a subtle way by having a fleet of vans traveling around the city wrapped with aspects of its identity.

W Hotels' image is progressive and somewhat edgy, but also based on natural elements and simplicity. Designer John Sayles decided that a purely conceptual approach that suggested the hotel experience would be the best way to decorate the van. On the sides of the van, an asymmetrical image of two martini glasses reveals a hidden "W", while on the back of the van, blades of grass cross to form a "W". The simplicity of the images speaks volumes about the hotel chain's understated elegance and level of sophistication.

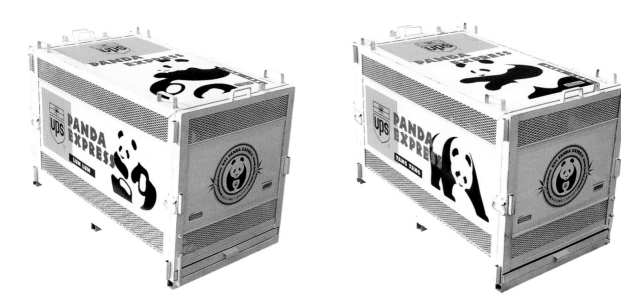

A GRAPHIC VOCABULARY BASED ON PANDA ICONS SERVED AS THE CONCEPT
FOR AN IDENTITY THAT WAS EASILY ADAPTED BY DEEP DESIGN TO PANDA
EXPRESS ITEMS RANGING FROM CRATES TO AIRCRAFT.

When the Chinese government donated two pandas to the Atlanta Zoo, United Parcel Service was entrusted with safely transporting the pandas from Beijing to Atlanta. The international interest generated by this event, and accompanying media coverage, prompted UPS to hire Deep Design to develop an identity for their "Panda Express" that could be applied to trucks, crates, and the aircraft used to transport the pandas.

Art directors Mark Steingruber and Rick Grimsley first designed an official-looking, emblem-like logo for the UPS Panda Express with a graphically reduced frontal view of a panda at the core of its circular format. From there, they developed a graphic vocabulary based on a series of black-and-white panda icons. The variety of poses and graphic similarity of the icons gave the designers a variety of options for decorating shipping crates as well as the black-striped airplane that carried the pandas. The designers created a palette of red, green, and yellow that coordinates with UPS's yellow logo and adds a bright accent to the black-and-white pandas and aircraft colors.

CLIENT
United Parcel Service

DESIGN FIRM
Deep Design

ART DIRECTORS
P. Mark Steingruber,
Rick Grimsley

DESIGNER/ILLUSTRATOR
P. Mark Steingruber

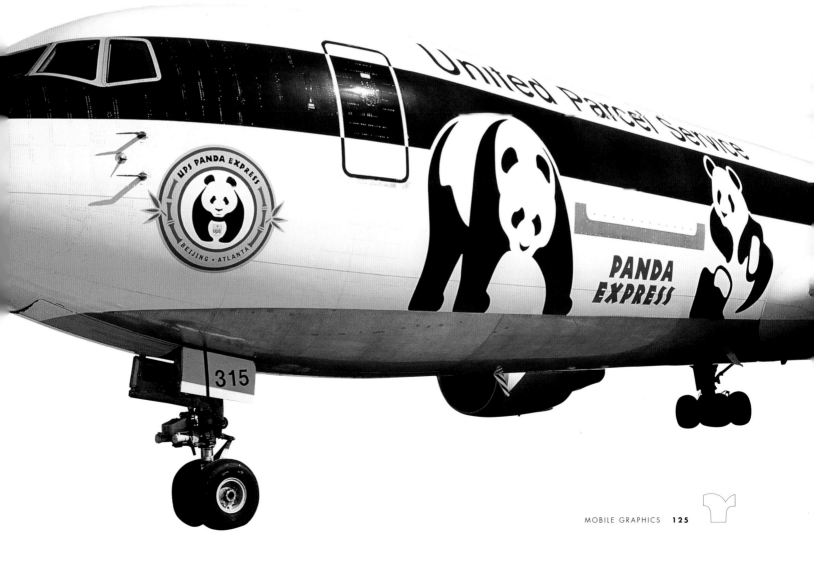

CONSUMABLES | 07

CLIENT
McKenzie River Corporation

DESIGN FIRM
Turner Duckworth

CREATIVE DIRECTORS
David Turner, Bruce Duckworth

DESIGNER
David Turner

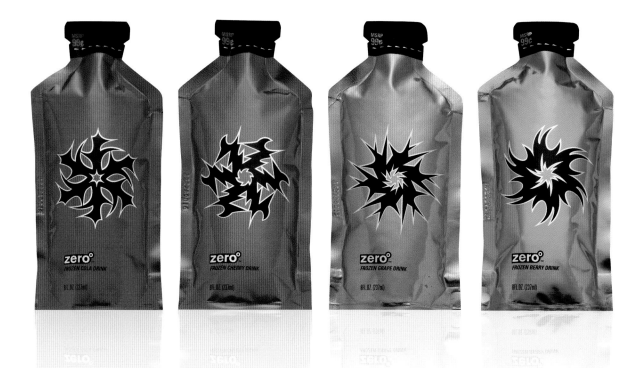

A NEW PRODUCT THAT NEEDED TO BE KEPT FROZEN, YET SQUEEZABLE,
REQUIRED A DESIGN APPROACH THAT APPEALED TO KIDS AND WORKED ON
AN OUT-OF-THE-ORDINARY FOIL CONTAINER.

The frigid nature of Zero°, a new frozen drink aimed at kids, is clearly communicated in its name. However, coming up with a "cool" name for the beverage was just one aspect of the brand identity Turner Duckworth created for their client.

One of the biggest challenges the design firm faced was developing graphics that would work on the client's choice of container: a foil pouch that would help maintain the beverage's frozen state and allow users to squeeze out its contents. Not only did the pouch lack rigidity, it's seamed sides and unusual shape prevented any wraparound graphics, and its flexible surface required flexo printing, a process that can create problematic image reproduction.

Turner and Duckworth's solution was to keep the design simple, designating a different symbol and colored foil for each of the four flavor varieties. The black-and-white symbols themselves suggest an unholy combination of snowflakes and Ninja throwing stars—an appropriate choice for the product's intended market.

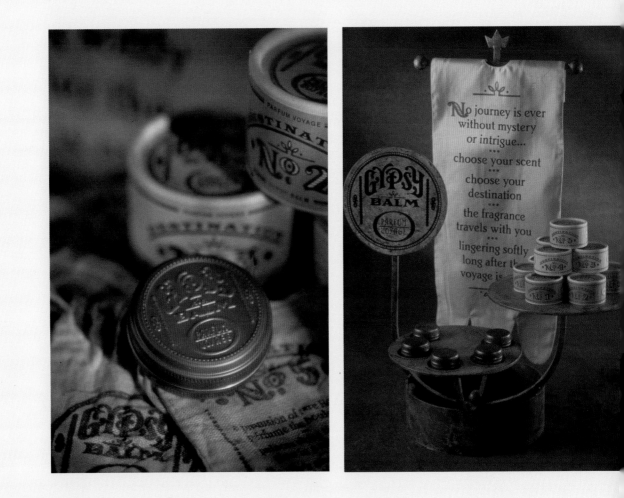

CLIENT
Gianna Rose

DESIGN FIRM
Sayles Graphic Design

ART DIRECTOR
John Sayles

DESIGNER/ILLUSTRATOR
John Sayles

HOW DO YOU CREATE STRONG SHELF PRESENCE FOR A TINY CONTAINER HOUSING JUST 0.4 OUNCE OF A HIGHLY CONCENTRATED FRAGRANCE? SAYLES GRAPHIC DESIGN'S IMAGINATIVE BRANDING AND PACKAGING SOLUTION TRANSLATES SEAMLESSLY ACROSS THE FRAGRANCE CONTAINER, ITS CLOTH BAG AND ONTO THE OUTER CONTAINER THAT HOUSES IT.

Sayles Graphic Design captures the restless spirit of the gypsy lifestyle with its brand identity and packaging design for Gypsy Balm, a perfume suspended in beeswax. But the design does much more than project a spirited image—the packaging for this product needed to contain, protect, and successfully market a product that would be sold in a quantity so small, that it wouldn't fill anything larger than a 0.4 ounce copper tin.

Working with such a tiny tin prompted firm principal John Sayles to contain it in a printed cloth bag. The bag, which features a short poem describing each of Gypsy Balm's five fragrances, adds to the perceived bottle of the product. To protect the product during shipping, provide a means of displaying, it and discourage shoplifters, Sayles designed a round box made of chipboard fitted with a paper band.

The circular format of the tin and box, the cloth bag, and the variety of materials involved in the packaging required Sayles to develop a design scheme that would work across the board. Because color would be limited (and non-existent in the case of the tin's molded lid) Sayles designed a distinctive logo based on curly, hand-lettered type that fits neatly on the circular lids of the outer container and tin and reads equally as well as an embossed as well as a printed image. Evolving the character of the logo into additional typographical applications provided the unifying element necessary to tying other elements of the packaging together.

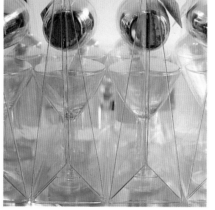

CLIENT
Tom Dixon/Habitat

DESIGN FIRM
Studio Myerscough

CREATING A CONSISTENT LOOK FOR A HOLIDAY LINE OF GIFT PRODUCTS OF ALL SHAPES AND SIZES REQUIRED DEVELOPING A CLEVER, EYE-CATCHING THEME AND APPLYING IT TO A PACKAGING CONCEPT THAT WOULD WORK EFFECTIVELY FOR A BROAD RANGE OF ITEMS.

For its 1999 holiday decorating and gift merchandise, Habitat wanted to package its products in ways that were appealing and thematically linked. With the dawning of the millennium, Studio Myerscough wanted to convey optimism for the future with a distinctive futuristic theme that immediately set Habitat's merchandise apart from other more traditionally packaged holiday fare.

The basis of the Habitat holiday packaging is tags and labels bearing the HAB99 logotype in techostyled type. A graphic theme of clean, non-obtrusive text and a simple palette of pale blue, red, and black is established with the tags and labels.

From there, firm principal Max Myerscough devised a minimal means of packaging the merchandise that allows for total visibility. Spices and coffee are packaged in totally transparent generic jars or space-age-shaped capsules with simple labels. Vacuum-formed clam packs and vacuum/heat-sealed packs were used for other merchandise, conveying the impression of freeze-dried food consumed on a space mission. The silver Mylar of the heat-sealed packs and jar lids also reinforce the packaging's new-age image of plastic and metal.

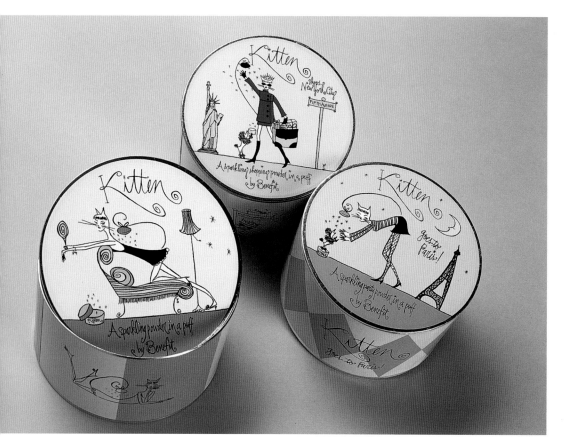

CLIENT/DESIGN FIRM
BeneFit

ART DIRECTOR
Armagh Cassil

DESIGNER
Hannah Malott

ILLUSTRATOR
Kelly Burke

A TOUCH OF WHIMSY AND WRAPAROUND GRAPHICS WITH A FASHION-FOR-
WARD ATTITUDE HELPED TO TRANSFORM ORDINARY CYLINDRICAL CONTAIN-
ERS INTO A LINE OF EXTRAORDINARILY FEMININE POWDER PACKAGING FOR
BENEFIT'S "KITTEN" POWDER-IN-A-PUFF PRODUCTS.

"We wanted a cute, 'girly' name," says BeneFit Cosmetics designer Hannah Malott of the name "Kitten" she and her creative
team conceived for a line of powder in a puff. From there, the Kitten brand evolved into a packaging concept that features
"Kitten" a female/feline hybrid brought to life by illustrator Kelly Burke. The Kitten logotype, a curly script also penned by
Burke, fits the ultra-feminine, contemporary look of the Kitten powder boxes.

The original Kitten powder puff depicts Kitten lounging on a chaise on its lid. Since then, BeneFit has introduced two addi-
tional powder puff products. The creative team chose to invent names and packaging concepts for the new products that depict
Kitten in other venues. Kitten Goes to Paris is described as a "party powder," while Kitten Shops New York City is called a
"shopping powder."

In addition to featuring a color illustration of Kitten on each of the box's circular lids, a thematically linked pen-and-ink illus-
tration of Kitten appears on the side of each cylindrical container along with a description of the product, rendered in the same
style as the logo. To further unify the concept, the pastel palette established on each of the box's lids is carried onto the sides
of the boxes with patterns of stripes and diamonds.

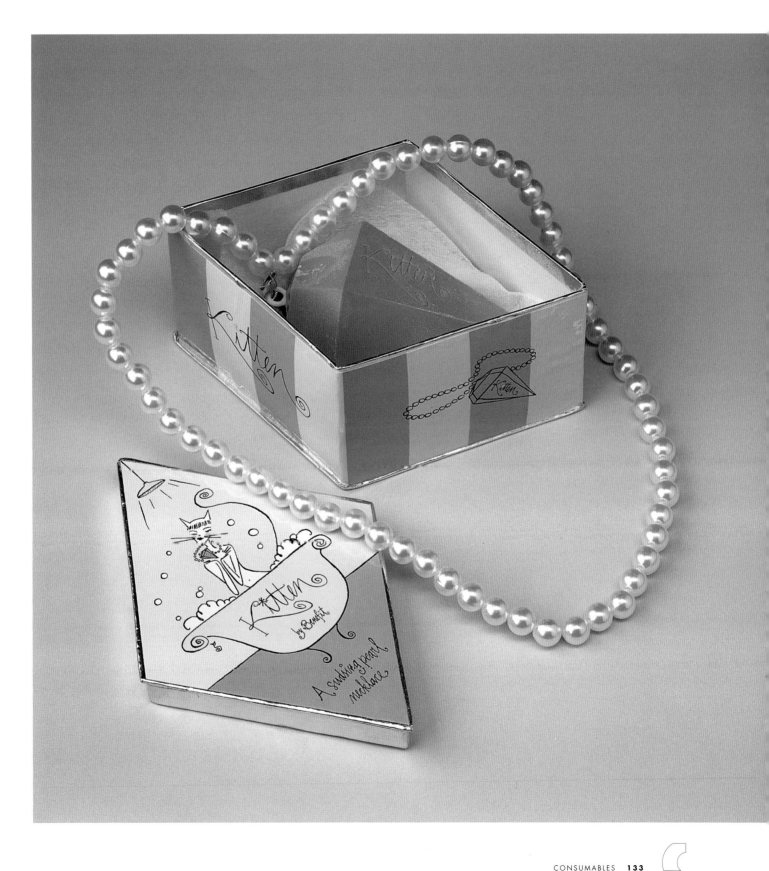

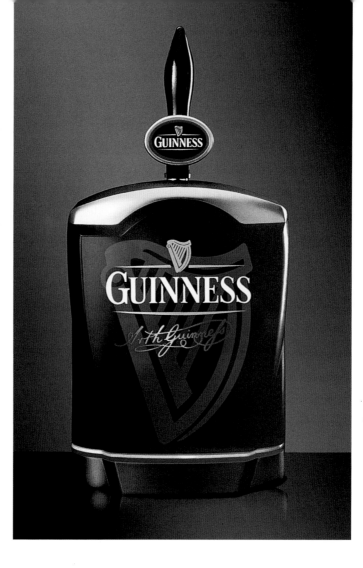

CLIENT
Guinness

DESIGN FIRM
Primo Angeli Inc.

ART DIRECTOR
Primo Angeli

DESIGNERS
Coco Qui, Oscar Mulder,
Kelson Mau

WHEN IT COMES TO SELLING BREW TO YOUTHFUL CONSUMERS, DON'T DIS-MISS THE POWER OF THE BEER PUMP. PRIMO ANGELI HELPED GUINNESS REJUVENATE SALES OF ITS DRAFT BEER BY SUCCESSFULLY ADAPTING THE BREWERY'S LOGO AND BRAND ATTRIBUTES TO THE ODD SHAPE AND IRREG-ULAR SURFACE OF ITS BEER PUMPS.

When Primo Angeli Inc. was retained by Guinness to upgrade its brand identity, the Dublin-based brewery wanted to appeal to a more youthful consumer. Guinness feared that Ireland's youth was increasingly turning to American lagers, dismissing the venerable Guinness brand as the preferred brew of their parents.

Because Irish youth are drawn to the social atmosphere of the pubs, one of the most prominent places to display the revamped Guinness brand was on the beer pump. In fact, developing a more youthful presence for Guinness exclusive to this environment and its marketing of Guinness Draught allowed Guinness to retain its original brand identity, for its traditional bottled beer which appealed to a more mature demographic.

The Primo Angeli design team took the Guinness logotype and displayed it prominently in an oval on the pump's handle as well as its base. The Guinness harp, an important feature of the brewer's identity, was reconfigured in a more contemporary style. For appetite appeal, the design team fashioned the overall shape of the pump to resemble that of a mug of beer, even adding a golden cup to suggest a foamy head.

HORNALL ANDERSON DESIGN WORKS MAKES THE MOST
OF AN UNUSUAL CLIENT REQUEST BY CREATING A PACK-
AGING CONCEPT AND POINT-OF-PURCHASE STRATEGY
THAT FOCUSES ATTENTION ON THE CIRCULAR LID OF A
HEXAGONALLY SHAPED JAR.

When Sticky Fingers Bakery decided to market a line of bakery jams to be sold in specialty stores and via mail order, the company researched various glass container shapes and decided on a hexagonal jar as a container for its jams. Although the bakery's choice of this unusual jar gave their product an upscale, boutique look, its lack of a front panel presented somewhat of a challenge to the designers at Hornall Anderson Design Works.

The designers soon realized that the jar's lid offered as much visibility for billboarding the Sticky Fingers Brand as the jar's sides. With this in mind, they designed a circular lid label bearing each jam flavor with a coordinated fruit illustration. The Sticky Fingers name and the jam flavor also appears on a label that wraps around three of the jar's sides. Hangtags with diagonally cropped corners reinforce the Sticky Fingers brand name and the angles of the faceted jar. The labels and hangtags are coordinated with an accent color and fruit illustration for each flavor.

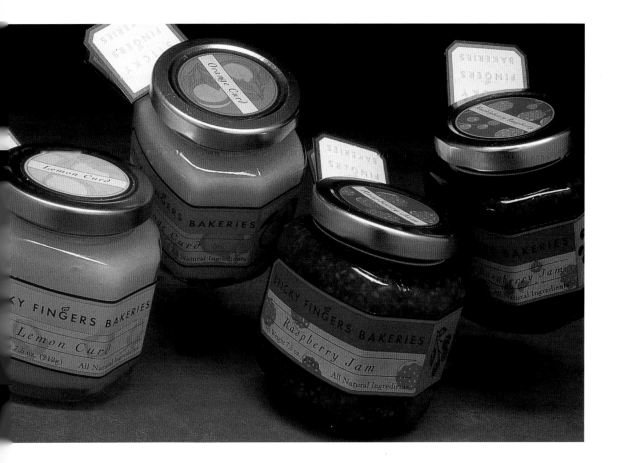

CLIENT
Sticky Fingers Bakery

DESIGN FIRM
Hornall Anderson Design
Works

ART DIRECTOR
Jana Nishi

DESIGNERS
Jana Nishi, Sonja Max

CLIENT
Sephora/Sterling Group

DESIGN FIRM
Sayuri Studio

ART DIRECTOR
Sayuri Shoji

DESIGNER
Sayuri Shoji

PHOTOGRAPHY
Sayuri Shoji

WHEN FACED WITH THE PROSPECT OF DESIGNING PACKAGING FOR A LINE
OF FLOATING CANDLES, SAYURI SHOJI DECIDED TO LET THE PRODUCT
SHOWCASE ITSELF WITH A MINIMAL PACKAGING CONCEPT THAT CAPITAL-
IZES ON THE CANDLES' TRANSPARENCY AND SIMPLICITY OF DESIGN.

The colorful and transparent quality of Floats floating candles inspired designer Sayuri Shoji to con-
ceive a package design that would allow the beauty of the candles to shine through. Her solution
was a transparent, U-shaped plastic clamshell for the candles that was easily adaptable to packag-
ing single candles as well as color-coordinated groups of three.

Product identification and information was handled sparingly, confined to the sealed end of the pack-
age. The clean and simple handling of the black-printed text is in step with the streamlined simplic-
ity and clarity of the Floats product and its packaging concept.

CLIENT
H₂O

DESIGN FIRM
Sayuri Studio

ART DIRECTORS
Sayuri Shoji,

Cindy Melk

DESIGNERS
Sayuri Shoji,

Cindy Melk

INSTEAD OF DESIGNING A PRINTED LABEL BEARING A LOGO TO BE PLACED ON A PERFUME BOTTLE, DESIGNER SAYURI SHOJI DEVELOPED A PACKAGING CONCEPT THAT CREATES A PHYSICAL REPRESENTATION OF THIS FRAGRANCE'S BRAND ATTRIBUTES.

The connotations of fluidity associated with the H₂O name, and the desire to appeal to an upscale clientele with an avant-garde packaging concept, led designer Sayuri Shoji and H₂O president Cindy Melk to collaborate on a packaging concept for the perfume that's really a layered container. The bottle that contains the fragrance is housed inside a thin-plastic outer container that contains blue-colored oil suspended in water.

To make their concept viable, Shoji had to find two cylindrical containers with straight vertical sides to facilitate the flow of the oils in water. The simplicity of the cylindrical bottles also reinforced the simplicity of the H₂O packaging concept.

Because brand identification was built on the visual interest and engaging interactivity prompted by the bottle's design, developing a logo wasn't an important factor for H₂O. Shoji handled the H₂O name as unobtrusively as possible, setting it to run vertically from top to bottom on the interior bottle that houses the fragrance. The fragrance is shipped and sold— unencumbered by any obvious, outer packaging—in a clear, plastic case.

CLIENT
Dori Feeding Products

DESIGN FIRM
Brand Group

DESIGNER
Claudio Novaes

ALTHOUGH DORI OFFERS A CONSISTENT LINE OF SNACK FOODS, THEIR PRODUCTS NEEDED TO BE MARKETED DIFFERENTLY TO CHILDREN THAN TO ADULTS. THE BRAND GROUP RESPONDED BY DEVELOPING A FLEXIBLE SYSTEM OF DIFFERENT BRAND AND PACKAGING CONCEPTS FOR CHILDREN AND ADULTS BASED ON A LOGO THAT RETAINS ITS PROMINENCE WHEN ADAPTED TO A VARIETY OF COLOR AND PACKAGING APPLICATIONS.

Most important to developing a brand identity for Dori snacks was designing a colorful and fun-oriented logo that would work on bags containing adult and children's versions of Dori's products. Although the kid's version of Dori's snacks features cartoon characters, Brand Group's Claudio Novaes developed a brightly colored logo and palette that's consistently applied to both the adult and kid's lines of snacks, as well as a windowed format for the bags that features a scalloped edge at the bottom of the bag.

The Dori logo, with its letters formed from brightly colored circles, provided a graphic vocabulary that could easily be adapted to other identity applications including Dori's transport vehicles, where the circular letters on the Dori slogan are filled in with the brand identity's color. Scalloped edges at the top and the bottom of the truck's trailer complete the identity application.

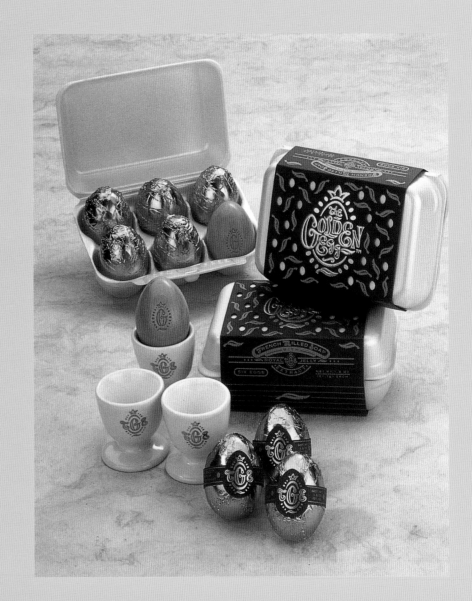

CLIENT
Gianna Rose Atelier

DESIGN
Sayles Graphic Design

ART DIRECTOR
John Sayles

DESIGNER/ILLUSTRATOR
John Sayles

COMING UP WITH AN EFFECTIVE PACKAGING CONCEPT FOR A LINE OF EGG-SHAPED SOAPS CHALLENGED JOHN SAYLES TO DEVELOP A DESIGN THAT WOULD WORK ON AN OVAL FORMAT. SAYLES TOOK HIS LEAD FROM THE PRODUCT'S SHAPE, DESIGNING AN ELEGANT VERSION OF AN EGG CARTON AS PACKAGING FOR THE SOAP LINE.

Many of us are accustomed to decorating Easter eggs, but beyond that, we have little experience dressing up eggs for display. However, John Sayles of Sayles Graphic Design has the Midas touch when it comes to designing packaging for eggs, as in the case of his design for Golden Egg, a line of perfumed soaps. Sold at upscale retail stores, the line of egg-shaped soaps gets its name from the fairy-tale treasure of the same name.

"The upscale nature of the product called for unusual yet elegant packaging," says Sayles, who gave his packaging choice of an egg carton a dose of elegance with its embossed, foil-stamped wrap. Sayles chose a regal, purple and gold palette to perpetuate the fairy-tale image.

"Sometimes the solution to a packaging problem is obvious," says Sayles. "Don't be afraid to go down the road that at first seems cliché."

SOUVENIR AND PROMOTIONAL MERCHANDISE | 08

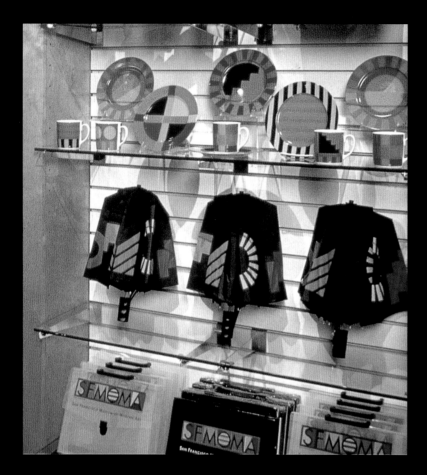

SAN FRANCISCO MUSEUM OF MODERN ART

CLIENT
San Francisco Museum of Modern Art

DESIGN FIRM
Michael Osborne Design

ART DIRECTOR
Michael Osborne

DESIGNER
Michael Osborne

A GRAPHIC SYSTEM OF MODULAR UNITS FOR THE SFMOMA LOGO WORKS
EQUALLY AS WELL BROKEN DOWN INTO SINGULAR UNITS OR SPELLED OUT.
THE APPROACH ALLOWED FOR A RANGE OF APPLICATIONS ON SOUVENIR
MERCHANDISE.

The distinctive, contemporary architecture of the San Francisco Museum of Modern Art (SFMOMA) built in 1995, soon established it as a major tourist destination. As the museum's popularity has grown, its Museum Store has become equally popular as a shopping venue for locals as well as tourists.

To capitalize on the museum's popularity, SFMOMA commissioned Michael Osborne Design to design a mark that could be put on a line of its own souvenir merchandise, including mugs, tote bags, and umbrellas. The firm's designers took their lead from the building's architecture, creating a series of letterforms based on elements of the building, to spell out SFMOMA.

Although they work well together forming the SFMOMA logo, the graphic appeal inherent in the unusual letterforms allows each to function equally as well alone, as a graphic element on an umbrella panel or on a shopping bag. The logo's letterforms have also inspired a line of designer plates and matching mugs that echo the identity's bright colors.

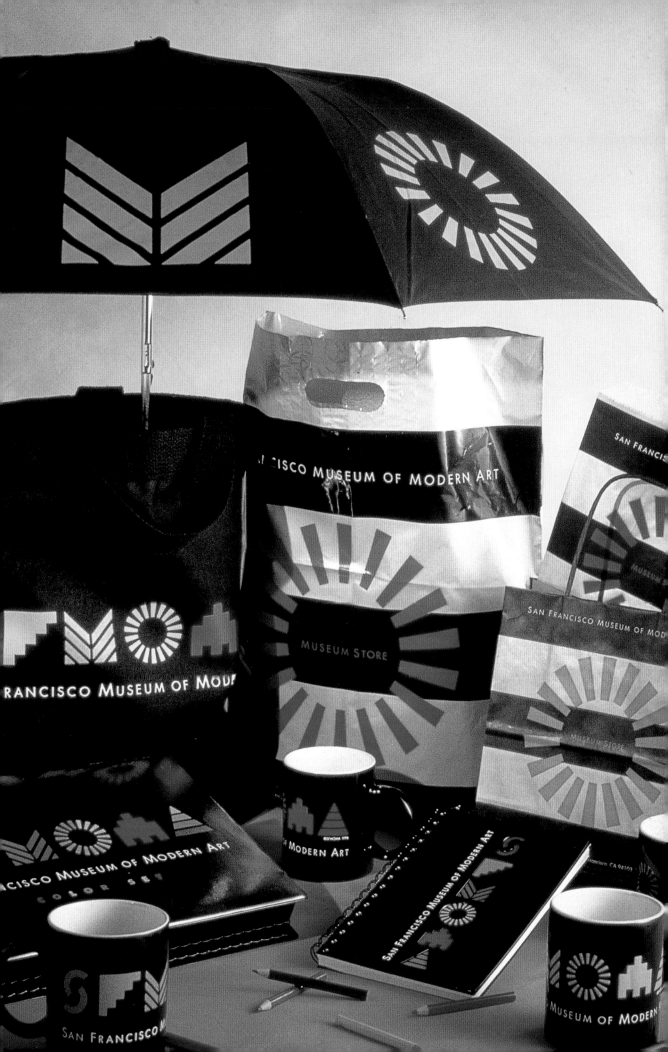

CLIENT
Canal City

DESIGN FIRM
Selbert Perkins Design Collaborative

CREATIVE DIRECTORS
Robin Perkins, Clifford Selbert

TIME, NATURE AND THE UNIVERSE PROVIDED A GRAPHIC THEME FOR A FLEX-
IBLE IDENTITY SYSTEM THAT COULD BE UNDERSTOOD BY AN INTERNATIONAL
AUDIENCE AND APPLIED TO A VARIETY OF SOUVENIR ITEMS SOLD WITHIN
THIS JAPANESE URBAN CENTER.

Canal City, a mixed-use urban center based in Fukuoka, Japan, was built with the concept of cre-
ating an image theme that would appeal to an international audience and work in every facet of
the center's design, from architecture to souvenir merchandise. Working as part of a design term that
included architects, environmental designers, landscape architects, and water feature and lighting
designers, Selbert Perkins Design Collaborative was involved in brainstorming a concept for Canal
City that would appeal to a universal audience. "We collectively came up with the idea that this
place would be a walk through the Universe or a celebration of time and space and our galaxy,
says firm president Robin Perkins. From there, the design firm developed a logo that communicates
this concept.

Other elements in the Center include time- and nature-based sculptures, bearing interplanetary motifs.
The graphic elements of the logo, and sculpture-inspired icons, provided a wealth of graphic possi-
bilities that appear on a variety of souvenir items, ranging from umbrellas to teacups, which are sold
in a shop within the urban center. The design team came up with designs for a total of sixteen prod-
ucts and within each product category as many as ten different designs.

CLIENT
Hewlett Packard

DESIGN FIRM
Olika

CREATIVE DIRECTOR
Lori Siebert

DESIGNERS
Lisa Ballard, David Carroll,
Barb Natulionus

PROMOTING A CORPORATE CONFERENCE HELD IN HILTON HEAD CHAL-
LENGED OLIKA TO DEVELOP NAUTICALLY THEMED ICONOGRAPHY THAT
COULD BE ADAPTED TO A VARIETY OF PROMOTIONAL AND MERCHANDISE
APPLICATIONS. THE DESIGNERS RESPONDED WITH AN IDENTITY THAT
COULD BE EXPANDED UPON TO SUIT BANNERS AND VERTICALLY FORMATTED
GEAR, AND BROKEN DOWN INTO A MEDALLION THAT SUITED SMALLER
APPLICATIONS.

When Hewlett Packard held its annual developers meeting in Hilton Head, the
company wanted an identity for the conference that would work equally as well on
banners and binders as it did on merchandise giveaways for attendees. Olika was
hired to develop an identity that would convey a sense of the conference's "Partners
in Progress" theme as well as the relaxed, seaside atmosphere of the Hilton Head
resort site.

The Olika design team started by designing a logo that suggests a man and woman working together to sail a ship. The medal-
lion-like logo works well alone on sport shirts and a brief case that contained conference materials. To create a version of the
logo that would work on a the vertical format of a beach towel and banners, the Olika design team created a star-and-ban-
ner configuration with the conference's name and linked it with the logo with a series of stripes. The stripes, which are print-
ed in a variety of paired combinations from the logo's palette, serve as a unifying element for the suite of materials, appearing
on merchandise hangtags as well.

CLIENT
Grauman's Chinese Theater

DESIGN FIRM
Smullen Design Inc.

CREATIVE DIRECTOR
Maureen Smullen

DESIGNERS
Maureen Smullen, Amy Hershman, Jim Brazeale

ALL ASPECTS OF HOLLYWOOD'S GRAUMAN'S CHINESE THEATER COME INTO PLAY IN A FLEXIBLE SYSTEM OF ICONOGRAPHY THAT CAN BE APPLIED TO SOUVENIR MERCHANDISE RANGING FROM MUGS TO JACKETS.

Smullen Design's identity concept for Hollywood's Grauman's Chinese Theatre's is based on its famous celebrity sidewalk, where stars leave their hand- and footprints, as well as its distinctive architecture. "That's the most unmistakable image of the Chinese Theatre," says firm principal Maureen Smullen, adding that tourists don't need an address—they find the theater by recognizing its pagoda-like facade. Smullen and her design team developed a basic, circular logo for the theater that features a rendering of its pagoda-style architecture with spotlights beaming into the sky and a suggestion of its celebrity sidewalk in front.

Although the theater's architecture served as the basis for Smullen's initial concept, repeating it on the broad range of souvenir merchandise sold in the theater's gift shop wouldn't have given shopper's a variety of options. For added visual interest, Smullen and her design team incorporated other iconography into the identity, based on the theater's interior fixtures. A Chinese dragon, inspired by an oriental rug, wraps around the circular logo and rides alone on smaller merchandise such as watches. A flame-like motif, inspired by a sconce, encircles the logo on other merchandise applications.

Because another important aspect of the theater's identity is its famous sidewalk of celebrity hand- and footprints, Smullen and her design team created another graphic motif that focuses on the celebrity sidewalk, showing imprints in reverse against a rectangular configuration of text. This additional element rides on the reverse side of mugs, and serves as another application on T-shirts and other popular merchandise.

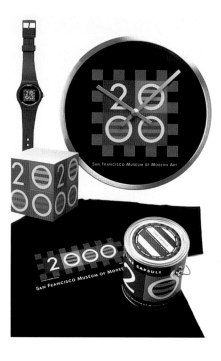

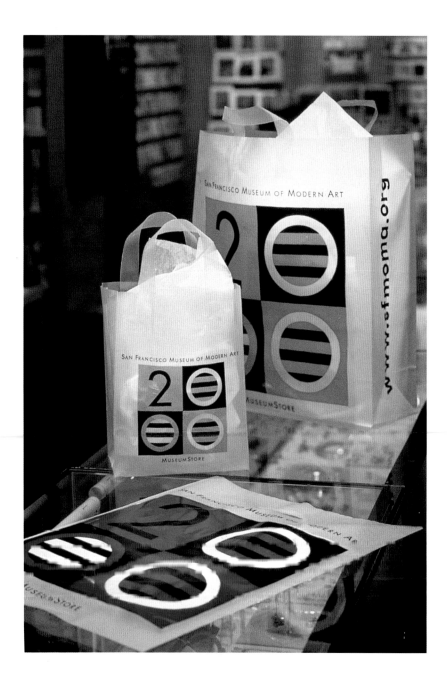

CLIENT
San Francisco Museum of Modern Art

DESIGN FIRM
Michael Osborne Design

ART DIRECTOR
Michael Osborne

DESIGNER
Michelle Regenbogen

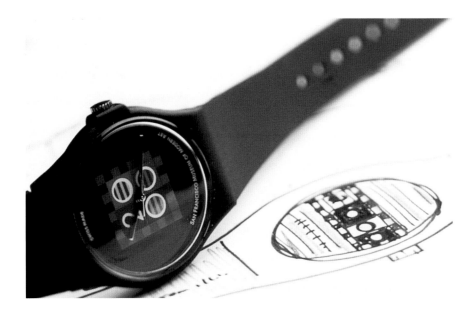

CELEBRATING THE NEW MILLENNIUM AT SFMOMA SPAWNED THE CREATION OF SPECIALTY SOUVENIR MERCHANDISE THAT WAS VISUALLY LINKED WITH THE MUSEUM'S OTHER SOUVENIR MERCHANDISE. MICHAEL OSBORNE DESIGN CREATED A 2000 LOGO THAT COORDINATES WITH SFMOMA'S EXISTING IDENTITY AND WAS EASILY ADAPTED TO A RANGE OF MERCHAN-DISE APPLICATIONS.

The success of branded merchandise for the San Francisco Museum of Modern Art (SFMOMA), designed by Michael Osborne Design, prompted museum officials to commission the design firm to come up with a new logo and merchandise to celebrate the new millennium. Taking its lead from the bright colors and geometry of the SFMOMA logo, the firm's designers came up with a "2000 logo" that would appeal equally as well to shoppers responding to merchandise bearing a high design aesthetic.

In addition to notepads, T-shirts, hats, and other souvenir merchandise applications, the designers also wanted to develop designs for time-related merchandise such as clocks and watches. The geom-etry of the logo's numerals imposed on squares offered a perfect opportunity for creating a stacked arrangement that forms a square. The square configuration worked beautifully on the circular format of the clock and watch as well as a memo cube. Elements of the logo, such as the bright stripes within its zeros, served as additional graphic elements that could be placed on the lid of a paint can, as well as other applications.

CLIENT
Portland Institute of Contemporary Art (PICA)

DESIGN FIRM
Plazm Design

ART DIRECTORS
Joshua Berger, Niko Courtelis, Pete McCracken

DESIGNERS
Joshua Berger, Niko Courtelis, Pete McCracken, Sung Choi

COPYWRITER
Steve Sandoz, Wieden & Kennedy

PHOTOGRAPHY
Susan Seubert

ARCHIVAL PHOTOGRAPHY
Sally Schoolmaster

ARCHITECTURAL DRAWINGS
Brad Cloephil, Allied Works Architecture

PRODUCTION COORDINATOR
Dennis Frasier, Wieden & Kennedy

CREATING A PRESENTATION PIECE BASED AROUND RAW CONSTRUCTION MATERIALS WAS NO SMALL FEAT, BUT PLAZM'S CLEAN DESIGN PERFECTLY COMPLEMENTED THE SIMPLICITY OF THE MATERIALS AND RESULTED IN A BEAUTIFUL PACKAGE.

When the Portland Institute of Contemporary Art (PICA) contacted Plazm Design, they were looking for a dual-purpose campaign that would educate the community on its efforts and stimulate fundraising among its three target groups (high-end donors, mid-range, and small, individual contributors). Plazm's design team used the organization's move to a new space as the vehicle for their campaign materials, using construction as a visual metaphor.

Fifty high-end givers who merited an in-person presentation were given a special leave-behind box created by Plazm. "The box was labeled 'building' and inside, prospective donors found individually labeled, pre-cut plexi shapes and wood blocks scavenged from the construction site," says Plazm principal, Joshua Berger adding that the items in the box provided a hands-on connection with PICA's new home. When the blocks are removed from the box, prospective donors are presented with the question, "What is PICA?" Of course, the box's contents and other presentation materials provide the answer.

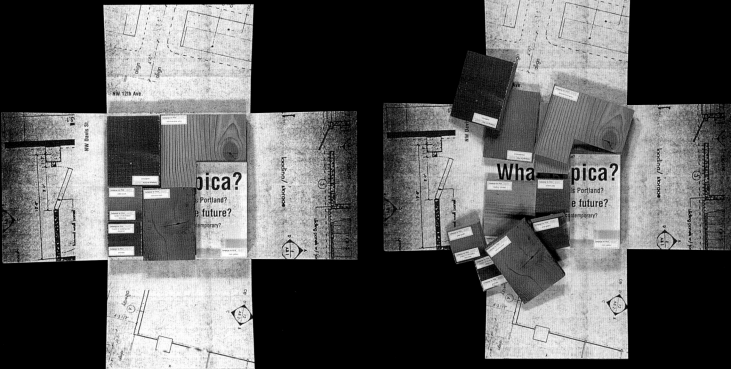

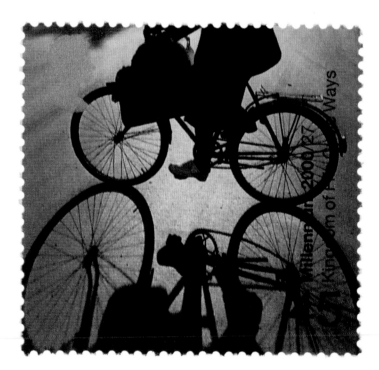

OTHER APPLICATIONS | 09

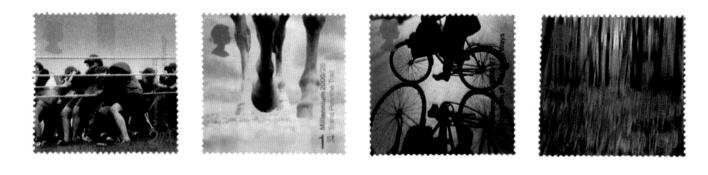

CLIENT
Royal Mail

DESIGN FIRM
Pentagram

CREATIVE DIRECTOR
David Hillman

DESIGNER
Deborah Osborne

CAPTURING THE SPIRIT OF GREAT BRITAIN ON A SERIES OF POSTAGE STAMPS CHALLENGED PENTAGRAM TO DEVELOP PHOTOGRAPHIC IMAGERY THAT SPEAKS VOLUMES OF BRITAIN'S HERITAGE AND FUTURE WITHIN A TINY FORMAT.

To celebrate the millennium, the British Royal Mail invited Pentagram to design a set of photographic postage stamps. Various themes were chosen to celebrate and promote millennium-funded projects covering a wide range of subjects, all of which have laid foundations for the future. Themes included conservation, regeneration, environmental awareness, public spaces, and the documentation of historic events.

Hillman and his creative team commissioned, briefed, and art directed the photographers for the stamps, which were released in monthly succession during 2000.

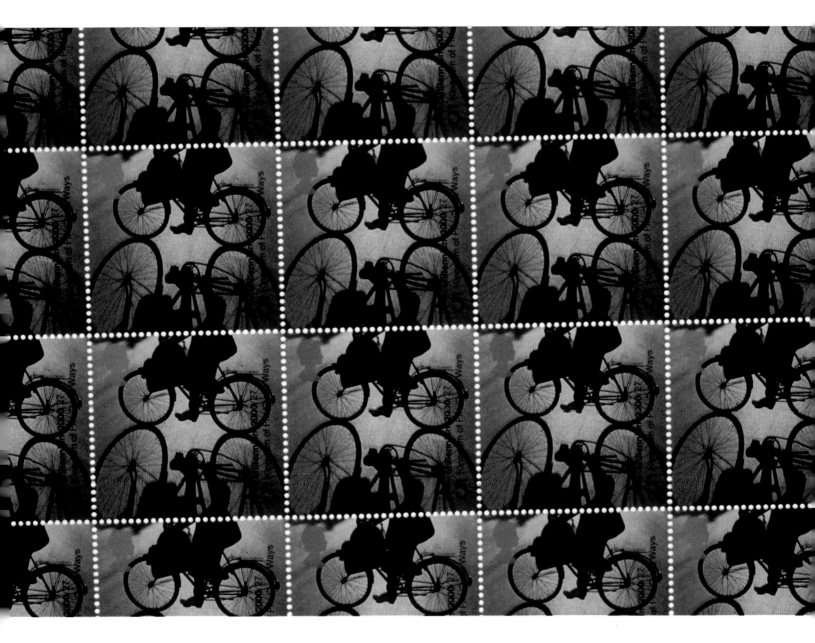

CLIENT
P. Puff Industries

DESIGN FIRM
Haley Johnson Design Company

ART DIRECTOR
Haley Johnson

DESIGNER
Haley Johnson

ILLUSTRATOR
Haley Johnson

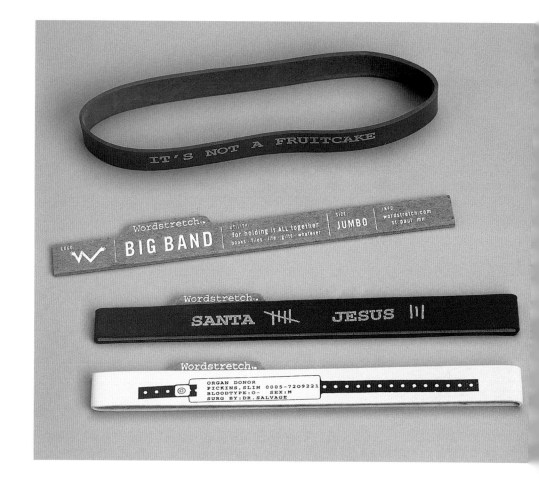

DESIGNER HALEY JOHNSON DECIDED THAT A BIG RUBBER BAND IS BEST PACKAGED WITHOUT A CONTAINER AND DEVISED, INSTEAD, ON STRETCHERS MADE FROM HEAVYWEIGHT CHIPBOARD TO REINFORCE THE UTILITARIAN NATURE OF THE PRODUCT.

Q: How do you package something as basic as a big rubber band?

A: With nothing. Something as useful and versatile as a rubber band is better off showcasing itself, especially when it has something to say.

After eliminating traditional rubber band packaging options such as bags and cartons, designer Hayley Johnson came to this conclusion when conceiving a logo and packaging concept for Wordstretch, a collection of rubber bands printed with witty sayings. Her solution was to come up with a stretcher bearing her client's logo and message on the stretcher itself and an index tab that's visible above the rubber band. The stretchers reinforce the rubber band's usefulness, without obliterating their message.

Because rigidity was an issue, Johnson had the stretchers die-cut out of heavyweight chipboard and foil stamped in silver with her client's name and message. The no-nonsense look of the industrial chipboard helped to reinforce the utilitarian nature of the Wordstretch Big Band.

CLIENT
Girl Babies, Inc.

DESIGN FIRM
Haley Johnson Design Company

ART DIRECTOR
Haley Johnson

DESIGNER
Haley Johnson

ILLUSTRATOR
Haley Johnson

CREATING SHELF APPEAL FOR SOMETHING AS BASIC AS CHALK AND SPONGES REQUIRED AN INNOVATIVE MARKETING APPROACH BASED ON HUMOR, MINIMAL PACKAGING, AND A RETRO LOOK.

There's nothing handier than a sponge or a piece of chalk. Smart Women emphasizes the usefulness of these items with humor and a retro look that gives them far more shelf appeal than more traditional packaging approaches.

Smart Women's package designer, Hayley Johnson, started by using an ad-driven script typeface for the Smart Women logo. A wraparound, two-color band with "Smart Women rise to the occasion," and a retro-style illustration was all that was needed to package a self-rising sponge. Sticks of chalk are packaged in a similar manner: shrink-wrapped in plastic beneath the paper band.

Despite the low-budget, utilitarian look of the packaging, these products are sold over the Internet and specialty shops as sophisticated gift items.

CLIENT
RiverSoft

DESIGN FIRM
@KA

ART DIRECTOR
Albert Kueh

DESIGNER
Albert Kueh

PHOTOGRAPHER
Adrian J. Swift

CREATING BRAND-RELATED IMAGERY FOR A CONTAINER THAT, WHEN FOLD-
ED, WORKS AS A PROTECTIVE CONTAINER FOR STORAGE AND SHIPPING,
AND, WHEN UNFOLDED, AS A WALL-HANGING UNIT FOR EASY ACCESS TO
SOFTWARE DISCS AND MANUALS, MADE THE DESIGN CHALLENGE TWO-
FOLD. IT NEEDED TO GET THE MESSAGE ACROSS BUT BE ATTRACTIVE
ENOUGH TO BE SEEN ON A DAILY BASIS.

Form follows function with @KA's packaging concept for RiverSoft, a program that improves a com-
puter's system performance. The performance of the packaging is equally efficient in the way it func-
tions as an on the shelf or wall hanging unit for easy access to RiverSoft's manuals and software discs.

For shipment and storage, the box folds up into a compact container, displaying water droplets
against a blue field. When it's unfolded, the droplets extend into a broader picture, literally, of the
software packaging with water drops sprinkled on top. The effect was achieved through a series of
water-doused photographs by photographer Adrian J. Swift. The theme is repeated in the manuals'
cover photographs of a droplet-drenched open booklet.

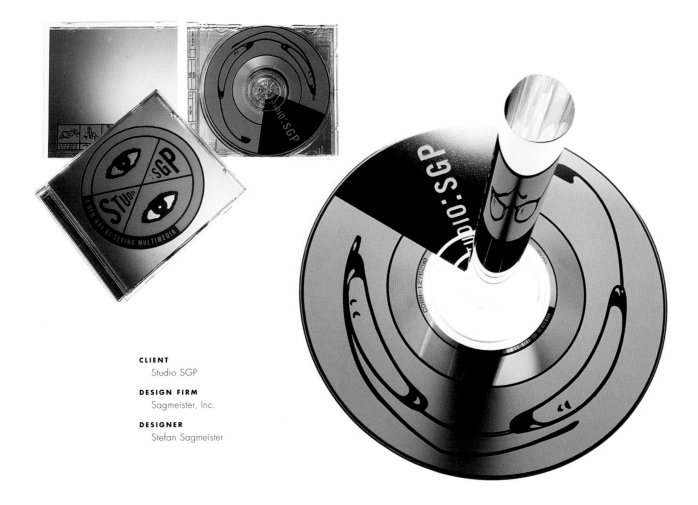

CLIENT
Studio SGP

DESIGN FIRM
Sagmeister, Inc.

DESIGNER
Stefan Sagmeister

TO EMPHASIZE THE INTERACTIVE ASPECTS OF HIS CLIENT'S SOFTWARE, DESIGNER STEFAN SAGMEISTER DEVELOPED A PACKAGING CONCEPT FOR THE DISC THAT ENCOURAGES RECIPIENTS TO MANIPULATE ITS COMPONENTS IN A WAY THAT REVEALS THE COMPANY'S LOGO.

Because Studio SGP is a multimedia company, designer Stefan Sagmeister wanted to develop a packaging concept for his client's demo disc that would communicate interactivity. His solution was to develop a packaging design that would engage recipients and encourage them to interact, proactively, with the packaging and its compact disc.

The jewel case's enigmatic cover image is printed on a highly reflective, Mylar substrate. Its engaging and intriguing imagery encourages recipients to open the jewel case, where an equally intriguing image appears on the demo disc. Diagrams and instructions on the cover's reverse side tell recipients to roll up the Mylar cover panel and insert it in the center of the disc, where the panel's reflective surface reveals the Studio SGP logo.

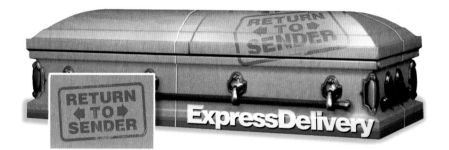

CLIENT
WhiteLight Art Caskets

DESIGN FIRM
xfactor design

ART DIRECTOR
Ray Phillips

DESIGNER
Ray Phillips

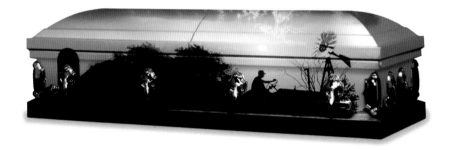

XFACTOR'S THEMATICALLY DESIGNED CASKETS EXPRESS THE INTERESTS AND DREAMS OF THE DECEASED IN THEIR ARTFUL INCORPORATION OF IMAGE MONTAGES THAT CAN BE SEAMLESSLY WRAPPED AROUND THE TOPS AND SIDES OF A CASKET.

Xfactor's thematically designed caskets let creative souls express themselves from the cradle to, literally, the grave. The design firm has developed thirty designs that represent professional interests, geographic locations, and other subjects of significance to its clients.

When xfactor creates a casket design, its designers start with copyright-free photos, which they layer to create a montage of images that will wrap around all sides of the casket's surface. Because the top of the casket is often not visible because it's open or hidden by flowers, the most prominent imagery is placed on the sides of the casket, with the focal point at the front.

Xfactor developed a special template in Photoshop that fits the caskets' fluted sides to use when any of its designs are being produced. After each design is completed, the Photoshop file is printed on adhesive vinyl, which is wrapped around and adhered to the casket's surface.

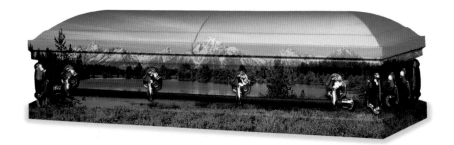

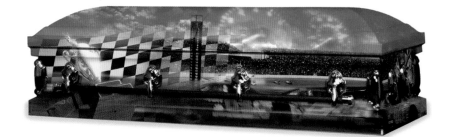

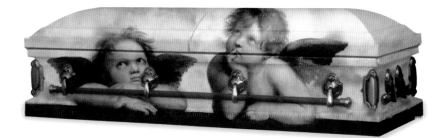

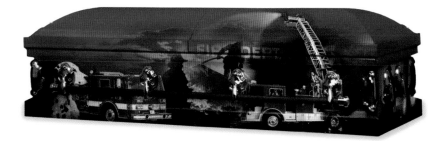

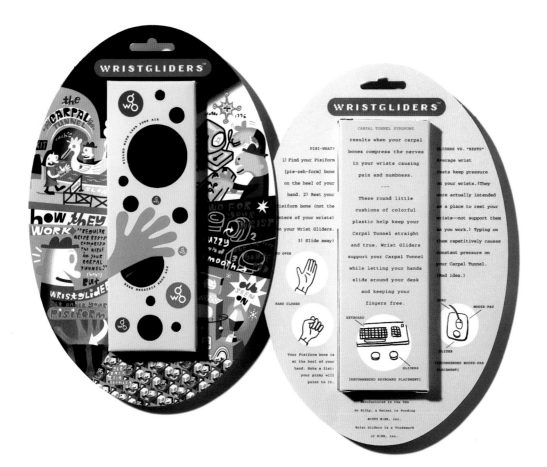

CLIENT
Wrist Gliders

DESIGN FIRM
AND Design

ART DIRECTOR/DESIGNER
Douglas Dearden

ILLUSTRATOR
J. Otto Seinbold

COPYWRITER
Christy C. Anderson

FACED WITH THE CHALLENGE OF DEVELOPING PACKAGING FOR TWO TINY CIRCLES THAT SUPPORT THE WRISTS, AND DESIGN'S DOUGLAS DEARDEN DECIDED A BOX, RIDDLED WITH CIRCULAR HOLES, WOULD PROVIDE A PROTECTIVE CONTAINER, YET STILL ALLOW EXPLORATORY ACCESS TO THE PRODUCT.

If your wrists hurt, Wrist Gliders are the answer. Designed to prevent carpal tunnel syndrome, as well as help those who suffer from it, Wrist Gliders are actually two small, cushy discs that support the wrists while users are typing. To answer Wrist Gliders' need for packaging for its product, AND Design was enlisted to develop a design and a logo.

AND Design's Douglas Dearden first designed a logo that incorporates the two little circles that support your wrists. From there, he needed to develop a packaging concept that would stack and display and allow the discs to be touched, yet secure them in a way that would discourage shoplifting. "They're so small, they could easily be stolen," Dearden explains.

His solution was a hanging board that incorporates a box for the wrist gliders. The boards stack easily and don't take up a lot of shelf space, while the die-cut, circular holes in the box encourage consumers to poke and squeeze the cushy gliders within. Whimsical illustrations by Otto Seinbold catch the eye and tell the story of how Wrist Gliders can help prevent carpal tunnel syndrome.

CLIENT
ConnectCare

DESIGN FIRM
Greteman Group

CREATIVE DIRECTOR
Sonia Greteman

ART DIRECTOR
Sonia Greteman, James Strange

DESIGNER
Garrett Fresh

ILLUSTRATOR
Garrett Fresh

COPYWRITER
Deanna Harmers

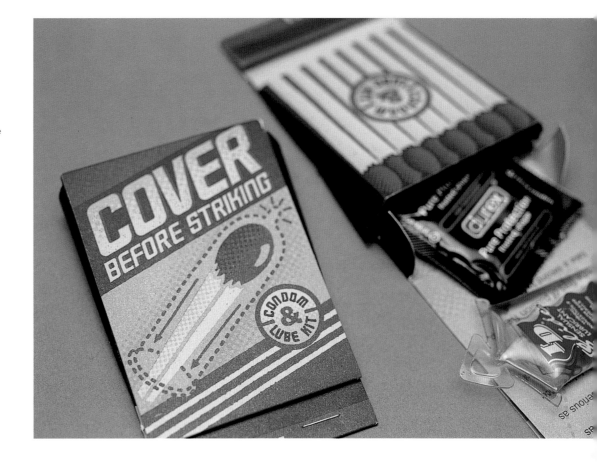

WHEN FACED WITH THE CHALLENGE OF CREATING PACKAGING FOR A CON-
DOM AND LUBE KIT, THE GRETEMAN GROUP USED HUMOR AND A MATCH-
BOOK FORMAT TO ENCOURAGE RECIPIENTS TO "COVER BEFORE STRIKING."

"Cover Before Striking" proclaims this combination condom and lube kit, aimed to help prevent the spread of HIV and AIDS. Distributed at gay clubs and adult bookstores in the Wichita, Kansas, area, the kit mimics the look of a vintage matchbook with its retro palette and typography. Related text, with statements such as "Don't get burned," supports the kit's matchbook theme.

Wichita's Greteman Group conceived the matchbook idea as a lighted-hearted means of educating others on how to avoid the dangers of HIV and AIDS. "We wanted it to be young and hip," relates creative director Sonia Greteman. When opened, the matchbook's lid flips up to reveal a condom and lubricant and instructions on how to use them.

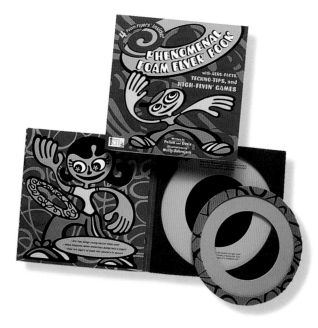

CLIENT
Innovative Kids

DESIGN FIRM
Olika

ART DIRECTOR
Bob Filipowitz

ILLUSTRATOR
Molly Zakrajsek

DEALING WITH PUNCH-OUT PIECES AND TOYS WITHIN THE FORMAT OF A
CHILDREN'S BOOK CHALLENGED OLIKA'S DESIGNERS TO DEVELOP GRAPH-
ICS THAT CONVEYED THE THEME OF EACH BOOK AND WORKED WITHIN
AND AROUND ITS TOY ENCLOSURES.

Innovative Kids publishes interactive books for children. The books generally have punch-out pieces
that can be assembled or toys actually inserted into the book's pages, so that children become more
engaged and learn more as a combination of reading and doing.

Olika helped the publisher in the development of two of its projects: a tri-fold booklet about gliders
that includes a punch-out, ready-to-assemble glider, and another book about aerodynamics that
includes foam frisbees. Olika developed illustrations and patterns that would engage children and
work with the toys, using bright colors and swirly, patterned backgrounds to suggest flight. The pat-
terns were also applied directly to the toys to thematically link them with the book.

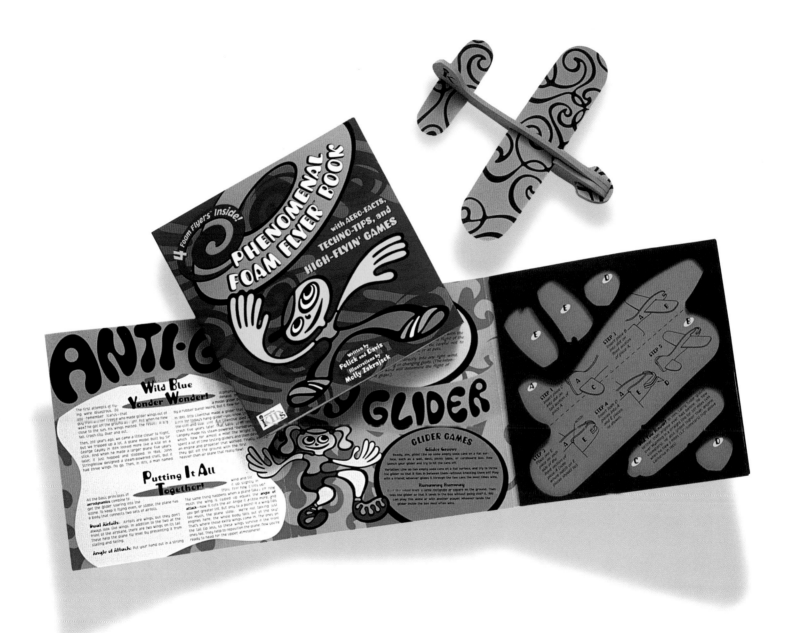

FOUR SEASONALLY THEMED FESTIVALS, CREATED TO LIFT THE SPIRITS OF YOUNG CANCER PATIENTS, ARE LINKED BY A CHEERFUL LOGO AND IMAGERY THAT'S DESIGNED TO WORK WITH THE LOGO ON INVITATIONS AND POSTERS AS WELL AS SEPARATELY ON GARMENT GIVEAWAYS.

Affiliated with St. Jude Hospital in Memphis, Target House provides a nurturing, home-like environment for recovering young cancer patients and their families. To lift spirits, Target House holds four seasonally themed carnivals every year.

Olika lent its efforts to the event by developing a graphic theme and identity that would appeal to kids and work for all four carnivals. In addition to appearing on invitations and posters, the new identity was applied to garment giveaways, donated by Target.

The Olika design team started by developing a new name, Whoop-di-doo, for all four carnivals. The spirited Whoop-di-doo logo serves as the primary unifying element for all four of the carnivals' identity materials. From there, character icons were developed to represent each of the four seasons. Their small, circular format allowed them to be easily placed as embroidered emblems on hats. Background motifs were also designed to tie in with each season, so that each carnival would have its own distinct look, yet be linked by similar design elements.

CLIENT
Target House

DESIGN FIRM
Olika

ART DIRECTOR
Mike Rice

ILLUSTRATOR
Molly Zakrajsek

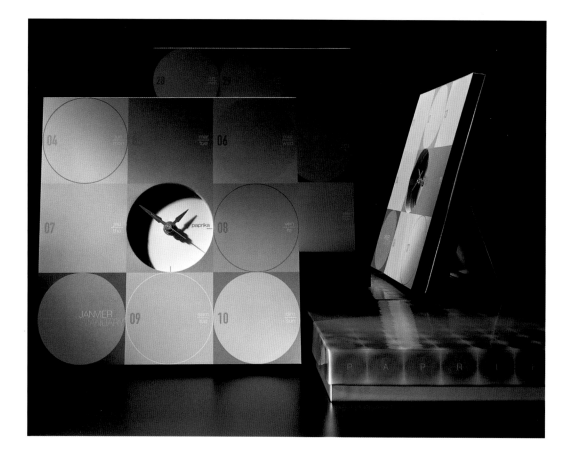

CLIENT
Paprika

DESIGN FIRM
Paprika

ART DIRECTOR
Louis Gagnon

DESIGNER
Francis Turgeon

PAPRIKA'S INNOVATIVE SELF-PROMOTION FUNCTIONS AS A CLOCK AS WELL AS AN AGENDA PAD. A PATTERN OF SQUARES AND CIRCLES HELPS TO UNIFY THE PIECE'S CALENDAR SQUARES AND CLOCK FACE.

As the designers at Paprika brainstormed a self-promotional gift for the holidays, what started as a paper clock soon became an agenda clock. From there, the design team ultimately conceived a clock surrounded by a pad with a series of tear-off sheets for each week of the year. Users can jot down appointments for each day of the week within each of the clock's seven squares, and tear it off at the end of the week, to reveal a fresh set of squares and the next week of the calendar year.

Paprika's innovative idea is also an attractive fixture in anybody's office or home. The circular die-cut that displays the clock face is repeated in a configuration of circles and squares colored with a subtle palette that coordinates with any decor.

Packaged in its own silver gift box, the clock was so well received Paprika decided to produce a 2001 calendar/clock, which was sold throughout North America.

AN INVITATION TO AN AIRCRAFT OWNER'S EVENT CHALLENGED THE GRETEMAN GROUP TO CREATE CONCEPT AND IDENTITY ELEMENTS THAT WOULD WORK ON A VARIETY OF ITEMS AND STAND OUT IN A FIELD OF TEXT. THE DESIGNERS RESPONDED BY INCORPORATING AIRY GRAPHICS AND A CONSISTENT PALETTE INTO A DESIGN THEME THAT UNIFIES A CUSTOM-PACKAGED KITE AND ITS VARIOUS INSERTS.

An invitation to a high-end aircraft owners event at Pebble Beach expresses fun and relaxation with its message of "Lift Your Spirit." To reinforce this theme, the invitation includes a kite. "We wanted to let others know what a truly special event this was going to be," explains the invitation's creative director, Greteman Group's Sonia Greteman.

To stand out from other mail, the custom-packaged kite arrived in a corrugated box. A label on the inside of the box's lid and the box's inserts are linked by a shared palette and the Lift Your Spirit logo, a combination of type and a kite image in a circular configuration. Airy gradients emanating from the logo suggest clouds—a motif that's repeated on the other components of the mailer and on the kite itself.

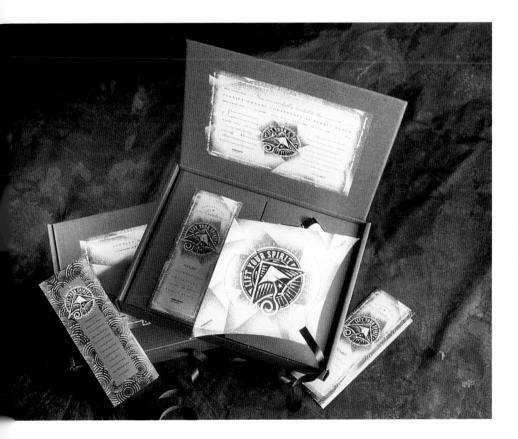

CLIENT
Flexjet

DESIGN FIRM
Greteman Group

CREATIVE DIRECTOR
Sonia Greteman

ART DIRECTORS
Sonia Greteman, James Strange

DESIGNER
James Strange

COPYWRITER
Raleigh Drennon

CLIENT
Arthur Andersen

DESIGN FIRM
Lippa Pearce Design

ART DIRECTOR
Domenic Lippa

DESIGNERS
Domenic Lippa, Mukesh Parmar

AS A RECRUITING TOOL FOR COLLEGE GRADUATES, LIPPA PEARCE DESIGN
DECIDED THAT A SET OF COASTERS WOULD BE MORE OF AN ATTENTION-
GETTER THAN A BROCHURE. FROM THERE, TYPOGRAPHY AND IMAGERY WAS
CONFIGURED TO FIT THE UNUSUAL FORMAT AND UNIFY THE SET.

Attracting qualified graduates in an increasingly competitive environment has often been a challenge for employers, who frequently publish recruitment brochures promoting their firms in ways that will appeal to young adults.

To stand out against the field, Domenic Lippa of Lippa Pearce Design suggested that Arthur Andersen promote itself with a set of "beer mats" or coasters, instead of a brochure. The coasters also offered an opportunity to deliver short, punchy pieces of information that would make an instant impact on their intended audience.

The coasters presented questions and quandaries on one side, with corresponding imagery and definitive statements on the opposite. The Lippa Pearce design team developed a consistent palette and typographic treatment to help unify the collection, and packaged them in a tin.

Intrigued?

Where do **you** want to be 5 years from now?

10

15

50

discover yourself

do **you** want to be

Look at yourself in a new light

Graduate Opportunities

ARTHURANDERSEN

4 U ?

We take a lon

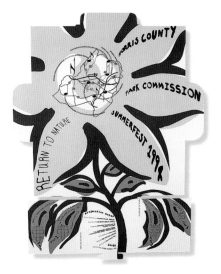
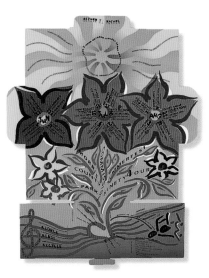

CLIENT
Morris County Parks Commission

DESIGN FIRM
Designation

CONCEPT
Richard Puder

DESIGNERS
Richard Puder, Mike Quon

ILLUSTRATOR
Mike Quon

DESIGNING A CONCERT POSTER THAT ALSO DOUBLES AS A PLANT CONTAINER CHALLENGED DESIGNER MIKE QUON TO INCORPORATE THE CONCERT INFORMATION WITHIN THE PLANTER'S DESIGN.

"Return to Nature" is the message of this poster promoting a series of free summer concerts at New Jersey's Morris County's parks. To emphasize the concerts' natural venues, the Morris County Parks Commission wanted a poster that would encourage recipients to get back to nature. To accomplish this, they enlisted the aid of Designation's Mike Quon to design a poster that would double as a planter.

Quon's challenge was to develop eye-catching graphics on a sheet of die-cut chipboard that would work equally as well when assembled into a four-sided planter. The poster's message, including performing artists, and the dates and locations of each concert, also needed to fit within the parameters of the poster/planter.

Quon's solution was to create a colorful composition that suggests growing and flowers. The concert information flows and conforms to the undulating patterns of the imagery's stems, leaves, and petals, in a way that makes the text as decorative as it is informative. The poster/planter was mailed with a packet of seeds and included directions on how to fold it into a planter.

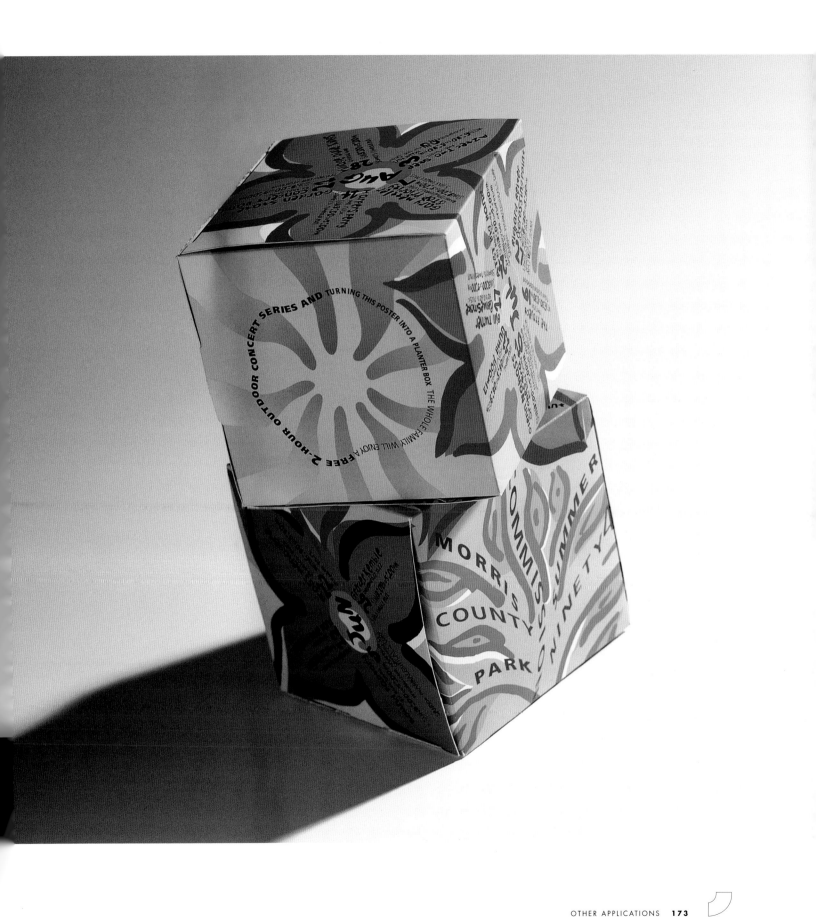

CLIENT
France Telecom

DESIGN FIRM
Metzler & Associates

CREATIVE DIRECTOR
M.S. Herrmann

ILLUSTRATORS
Emmanuelle Angibaud, Sacha Z

TO UNIFY A SERIES OF PHONE CARDS FOR FRANCE TELECOM, METZLER & ASSOCIATES COMMISSIONED A VARIETY OF ILLUSTRATORS TO COME UP WITH DESIGNS BASED ON A SINGLE THEME: THE PHONE BOOTH. THE ILLUSTRATORS COMPLIED WITH LIVELY AND EYE-CATCHING DEPICTIONS THAT EFFECTIVELY COMMUNICATE THIS UNUSUAL THEME WITHIN THE CONSTRAINTS OF A TINY, PLASTIC CARD.

Commissioned to design a series of phone cards for France Telecom, Metzler & Associates creative director Marc-Antoine Herrmann enlisted the aid of several illustrators to help him design telephone-themed imagery for the face of the cards.

To show that the phone cards can be used as a ticket to other destinations, illustrator Emmanuelle Angibaud combined phone booths with landmark destinations across the world. The phone booths appear in China, Russia, Egypt, and London, as well as in New York City.

Illustrator Sacha Z chose to depict fashion-conscious young women talking on public telephones in areas where she would like to see them—spaces that are the size of a phone booth such as an elevator, dressing room, beach cabana, and ski lift.

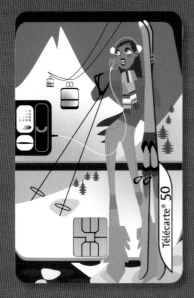

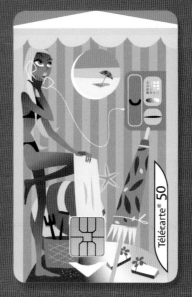

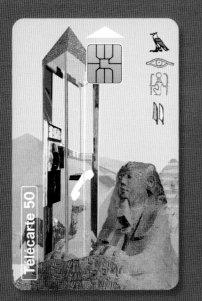

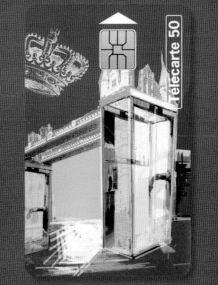

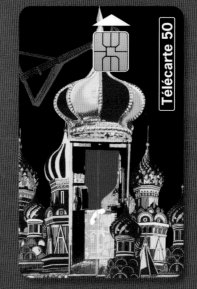

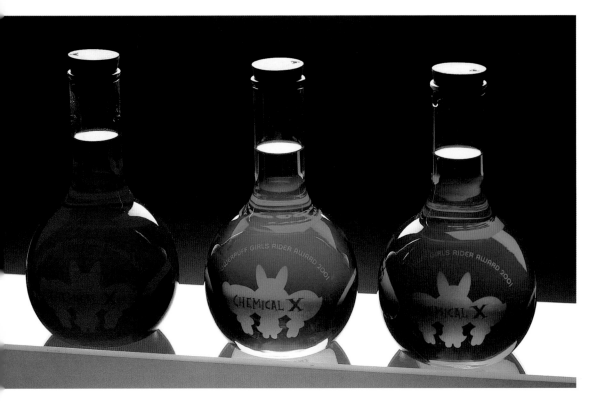

CLIENT
Cartoon Network

DESIGN FIRM
Jager Di Paola Kemp Design

CREATIVE DIRECTOR
Michael Jaeger

ART DIRECTOR
Richard Curren

DESIGNERS
James Lindars, Coberlin
Brownell, Dana Sacks

WHEN FACED WITH THE TASK OF CONCEIVING A TROPHY DESIGN FOR
WOMEN'S SURF AND SNOWBOARDING EVENTS SPONSORED BY CARTOON
NETWORK'S POWERPUFF GIRLS, JAGER DI PAOLA KEMP DESIGN DECIDED
THAT ENGRAVED AND FILLED CHEMICAL BEAKERS BEST REPRESENTED THE
MAGIC BEHIND THE POWERPUFF GIRLS' STRENGTH AND POWER.

In an effort to raise consumer awareness of the Powerpuff Girl brand, based on its popular cartoon series, the Cartoon Network sponsors surf and snowboarding events for women athletes. As the design firm behind the Powerpuff Girl brand's print and image campaign, Jager Di Paola Kemp Design was given the responsibility of designing trophy awards for these events.

The JDK design team conceived trophies inspired by "Chemical X," the secret ingredient in the experiment that made the Powerpuff Girls so powerful. Red, blue, and green solutions representing each of the three Powerpuff Girls were placed in laboratory beakers engraved with the Powerpuff Girls logo.

CLIENT
Glass Garden

DESIGN FIRM
Design Guys

CREATIVE DIRECTOR
Stev Sikora

DESIGNERS
Gary Patch, Jay Theige

CREATING A FUNCTIONAL YET ATTRACTIVE PACKAGING
FOR A LINE OF RECYCLED GLASS PEBBLES LED DESIGN
GUYS TO AN ELEGANT AND STURDY CONCEPT THAT
SECURES YET ALSO DISPLAYS THE PRODUCT.

Glass Garden manufactures a line of recycled glass pebbles and spheres that are used as landscaping accents in the garden. The landscaping specialists sought out Design Guys wanting an elegant, efficient, and economical packaging strategy that would showcase their product in retail garden centers.

The Design Guys creative team devised a simple corrugated cardboard cube to surround the glass product, secured in a plastic net bag. The cube is open at two ends to showcase the product within. To identify the product with their client's name, and add a decorative accent, the designers applied a plastic label, attached with plastic webbing that's knotted at each end. The label also serves as a sturdy handle.

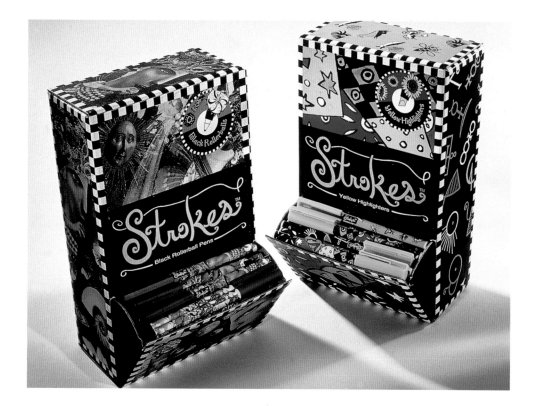

CLIENT
Northlich

DESIGN FIRM
Olika

CREATIVE DIRECTOR
Lori Siebert

DESIGNERS
Lisa Ballard, Diane Gliebe

DESIGNING A SERIES OF PENS MARKETED TO YOUNG GIRLS CALLED FOR A LOGO AND A SERIES
OF COORDINATED DESIGNS THAT WOULD WORK ON THE SLIM LINES OF A PEN SHAFT AS WELL
AS ON A COUNTER DISPLAY SYSTEM FOR THE PENS.

When Olika was commissioned to design a line of pens called "Strokes" for Empire Berol that would be marketed to young
girls, the firm was faced with a two-fold challenge: They needed to develop a variety of trendy image applications that their
demographic would respond to, while making them work effectively on the slim lines of a pen shaft. The Olika design team
also needed to design a Strokes logo as well as counter displays for the pens.

The designers started by coming up with six different visual themes that they thought would appeal to young girls. The multi
categories included faces and jewelry, primitive images, and all-black-and-white. Within each of the six categories, they devel
oped three different pen designs, linked by the same cap and ink color and similar imagery. The designers focused on devel-
oping patterns or collages that could be easily wrapped around the pen shafts.

Olika designed a counter display for each thematic category that incorporates the imagery from the pens in that category. The
Strokes logo expresses the sensibility of cursive writing with a pen and needed to work equally as well on the counter displays
as it did on the reduced scale of the pen shafts. In addition to the Strokes logo, a black-and-white checkerboard pattern helps
to visually link the counter displays.

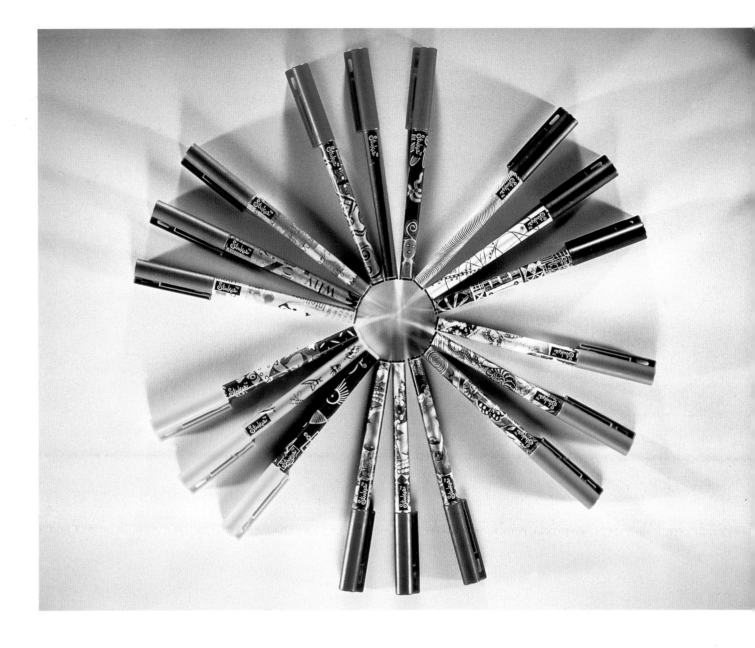

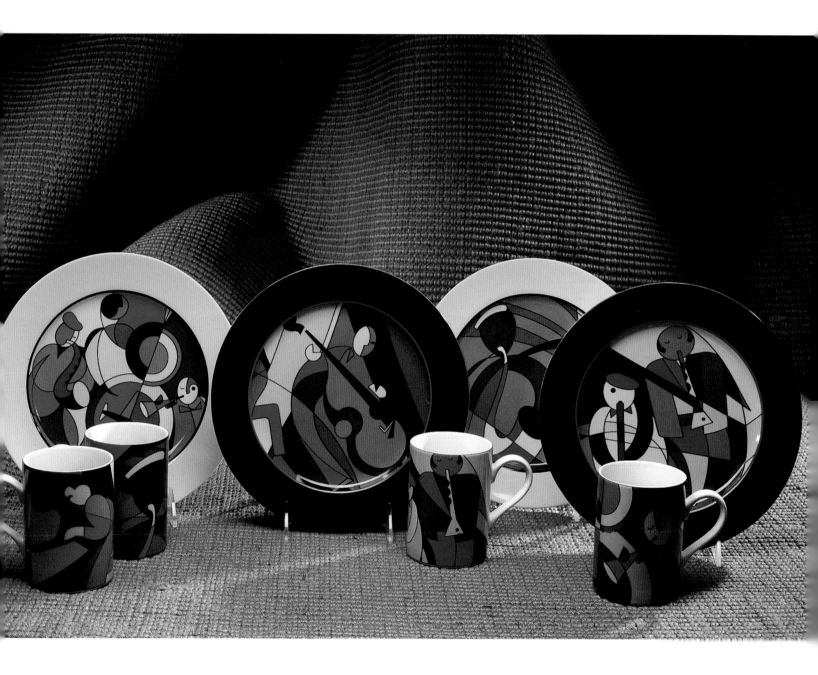

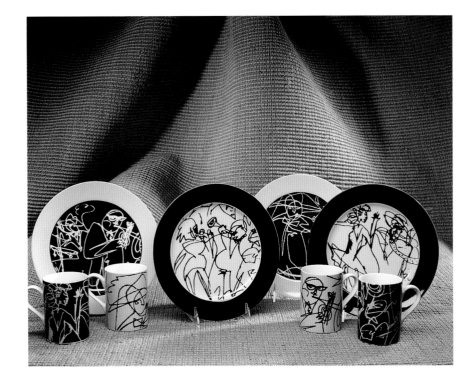

CLIENT
Aerobleu for Sasaki

DESIGN FIRM
Less Than 7

ART DIRECTORS
Brooks Branch, Henry Vizcarra

DESIGNERS
Chris Jaszkowiak, Christa Stone

ILLUSTRATOR
John Hillmer

CREATING TWO DIFFERENT LINES OF DINNERWARE, BASED ON THE SINGLE THEME OF JAZZ, PROMPTED DESIGNER BROOKS BRANCH TO CAPTURE THE BOHEMIAN SPIRIT WITH ONE DESIGN, AND A RAW, CABARET ATMOSPHERE WITH THE OTHER. STYLIZED, SEMI-ABSTRACT IMAGERY PROVIDED A MEANS OF ADAPTING THE DESIGNS TO MUGS AND PLATES IN A MANNER THAT'S ELEGANT ENOUGH TO WITHSTAND THE TEST OF TIME.

A love of jazz prompted Brooks Branch, firm principal of Less Than 7, to design two sets of jazz-inspired dinnerware. Although both capture the spirit of the jazz era, each line is distinctly different in its sensibility.

Less Than 7's Paris dinnerware uses a Picasso-esque approach (opposite) in its depiction of musicians and instruments to capture the Bohemian spirit of Paris during the jazz era. The three designs' semi-abstract quality and broad areas of color allowed for adaptation on the circular format of the plates as well as the cylindrical mugs.

The London dinnerware (above) series uses raw, black-and-white sketches of club scenes to convey a feeling of spirited music and dancing. The sense of motion inherent in John Hillmer's drawings suggests an air of rhythm and excitement that is most dramatically expressed in graphic black and white.

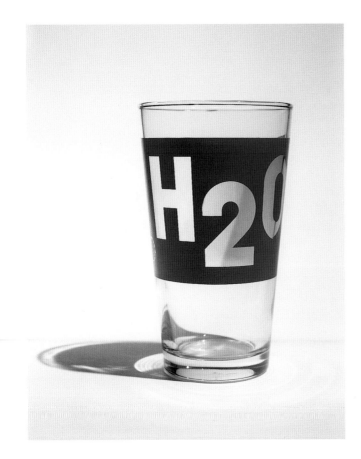

CLIENT
Urban Outfitters

DESIGN FIRM
B.C. Design

DESIGNER
Mike Calkins

A PURELY CONCEPTUAL APPROACH TO A SERIES OF GLASSES YIELDS DESIGNS UNITED BY A SINGULAR CONCEPT AS WELL TYPOGRAPHIC APPROACH AND COOL PALETTE.

When Mike Calkins of B.C. Design conceived his designs for a line of drinking glasses to be sold at Urban Outfitters, he wanted to do something more than placing a pleasing image on the outside of a glass. He thought it would be more interesting to create a glass that would interact and communicate with the drinker.

Calkins describes the purely typographic approach he devised as, "so simple that there would be this interaction with the contents and whatever it was saying." To make the concept viable, Calkins chose typefaces that were strong and bold enough to make a statement and allow the contents of the glasses to show through their messages. To ensure that nothing will get in the way of his concept's simplicity, the glasses' cool palette is as non-subjective as the typefaces Calkins chose.

CLIENT
Howard Miller

DESIGN FIRM
Palazzolo Design

CREATIVE DIRECTOR
Gregg Palazzolo

DESIGNER
Brad Hineline

ILLUSTRATOR
Roger Timmermanis

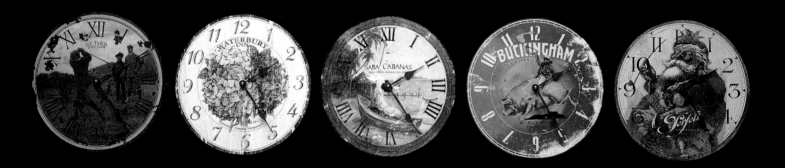

VINTAGE IMAGES THAT WORK WITHIN A CIRCULAR FORMAT AND MAINTAIN
AN ANTIQUE LOOK UNITE THIS SERIES OF WALL CLOCKS.

When client Howard Miller approached Palazzolo Design about designing a line of nostalgic clocks, they were fairly specific about some of the designs they were looking for, such as a holiday-themed clock, but were generally looking for conversation pieces with broad appeal.

Creating images that would work well within the clock faces' circular format first required extensive research. The floral image was easily found in an old seed catalog, but other images were purchased from stock, or were Photoshop reconstructions and/or combinations of found and purchased art. Firm principal Gregg Palazzolo even commissioned a painting from illustrator Roger Timmermanis for the Hemmingway-like Saba Cabana clock. All of the images were physically distressed to give them an antique quality.

The clocks are sold in furniture stores and through catalogs. According to Palazzolo, the biggest seller is the cowboy on the bucking pig.

CLIENT
Memories on Display

DESIGN FIRM
Olika

CREATIVE DIRECTOR
Lori Siebert

DESIGNER
Lisa Ballard

PHOTOGRAPHER
Mike Caporate

A UNITED COLLECTION OF NOSTALGIC IMAGERY AND VINTAGE TYPOGRAPHY
SERVES TO UNIFY SHOPPING BAGS AND A VARIETY OF VIDEO PACKAGES
OFFERED BY MEMORIES ON DISPLAY.

Memories on Display is a company that helps families preserve their memories by taking their cherished photos and putting them on videotape. When the newly formed company contacted Olika, they were looking for an identity that would work on a line of video packaging options as well as shopping bags.

In addition to a nostalgic-looking logo for Memories on Display, the Olika design team created a number of other identity applications that could work on a suite of gift packaging options their client wanted to offer. "They had different price points," explains firm principal Lori Siebert, adding that packaging ranged from a basic video box to binders and a printed tin. A second tier of logos was created for these items that picks up on the vintage look of the Memories on Display logo.

The unifying theme for the packaging and shopping bags is a series of collages the firm's design team created, comprised of old photographs and other memorabilia. The collages work equally well on binders, boxes, and tins, as they do in black-and-white on the brown, kraft surface of the shopping bags.

CLIENT
New York Post

DESIGN FIRM
Sagmeister Inc.

ART DIRECTOR
Stefan Sagmeister

DESIGNER
Stefan Sagmeister, Hjalti Karlsson

FACED WITH THE CHALLENGE OF DESIGNING A COMMEMORATIVE QUARTER TO REPRESENT NEW YORK STATE, STEFAN SAGMEISTER CHOSE TO REPRESENT THE FAMOUS AND THE WELL KNOWN WITHIN THE COIN'S LIMITED CIRCUMFERENCE.

What would you do if given the opportunity to design a state quarter? With the U.S. mint allowing each state to issue its own commemorative quarter every year, the *New York Post* posed this question to several design firms in the New York City area with the idea of featuring creative and humorous New York State quarter possibilities for the entertainment of its readers.

Sagmeister Inc. was one of the firms to respond, using Photoshop to blend a high-res scan of an actual quarter with images and type. The firm offered several designs bearing tribute to some of New York's most recognizable icons, including quarters honoring multimillionaire Donald Trump as well as the venerable hot dog, first offered at Coney Island and now sold on street corners all over Manhattan. Another concept was a direct plea to help the homeless.

TARGET CLOCK

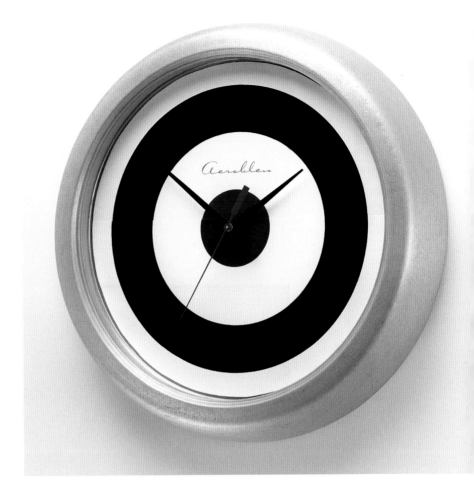

CLIENT
Aerobleu for UMBRA

DESIGN FIRM
Less Than 7

CREATIVE DIRECTOR
Brooks Branch

ART DIRECTORS
Brooks Branch, Henry Vizcarra

A 1940'S AVIATION THEME, BASED ON A PROPELLER
CONFIGURATION, SUITS ITSELF TO THE CIRCULAR FOR-
MAT OF A CLOCK.

The Target Clock, designed by Less Than 7, has its roots in a story invented by the firm's principal, Brooks Branch, that focuses on the adventures of a pilot in the late 1940s. Called "Aerobleu," the story has precipitated a series of flight-themed merchandise under the same name, including the Target Clock.

The streamlined, brushed-metal casing for the clock was inspired by the metallic fuselage of a single-engine plane. The clock's face, with its concentric circles, was designed to suggest an airplane propeller. Completing the clock's elegantly simple design is the distinctive Aerobleu logo Branch designed in an understated, deco-like script.

AND DESIGN
645 E. South Temple
Salt Lake City, UT 84102
CONTACT: DOUGLAS DEARDEN

B.C. DESIGN
157 Yesler Way, #316
Seattle, WA 98104
CONTACT: MIKE CALKINS

BELYEA
1809 Seventh Avenue, Suite 1250
Seattle, WA 38101
CONTACT: PATRICIA BELYEA

BENEFIT COSMETICS
685 Market Street, 7th Floor
San Francisco, CA 94105
CONTACT: HANNAH MALOTT

BIRD DESIGN
7039 Sunset Boulevard
Hollywood, CA 90028
CONTACT: PETER KING ROBBINS

BLACKCOFFEE DESIGN, INC.
840 Summer Street
Boston, MA 02127
CONTACT: LISA SAVARD

BOELTS BROS. ASSOCIATES
345 E. University Boulevard
Tucson, AZ 05705
CONTACT: JACKSON BOELTS

BRAND GROUP
Rua Helena 260 conjunto 33
CEP 04552-050 Vila Olimpia
Sao Paulo SP
Brasil
CONTACT: CLAUDIO NOVAES

CARTOON NETWORK
1050 Techwood Drive
Atlanta, GA 30318
CONTACT: GARY ALBRIGHT

CMB DESIGN PARTNERS INC.
608 Sutter Street, Suite 200
Folsom, CA 95630
CONTACT: JEFF BAYNE

DEEP DESIGN
5901 Peachtree Dunwoody Road
Suite 270, Building C
Atlanta, GA 30328
CONTACT: MARK STEINGRUBER

DESIGNATION
53 Spring Street, 5th Floor
New York, NY 10012
CONTACT: MIKE QUON

DESIGN GUYS
119 N. Fourth Street, Suite 400
Minneapolis, MN 55401
CONTACT: STEVE SIKORA

DOPPELGÖNGER, INC.
636 Broadway, #1202
New York, NY 10012
CONTACT: OTTO STEININGER

ERBE DESIGN
1500 Oxley Street
South Pasadena, CA 91030
CONTACT: MAUREEN ERBE

EVENSON DESIGN GROUP
4445 Overland Avenue
Culver City, CA 90230
CONTACT: STAN EVENSON

GIORGIO DAVANZO DESIGN
232 Belmont Avenue, East
Suite 506
Seattle, WA 98102-6306
CONTACT: GIORGIO DAVANZO

GIRO SPORT DESIGN
380 Encinal Street
Santa Cruz, CA 95060
CONTACT: ERIC RICHTER

GRETEMAN GROUP
1425 E. Douglas Street, Suite 200
Wichita, KS 67211
CONTACT: SONIA GRETEMAN

HAYLEY JOHNSON DESIGN COMPANY
3107 E. 42nd Street
Minneapolis, MN 55406
CONTACT: HAYLEY JOHNSON

#!+ (HIT) DESIGN
201 N.W. 35th Street
Oklahoma City, OK 73118
CONTACT: MATTHEW GOAD

HORNALL ANDERSON DESIGN WORKS
1008 Western Avenue, Suite 600
Seattle, WA 98104
CONTACT: CHRISTINA ARBINI

IRIDIUM
134 St. Paul Street
Ottawa, Ontario
Canada K1L 8E4
CONTACT: STEPHEN IWABA

JAGER DI PAOLA KEMP
47 Maple Street
Burlington, VT 05401
CONTACT: DAVID KEMP

JUICE DESIGN
351 9th Street, #302
San Francisco, CA 94103
CONTACT: BRETT CRITCHLOW

KAWASAKI MOTORS CORP., U.S.A.
9950 Jeronimo Road
Irvine, CA 92618
CONTACT: SHERYL BUSSARD

LESS THAN 7
3209 Lowry Road
Los Angeles, CA 90027
CONTACT: BROOKS BRANCH

LEWIS MOBERLY
33 Gresse Street
London, W1P 2LP, UK
CONTACT: ANN MARSHALL

LIFT COMMUNICATIONS, INC.
1100 N.W. Glisan Street, Suite 2D
Portland, OR 97209
CONTACT: AMY JOHNSON

LIPPA PEARCE DESIGN
358A Richmond Road
Twickenham, TW1 2DV, UK
CONTACT: DOMENIC LIPPA

METZLER & ASSOCICES
5, rue de Charonne
Cour Jacques Vigues
75011 Paris, France
CONTACT: MARC-ANTOINE HERRMANN

MICHAEL OSBORNE DESIGN
444 De Hara Street, Suite 207
San Francisco, CA 94107
CONTACT: MICHAEL OSBORNE

MIKE SALISBURY LLC
P.O. Box 2309
Venice, CA 90294
CONTACT: MIKE SALISBURY

MODERN DOG
7903 Greenwood Avenue, N.
Seattle, WA 98103
CONTACT: ROBYNNE RAYE

MORRIS CREATIVE, INC.
660 9th Avenue
Studio 3
San Diego, CA 92101
CONTACT: STEVEN MORRIS

OLIKA
1600 Sycamore Street
Cincinnati, OH 45210
CONTACT: LORI SIEBERT

PALAZZOLO DESIGN STUDIO
6410 Knapp, N.E.
Ada, MI 49301
CONTACT: GREGG PALAZZOLO

PAPRIKA
400 Laurier Ouest, Suite 610
Montreal, Quebec
Canada H2V 2K7

PENTAGRAM DESIGN, LTD.
11 Needham Road
London W11 2RP, UK
CONTACT: ANNALEX MILTON

PETRICK DESIGN
2100 N. Hoyne Avenue
Chicago, IL 60647
CONTACT: ROBERT E. PETRICK

PHOENIX CREATIVE CO.
611 North 10th Street, Suite 700
St. Louis, MO 63101
CONTACT: DEBORAH FINKELSTEIN

PLAZM MEDIA
P.O. Box 2863
Portland, OR 97208
CONTACT: JOSHUA BERGER

PRIMAL WEAR, INC.
8200 E. Pacific Place, #307
Denver, CO 80231
CONTACT: ALANN BOATRIGHT

PRIMO ANGELI, INC.
101 15th Street
San Francisco, CA 94103
CONTACT: RICHARD SCHEVE

P22
P.O. Box 770
Buffalo, NY 14213
CONTACT: RICHARD KEGLER

RED HERRING DESIGN
75 Varick Street, Suite 1508
New York, NY 10013
CONTACT: CAROL BOBOLTS

SAYLES GRAPHIC DESIGN
3701 Beaver Avenue
Des Moines, IA 50310
CONTACT: SHEREE CLARK

RICKABAUGH GRAPHICS
384 W. Johnstown Road
Gahanna, OH 43230
CONTACT: ERIC RICKABAUGH

SAGMEISTER, INC.
222 West 14th Street
New York, NY 10011
CONTACT: STEFAN SAGMEISTER

SAYURI STUDIO
(REPRESENTED BY PAUL MYERS & FRIENDS)
29 West 56th Street, Fourth Floor
New York, NY 10019
CONTACT: SAYURI SHOJI

SELBERT PERKINS DESIGN
1916 Main Street
Santa Monica, CA 90405
CONTACT: ROBIN PERKINS

STOLTZE DESIGN
39 Melcher Street, Fourth Floor
Boston, MA 02210
CONTACT: CLIFFORD STOLTZE

SUB POP RECORDS
2514 4th Avenue
Seattle, WA 98121
CONTACT: JEFF KLEINSMITH

SULLIVAN PERKINS
2811 McKinney Avenue, Suite 320
Dallas, TX 75204
CONTACT: KELLY ALLEN

THOMPSON STUDIO
5440 Old Easton Road
Doylestown, PA 18901
CONTACT: EMILY THOMPSON

TEMPLIN BRINK DESIGN
720 Tehama Street
San Francisco, CA 94103

TREK BICYCLE CORPORATION
801 West Madison Street
Waterloo, WI 537594
CONTACT: ERIC LYNN

TURNER DUCKWORTH
164 Townsend Street, #8
San Francisco, CA 94107
CONTACT: ELISE THOMPSON

VSA PARTNERS
1347 South State Street
Chicago, IL 60605
CONTACT: HANS SEEGER

WHAT!DESIGN
119 Braintree Street
Allston, MA 02134
CONTACT: AMY STRAUCH

WHITE LIGHT CASKETS
2515 Minor Way
Dallas, TX 75235
CONTACT: PATRICK FANT

WILLOW CREATIVE GROUP
222 East 14th Street
Cincinnati, OH 45210
CONTACT: DEBORAH DENT

WILSON SPORTING GOODS
8700 W. Bryn Mawr
Chicago, IL 60631
CONTACT: JEFF KORTENKAMP

ZUNDA DESIGN GROUP
41 North Main Street
South Norwalk, CT 06854
CONTACT: CHARLES ZUNDA

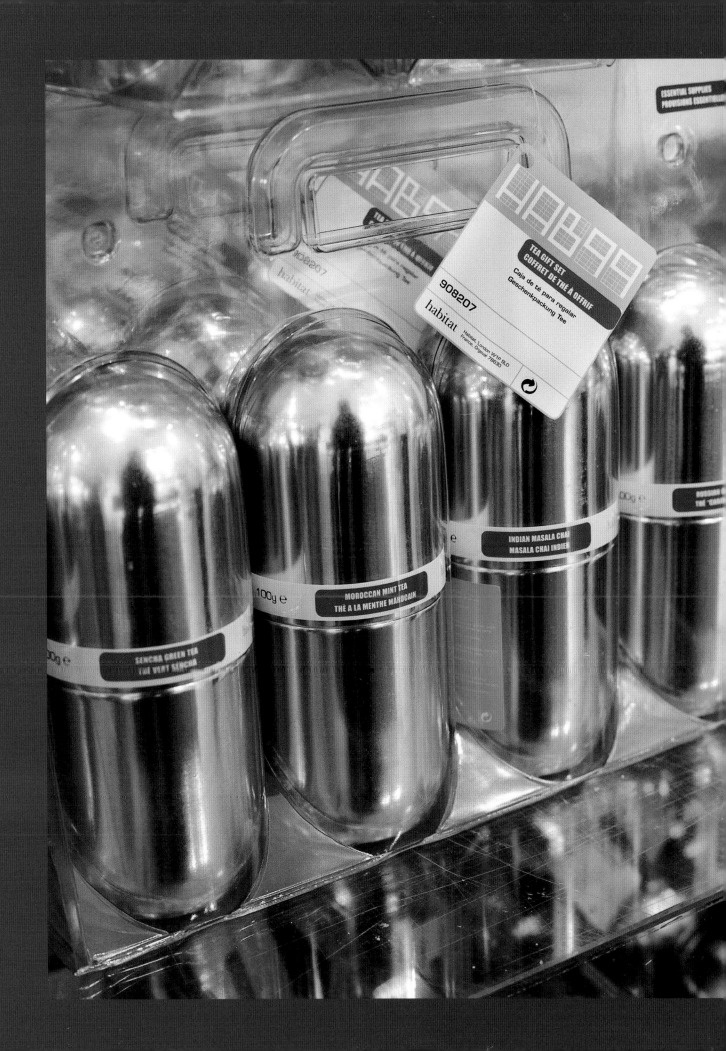

ABOUT THE AUTHOR

POPPY EVANS IS AN AWARD-WINNING WRITER AND GRAPHIC DESIGNER WHO ALSO TEACHES DESIGN-RELATED COURSES AT THE ART ACADEMY OF CINCINNATI. SHE HAS AUTHORED TWELVE BOOKS ON DESIGN AND IS A FREQUENT CONTRIBUTOR TO *PRINT, HOW,* AND *STEP-BY-STEP* MAGAZINES.